# THE KEW BOOK OF
# DRAWING
# FLOWERS

# THE KEW BOOK OF
# DRAWING
# FLOWERS

Failsafe lessons for drawing floral and botanical elements
for journalling, for stationery, for keeps

## BIANCA GIAROLA

SEARCH PRESS

This edition published in 2024 by

Search Press Ltd

Wellwood North Farm Road

Tunbridge Wells

Kent TN2 3DR

Reprinted 2024, 2025, 2026

ISBN 978-1-80092-227-3

Ebook ISBN 978-1-80093-209-8

Bookmarked Hub

For further ideas and inspiration, and to
join our free online community, visit
www.bookmarkedhub.com

Conceived, edited, and designed by

Quarto Publishing: an imprint of Quarto

1 Triptych Place

London

SE1 9SH

www.quarto.com

QUAR: 1169180

Editor: Claire Waite Brown

Managing editor: Lesley Henderson

Proofreader: May Corfield

Designer: Joanna Bettles

Art director Martina Calvio

Photographer: Nicki Dowey

Illustrator: Kuo Kang Chen

Publisher: Lorrainne Dickey

Printed in Huizhou, Guangdong, China TT122025

Fourth printing

MIX
Paper | Supporting
responsible forestry
FSC® C016973

# Contents

# Meet Bianca

Hello my petal, I'm Bianca, a botanical illustrator and artist based in Italy, and I will be your drawing teacher for today. Before we embark on our floral drawing expedition, I would like to introduce myself and share a glimpse of my artistic journey with you.

I had the privilege of growing up in the Italian countryside and, from a very young age, I found myself captivated by the beauty of nature. I remember spending my afternoons drawing on the porch, surrounded by my one-hundred-colour-crayons set that made me feel like a fully-fledged artist. This love for drawing has only deepened over the years, until it suddenly stopped. I don't remember exactly when but, by the time I was in middle school, I had completely stopped drawing. I started again more than fifteen years later, when I became a marketing manager at a communications agency in Milan.

So no, this is not the story of a lifelong pursuit, of a little girl who grew up drawing and couldn't for the life of her stop. This is the story of a person who was anything but an artist, until she decided to go back to being one.

When I was a teen, my dream was to be a writer: how ironic that now I'm an artist I have become a writer as well. After majoring in journalism at college, I listened a little too much to the people who told me I could never make a living out of it, and decided to give up my dream and find a 'real job'. I went into marketing, and stayed in the industry for a very long time, until it drained almost all of my mental energy, and I needed a break.

By chance, I came across a video on YouTube teaching calligraphy as a form of relaxation. So I picked up a pen and, this time, instead of writing a story, I wrote letters. They were very ugly at first, but there was something in handwriting, and there is still, that calmed my breath and made everything around me fade away. There is rigour and creativity, there is patience and the desire to experiment, there are rules and the desire to break them all.

And then the day arrived when letters weren't enough for me anymore. I was charmed by the floral frames some calligraphers would put around quotes, which always looked so pretty. I wanted to learn to draw them too. So, flower after flower, I found myself writing less and drawing more and now, through botanical illustration, I can express myself in the way I've always wanted to, as if this type of art had always been there, just waiting for me to discover it.

Over the years, I honed my skills and explored various forms of botanical illustration, but settled on black-and-white ink drawings as my main medium, with occasional splashes of watercolour.

Nature itself serves as my primary muse and teacher. The shades, textures and delicate intricacies of plants constantly inspire me to refine my craft and strive for greater degrees of expressionism, hoping to add a personal touch to every illustration that makes it instantly recognizable as my work. Each one of my illustrations is truly a labour of love.

I have written this book because I firmly believe that botanical illustration shouldn't be hard to learn. Many people, when approaching my work. say 'I could never do that' or 'I wish I was as talented as you'. Let me tell you, talent is a word with no meaning in my book. All you need to learn to draw flowers is a strong will and a great degree of patience. Those two things alone will carry you further than talent alone ever could.

Through this book I hope to share my passion for this art and inspire budding artists to pick up their pencils, observe the world around them with newfound curiosity and embark on an exciting journey of discovery through botanical illustration.

May your artistic endeavours blossom like the flowers you draw.

With gratitude,

*Bianca*

# Working in black and white

Botanical illustration is a beginner-friendly form of art that requires few supplies to get started. I most often work in black and white, whether in a journal, on stationery or for wall art. Here is a process of working that I recommend – and tools you can use for each stage – although you don't have to follow this, of course.

## Sketching and preliminary drawing

Sketching is a great habit to get into, since it is only by observing and practice that you can hone your skills in botanical drawing. Once you have a plan in place for what it is you want to draw, you can make a preliminary drawing in pencil, that you then work over in pen. These are just some of the most common tools used in botanical illustration. The specific tools an artist chooses may vary based on personal preference, style, comfort and the type of botanical illustration they specialize in.

*Hard pencils (H) create light lines, while soft pencils (B) produce darker and softer lines. The best advice, however, is to use whatever you feel most comfortable with. My personal favourite is a classic HB pencil, a perfect middle ground.*

*When you need to erase any pencil lines after inking, kneaded erasers are a good choice because they create very little mess. I use a mechanical eraser when I need to refine the sketch and be more precise.*

## Inking

When you are happy with your preliminary pencil drawing, the next stage is to ink it – some artists will go straight to working in ink, but don't feel you have to do so too; that takes a lot of courage and confidence (see pages 16–17).

To achieve different line qualities – for example, thicker outlines and thinner shading lines (see pages 40–41) – you will need to stock a few different nib sizes, and for drawing in highlights, and correcting mistakes, you'll need a few white gel pens.

*You can work in black and white on any paper, which is why this style is so perfect for journalling and embellishing stationery. For wall art that you want to last, go for an extra smooth, heavyweight, acid-free paper.*

*Black ink pens have a consistent ink flow and are resistant to fading. Use waterproof and archival pens and various nib sizes to create either bold contours or fine detail lines.*

*White gel pens are perfect for creating highlights, correcting mistakes and adding details to the most crowded parts of the drawing. Choose at least two nib sizes, one bigger and one smaller, and a good-quality pen to avoid smudging your lines and ending up with a dry and flaky result.*

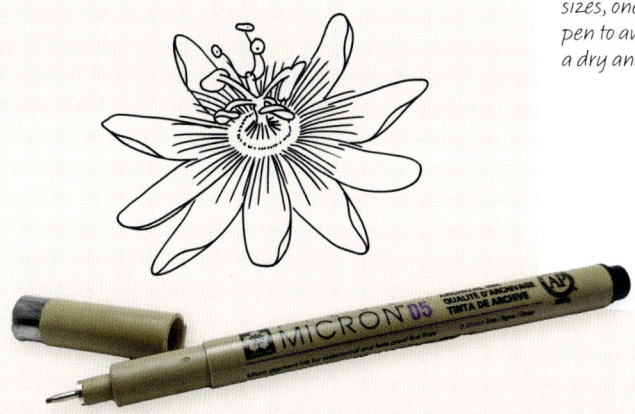

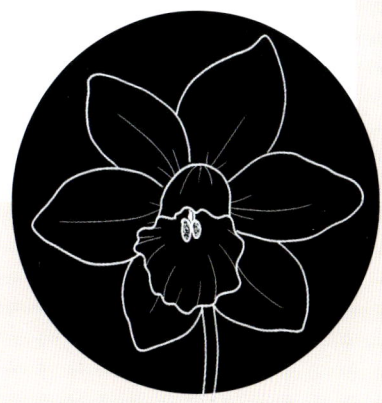

*There are many types of drawing tablet. I use my iPad Pro every day for sketching ideas or trying out new layouts and colour combinations.*

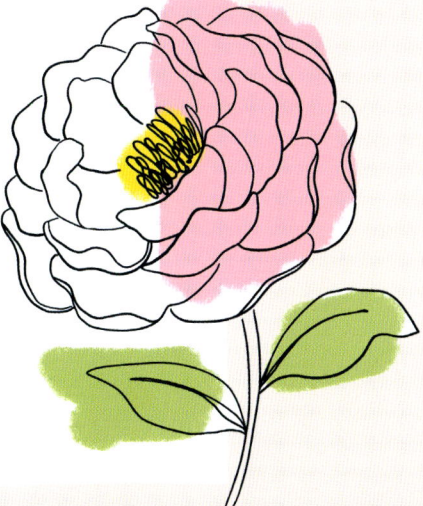

## Digital drawing

Using a tablet and drawing software is common practice and it can help you sketch freely on the go without having to rely on physical tools. The portability of tablets is unmatched, and sketching digitally can help you streamline your drawing process, especially when you're working on a final piece that will also be digital.

# Colouring basics

The focus of this book is on drawing, but there are some colouring tutorials, and it's useful to be aware of the most common colouring techniques used in botanical art, so that you can choose which one to focus on depending on the effects each technique gives. For example, you can take a flat, almost cartoony drawing to a much more layered and detailed piece. But of course, you don't have to. Whatever your skill level, tastes and art style, know that no level of realism is better than another.

Different levels of detail can be achieved with each tool, and some techniques are more time-consuming than others, so keep that in mind when considering a colouring method.

You will also need to consider your paper, since each colouring technique requires a specific surface to work to the best of its ability – as detailed on the following pages.

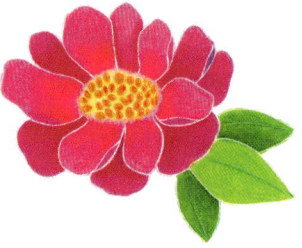

## COLOURED PENCILS

Coloured pencils are a common and accessible tool for colouring flower drawings. There is a vast range of shades available in a variety of quality grades, from student to artist grade.

- Pencils are easier to control than other colouring supplies.

- Many artists like coloured pencils because they're versatile, long-lasting and highly pigmented. They also blend easily and can create effortless shading.

- With the right technique, you can achieve an almost photorealistic result with coloured pencils.

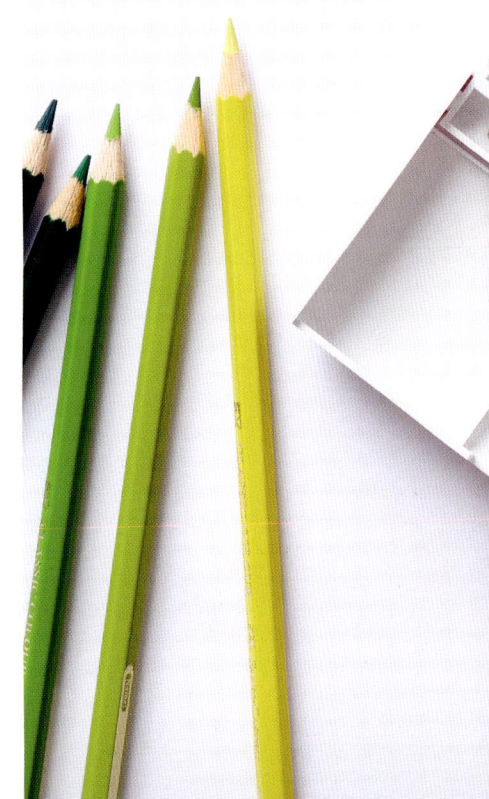

## WATERCOLOUR PENCILS

Watercolour pencils behave in exactly the same way as coloured pencils, but with the added bonus of turning into watercolours when touched with a wet brush.

- Working with watercolour pencils allows you to combine two popular techniques with greater control than watercolours alone, since you can more easily achieve a level of detail with pencils than with brushes.

- Use a watercolour or mixed-media paper when working with watercolour pencils.

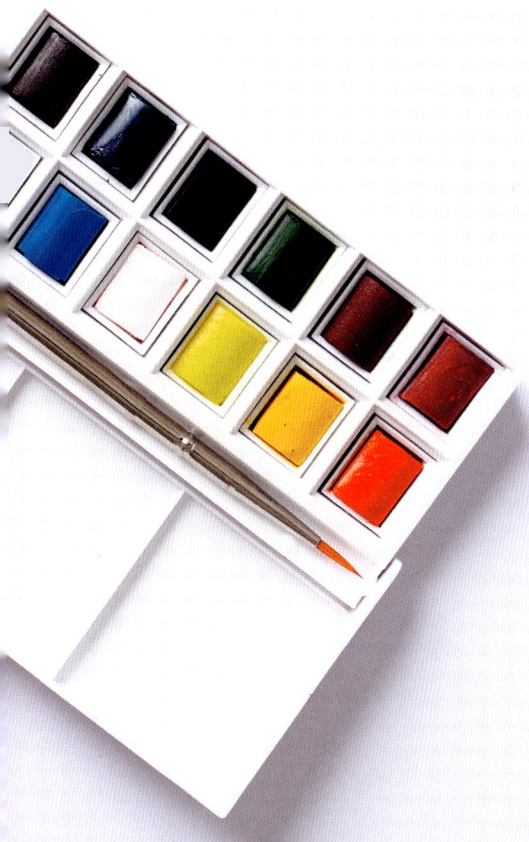

## WATERCOLOURS

Watercolours are incredibly versatile, allowing you to work in a highly detailed, almost photographic way, or to be more evocative with loose watercolour.

- Watercolour as a medium requires a good amount of study and experimentation in order to master it and find the style that resonates with you. It can be hard and frustrating at first because of the many things someone should learn even before picking up the brush, but it is one of the most beautiful techniques for colouring flowers.

- Use watercolour paper with watercolour paints.

## GOUACHE

Gouache has seen a great revival in the arts and craft community in recent years, and become a favoured medium for colouring botanical art. Essentially, gouache is opaque watercolour. It usually has white chalk as a filler in the formulation, which ensures that the final result is bright and eye-catching, similar to oil painting.

- Gouache paints are thick, easy-to-use colours that can be reworked with a little water to be activated once again.

- Since it needs water to be diluted, gouache performs best on watercolour paper.

## ACRYLICS

Acrylic paint is a water-based product but, unlike its water-based siblings, it fully covers the surface, has a glossy finish and becomes completely water-resistant once dry.

- Acrylic paint colours won't blend into one another, so you can work them in layers.

- Since it dries hard, acrylic paint is more durable and light-resistant than watercolour and gouache.

- Acrylic paints cannot be changed, or mistakes fixed, once the colour has dried.

- By using acrylic paints you can break free from the chains of paper, since they can be applied to canvas, plastic, glass, wood, metal and, of course, paper and card.

## MARKERS

Markers might not be as versatile as other colouring supplies, but their range of ready-to-use colours is unmatched. They're the perfect choice for artists who prefer to work fast and have a good understanding of how colours blend together.

- If you use artist-grade water-based markers you can add extra water to create different effects and change the shade and opacity of the colour. They tend to bleed less than alcohol-based markers, so are recommended for journalling or for when the only paper available is on the thinner side.

- Alcohol markers are a staple in the professional illustration, manga and fashion industries. They're vibrant, highly pigmented, quick-drying and, overall, far smoother than water-based markers.

- Alcohol markers can cover vast areas without streaking and, since there's no water inside the formula, they can be heavily layered without damaging or wetting the paper. However they are generally harder to use than water-based markers.

- To preserve the longevity of your markers, use them on extra smooth paper to protect the tips – especially brush tips. To avoid ghosting and bleeding, use a heavier paper.

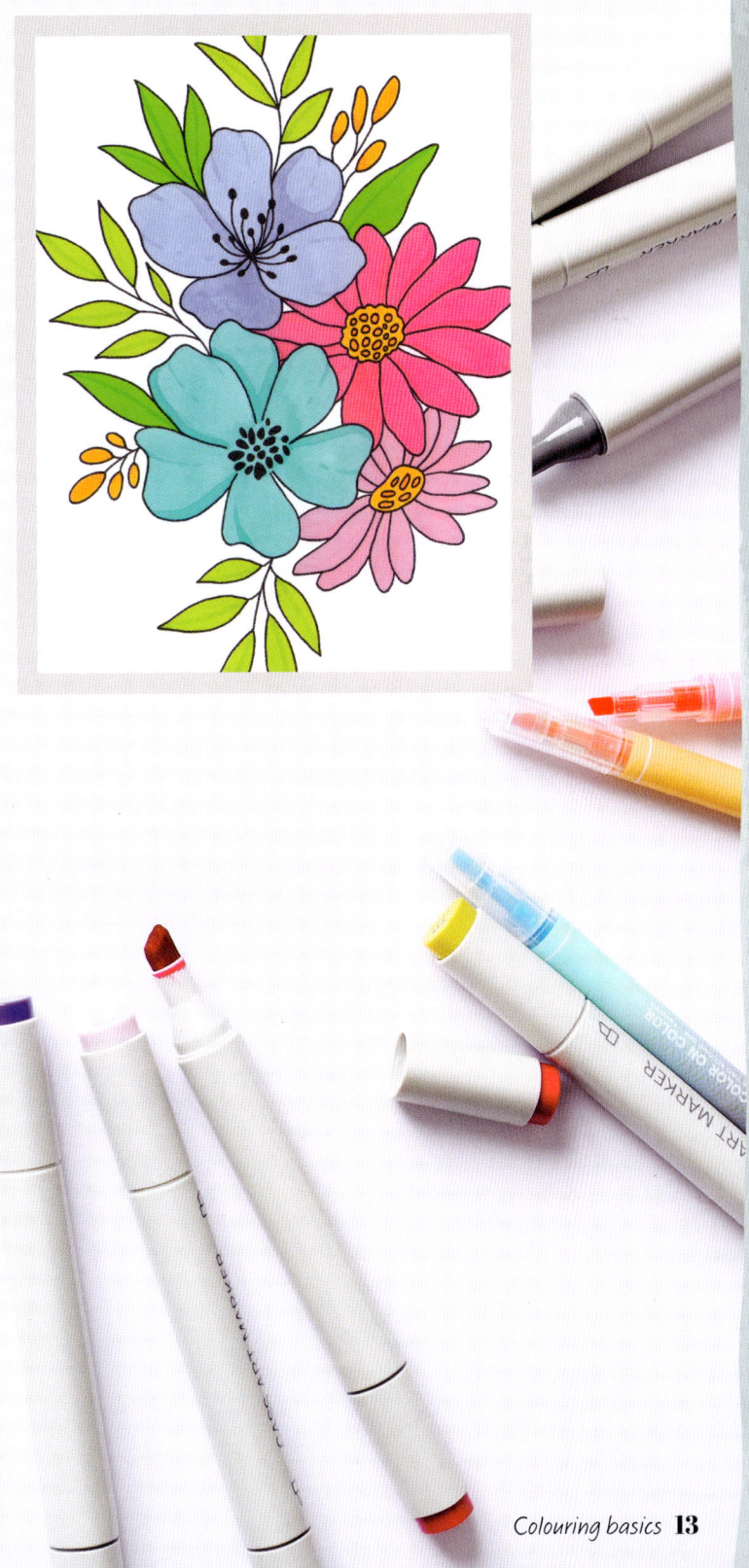

# Ways to approach the blank page

Approaching a blank page can be the most exciting and the most intimidating experience in your artistic journey, but using your skills to create something where once there was nothing is what being an artist is about.

If you don't have a clear picture of what you want to create, or the blank page blocks you more than inspires you, here are some tips to help you get started.

### EMBRACE THE BLANKNESS

One way to stop feeling intimidated by the empty page is to view it as simply the place where your ideas will come to life, a place where you have complete freedom above all.

### START SMALL

A large white piece of paper can definitely feel more intimidating than a small one. Opting for a sketchbook or creating smaller frames to work into inside the bigger canvas can help you define the space you're about to work into and feel less overwhelmed.

### FIND INSPIRATION

If you're struggling with ideas, browse through some art books, the social media pages of your favourite artists or pictures of nature where you can find some inspiration for your work. You can also curate a collection of works that you're curious about recreating in order to have new ideas always available to you.

### THUMBNAIL SKETCHING

You don't have to create a full-size sketch of your work right away. Thumbnail sketches are small versions of your idea that help you to quickly try out different compositions and elements. This is the perfect place for freedom and experimentation.

### DONE IS BETTER THAN PERFECT

Sometimes the fear of making mistakes, or not making a groundbreaking piece of art, can hinder your progress. Mistakes are a natural part of the creative process, so instead of getting discouraged, use them as learning opportunities. You can always learn and improve from each attempt.

### DON'T FORCE YOURSELF TOO MUCH

Some days are just not good days for practising, and that's fine. Sometimes you just need a little push, while on other days trying to push through could result in you not picking up the pen for weeks. Be gentle with yourself and learn to listen to what your mind is telling you. If you feel stuck or frustrated, sometimes stepping away from the blank page is the best option and, hopefully, you will return later with a fresh perspective.

### BREAK THE ICE

Often the hardest part is just getting started. Try drawing something simple, or even random, to get your creative juices flowing.

### YOU'RE NOT ALONE

Remember, you're not the only one. Every illustrator faces the blank page, with more or less enthusiasm each day. The key is to embrace the challenge and enjoy the creative journey. Give yourself some time and you'll soon develop your unique approach and style, making the blank page less and less intimidating and rather an inviting canvas for your art to bloom.

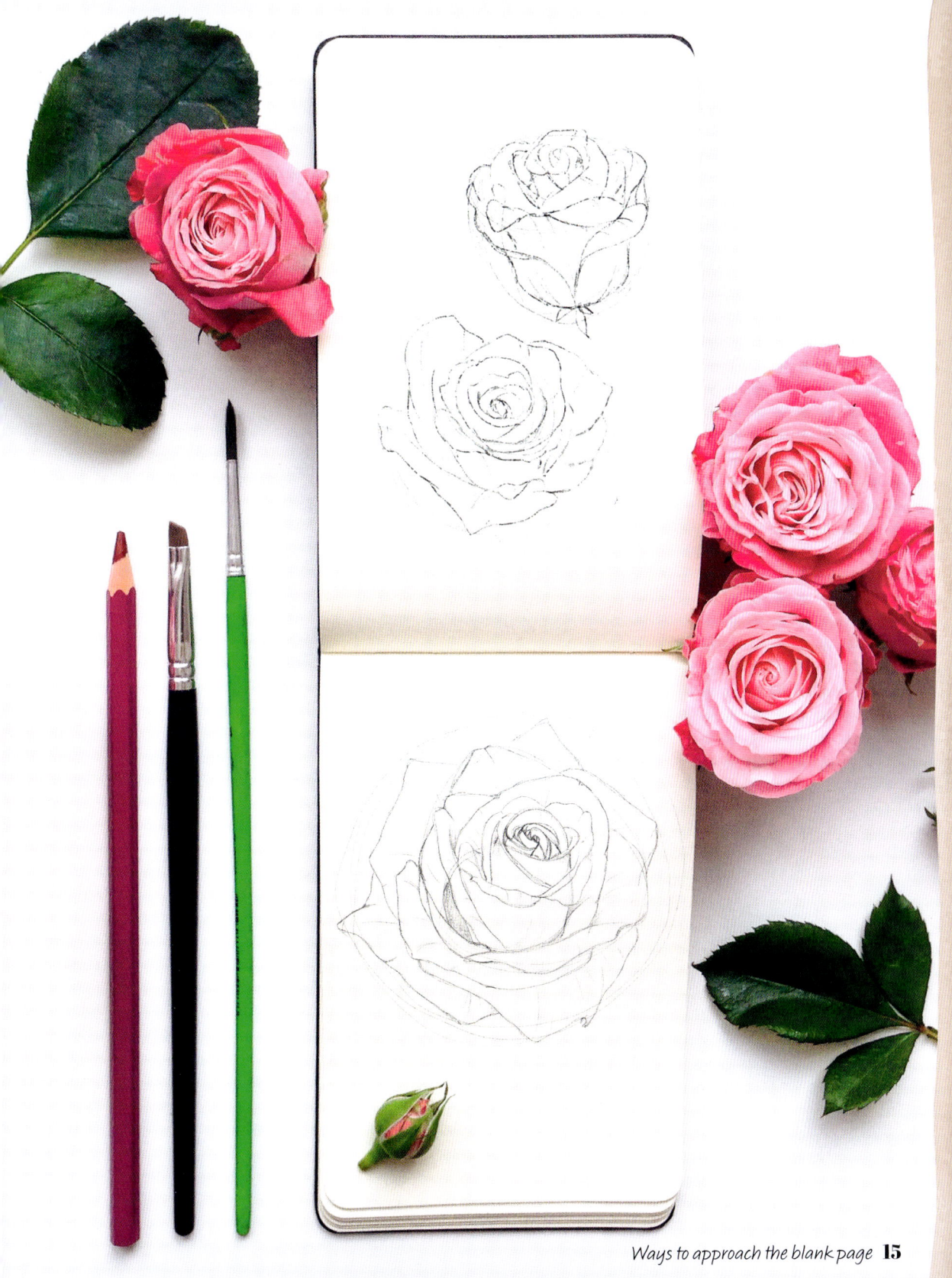

# The importance of sketching first

The tutorials in this book are shown in pen for clarity and readability, but, while it is tempting to pick up a pen and immediately start drawing, rushing ahead can lead to disappointing results. Sketching in pencil is an essential step in the illustration process, probably the most essential, since it serves as a foundation for your art piece, a solid ground on which you're building your piece stroke by stroke. This is why, with rare exceptions, it's an unskippable step, and it's better to incorporate the habit of sketching everything first from the very beginning of your botanical illustration journey.

### GOOD PRACTICE

Overall, sketching regularly helps to build your drawing skills and, the more you practise, the better you will eventually become at translating ideas from your mind onto paper.

### CORRECTIONS

Sketching is an important factor in reducing the stress of the drawing process. Knowing that nothing you're drawing is permanent and that everything can be corrected lifts a lot of weight from your shoulders, and allows you to explore different ideas without committing right away to a final version.

### PROBLEMS AND SOLUTIONS

Sketching is also a powerful problem-solving and time-management tool. When sketching, you might realize your idea comes with potential issues regarding the size and position of elements as well as with the overall balance of the composition. Identifying these problems early on allows you to find solutions and fine-tune your sketch, avoiding frustration later on: making changes in a sketch

is much quicker and easier than doing the same in an already refined drawing. This efficiency can save time and resources in the long run.

### CLIENT FEEDBACK

When working on a commission piece for a client it's customary for artists to present options from a sketching phase and, even when one of the options is chosen, to proceed with refining the sketch with the client's feedback until they're satisfied. This ensures everyone is on the same page before moving forward to the final artwork, saving time and headaches for the artist.

### DOODLING

The exception to the rule, and the only time I recommend you go in directly with pen and skip the sketching process, is with doodling. Doodles are meant to be drawn in pen since it's a technique born to be fast and worry-free, in which mistakes are not only embraced but cherished as part of the charm. Doodling relies on practice and repetition of elements so small and easy that they can be performed by

muscle memory alone without putting too much thought into them, so sketching the flowers first will only slow down the process and take most of the fun out of it.

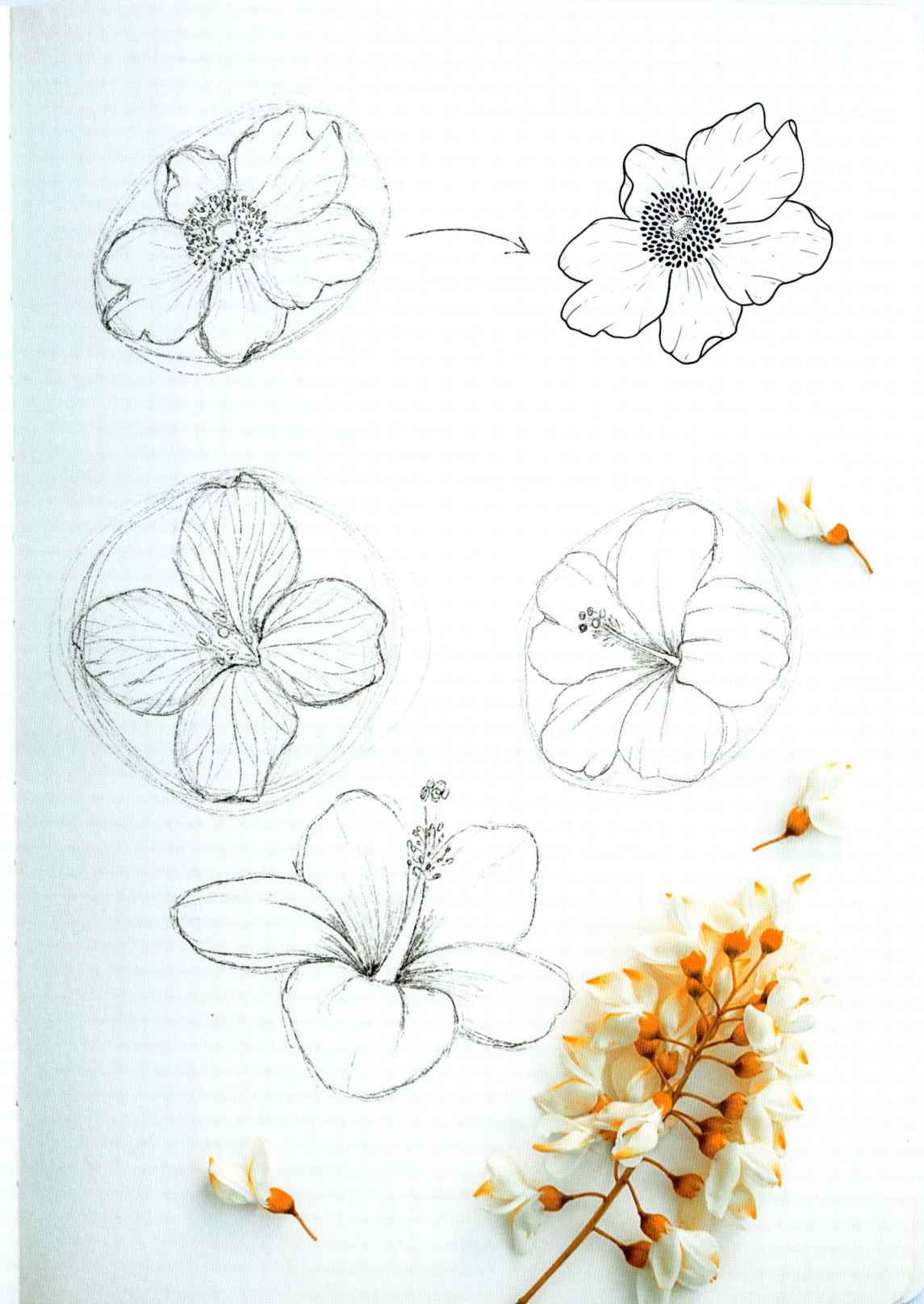

# Anatomy of a flower

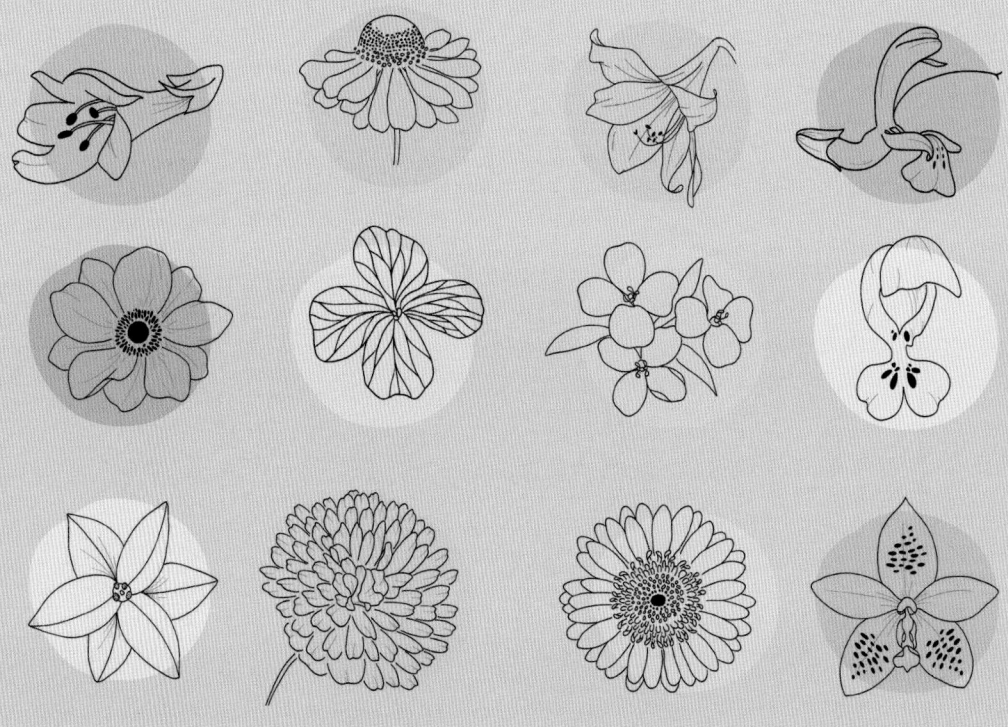

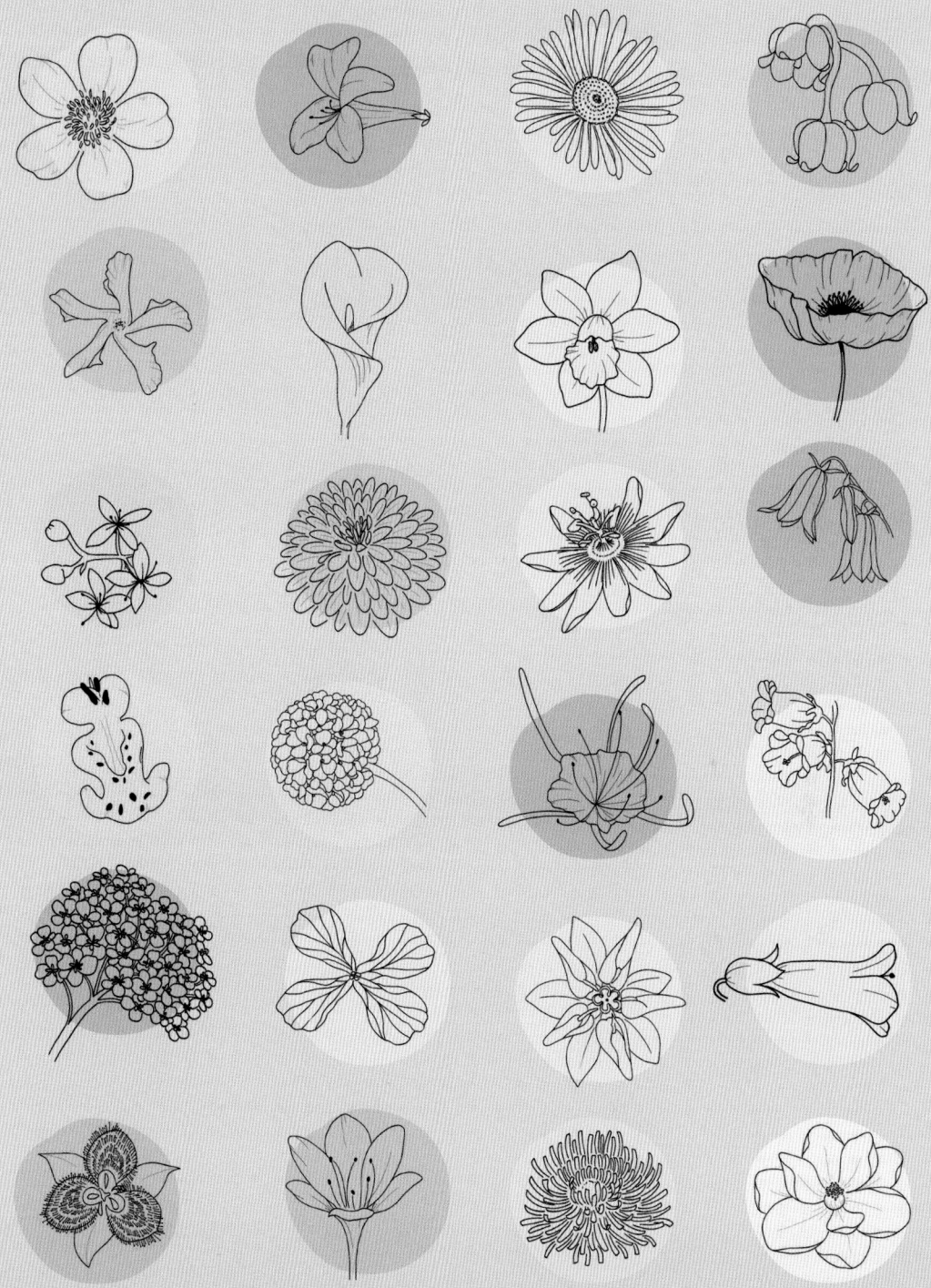

# The parts of a flower

Flowers are the reproductive organs of a plant. They have many different functions, including attracting insects for pollination.

In order to develop your flower-drawing skills, it is a good idea to brush up on your botany: a basic understanding of the parts of a flower and what they do will inform and improve your drawing.

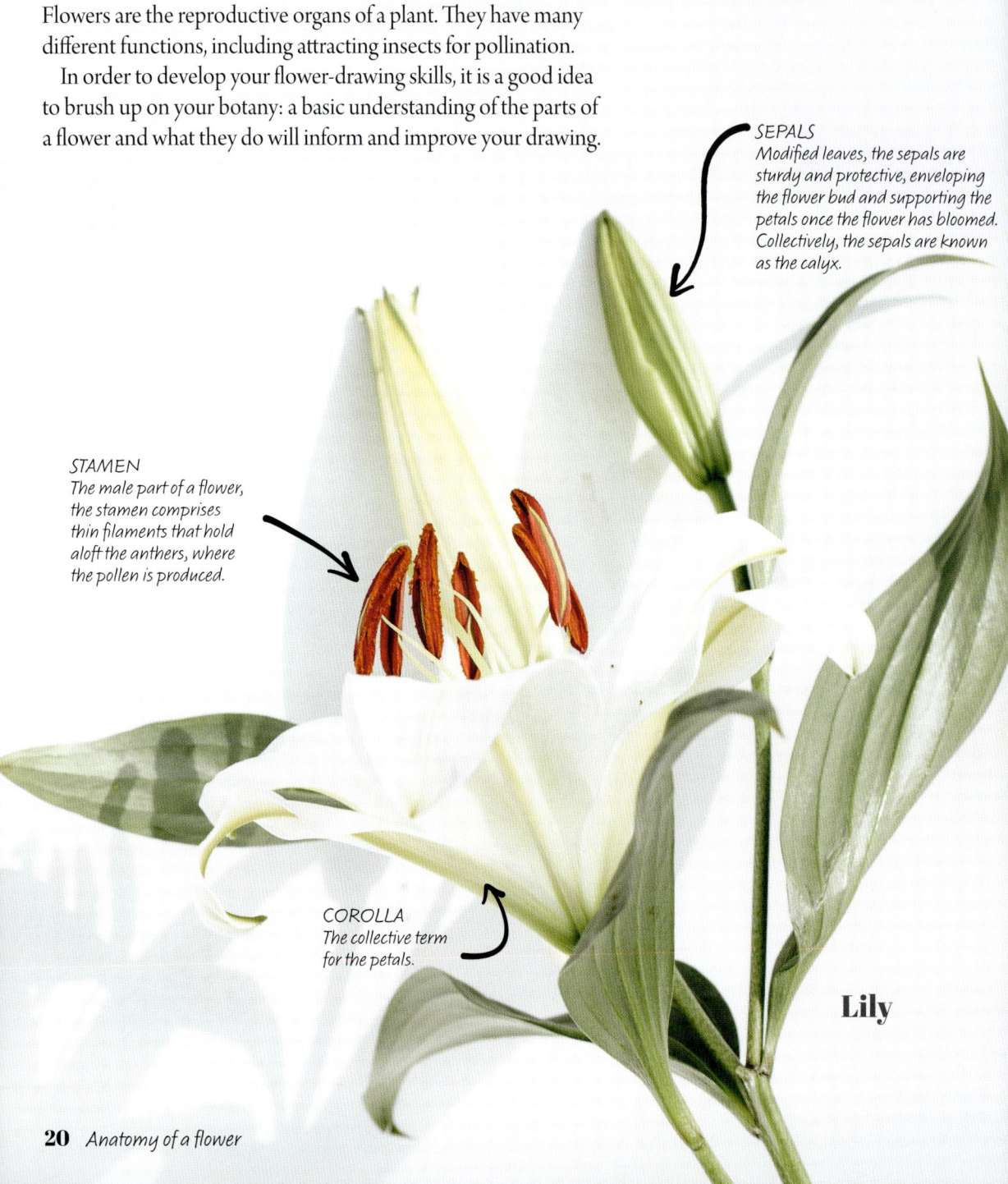

*SEPALS*
*Modified leaves, the sepals are sturdy and protective, enveloping the flower bud and supporting the petals once the flower has bloomed. Collectively, the sepals are known as the calyx.*

*STAMEN*
*The male part of a flower, the stamen comprises thin filaments that hold aloft the anthers, where the pollen is produced.*

*COROLLA*
*The collective term for the petals.*

**Lily**

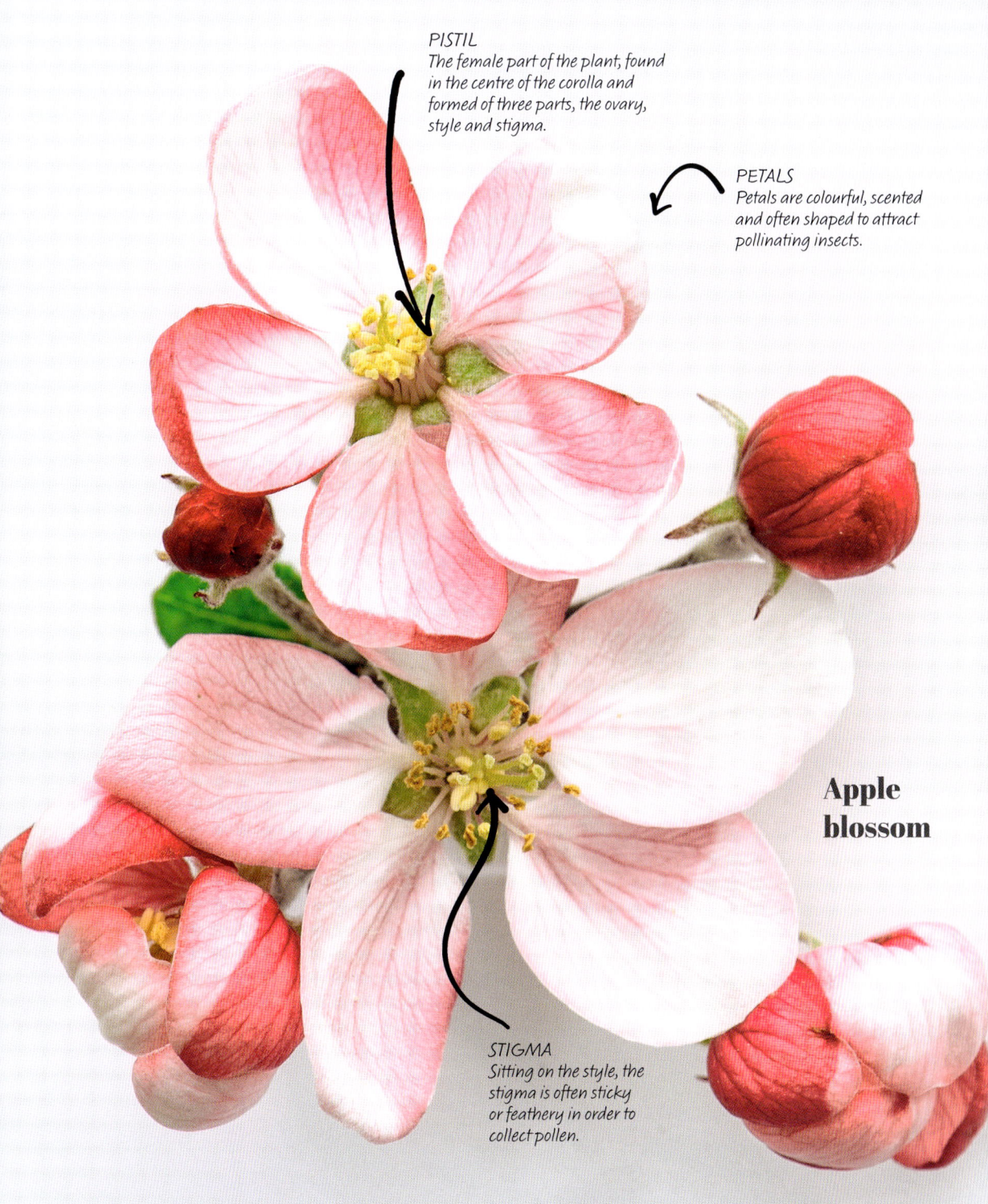

**PISTIL**
The female part of the plant, found in the centre of the corolla and formed of three parts, the ovary, style and stigma.

**PETALS**
Petals are colourful, scented and often shaped to attract pollinating insects.

**Apple blossom**

**STIGMA**
Sitting on the style, the stigma is often sticky or feathery in order to collect pollen.

# Floral symmetry

Floral symmetry is a way of classifying flowers, and is established by how many mirror-image parts a flower can be divided into, excluding the reproductive parts.

   Understanding how flower parts behave and interact with each other makes it easier to replicate their shape on paper in an organic way, and you will feel more confident when it comes to positioning or overlapping petals.

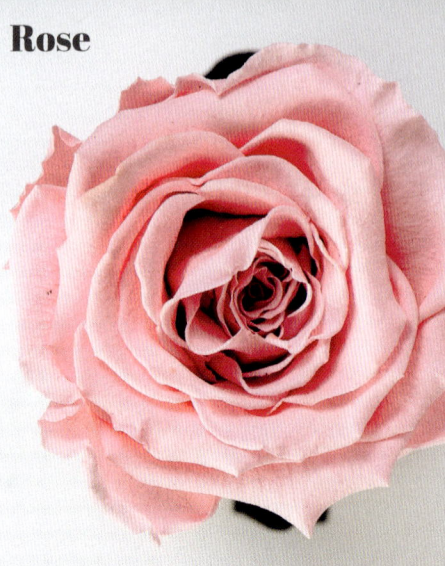

**Rose**

ASYMMETRIC
*Not every flower belongs in a specific symmetry category. Those flowers are naturally asymmetrical.*

ZYGOMORPHIC SYMMETRY
*These flowers can only be divided one way, usually with a line drawn vertically through the middle, in order to give two identical mirror images. Because of that, it's also called bilateral symmetry.*

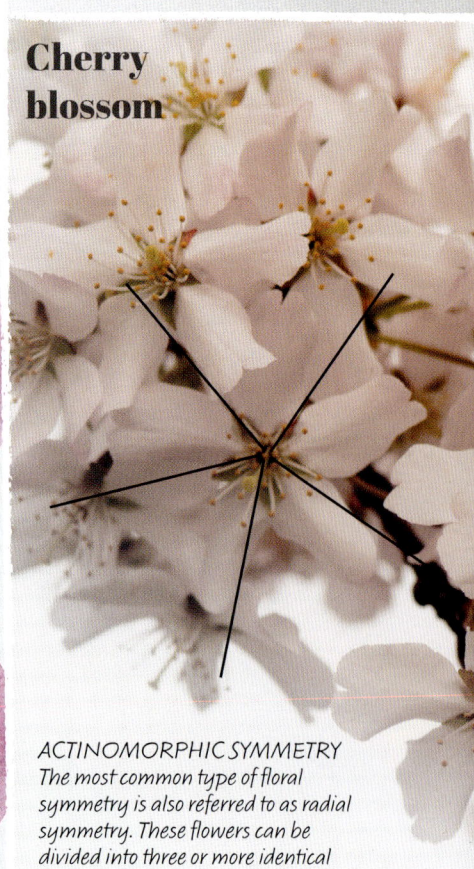

**Cherry blossom**

**Orchid**

ACTINOMORPHIC SYMMETRY
*The most common type of floral symmetry is also referred to as radial symmetry. These flowers can be divided into three or more identical parts. Usually, each part contains one petal.*

# Identifying starting shapes

Drawing a flower from scratch can feel overwhelming, but by identifying simple shapes you can break down the process and more easily transfer to paper what you see in nature or your mind's eye.

I've developed an easy method you can apply to any flower to identify the key shapes and help you approach the blank page in a stress-free way. Simply ask yourself these three questions:

1. What shape contains the whole flower?
2. Where and what shape is the centre of the flower?
3. What shape are the petals?

My advice is to always start your drawing with a pencil sketch to lay down the simple shapes that will serve as your rough guide. This way you have a base to work with, after which you can concentrate on making everything feel natural and organic.

*1*    Start by identifying the overall space the flower occupies. Which shape can contain it? Usually it's a circle or an oval.

*2*    Now look at what's inside the outermost shape. Ask the question: where and what shape is the centre of the flower? Usually other elements of the flower are attached to its centre. Generally speaking, the centre of the flower sits in another circle in the middle of the biggest shape. It may contain other small shapes as well.

*3*    What shape are the petals? The answer to this question will define your whole drawing, since each flower is identified by the shape of its petals. There are many petal shapes, but the most common are: ovals; rectangles or squares with rounded edges; hearts; drops; and circles.

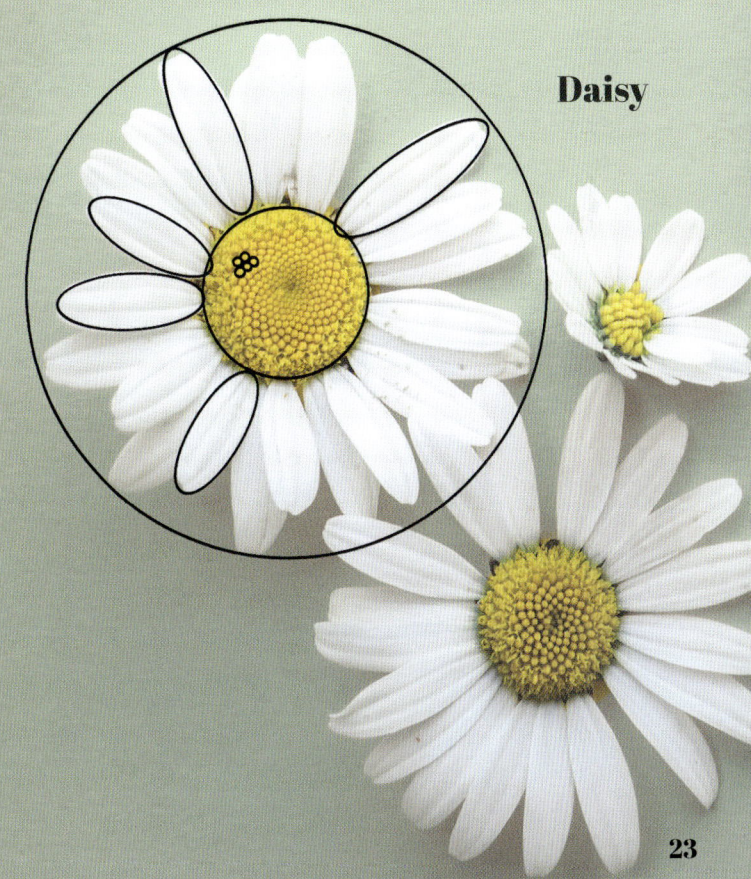

**Daisy**

# Saucer (acetabuliform)

These flowers are not flat, but not yet a cup (see page 32). They are shaped like a saucer, with petal tips turning upward to form a very shallow bowl.

A wide variety of flowers are saucers, most of them incredibly beautiful and very common drawing subjects. The challenge is to give a sense of lightness and movement even with the slightest curvature of the petals.

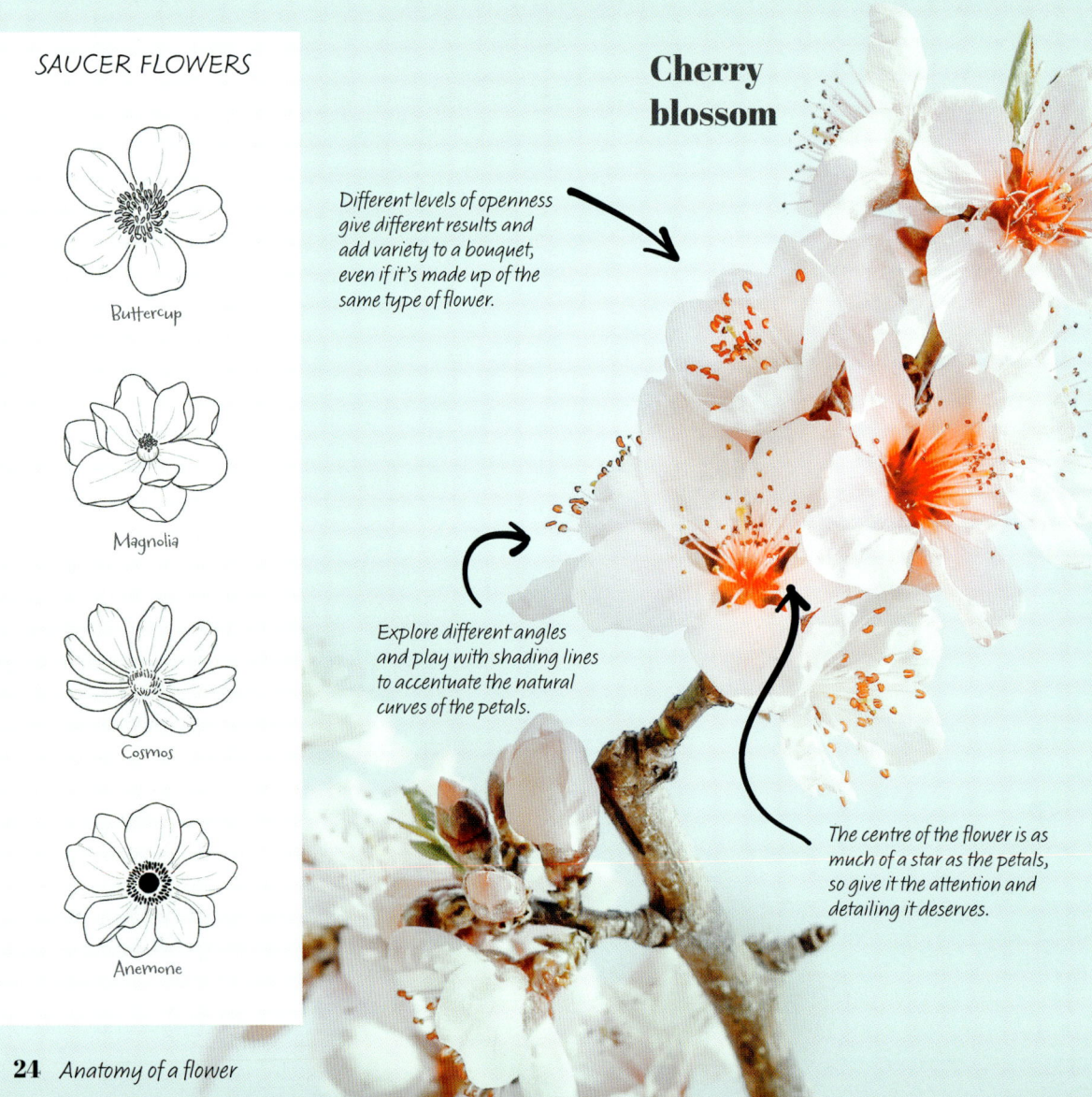

## SAUCER FLOWERS

Buttercup

Magnolia

Cosmos

Anemone

**Cherry blossom**

*Different levels of openness give different results and add variety to a bouquet, even if it's made up of the same type of flower.*

*Explore different angles and play with shading lines to accentuate the natural curves of the petals.*

*The centre of the flower is as much of a star as the petals, so give it the attention and detailing it deserves.*

# Cross (cruciform)

These flowers have four petals arranged in a cross, and radial (actinomorphic) symmetry. The petals are often circular or heart shaped. The flowers are usually small, and grow on herbaceous plants or shrubs. Many come from the Brassica family, formally known as the Cruciferae family.

Try drawing an actual cross, with the centre of the cross corresponding to the centre of the flower, and use the apexes as a guide to shape the petals and space them out evenly.

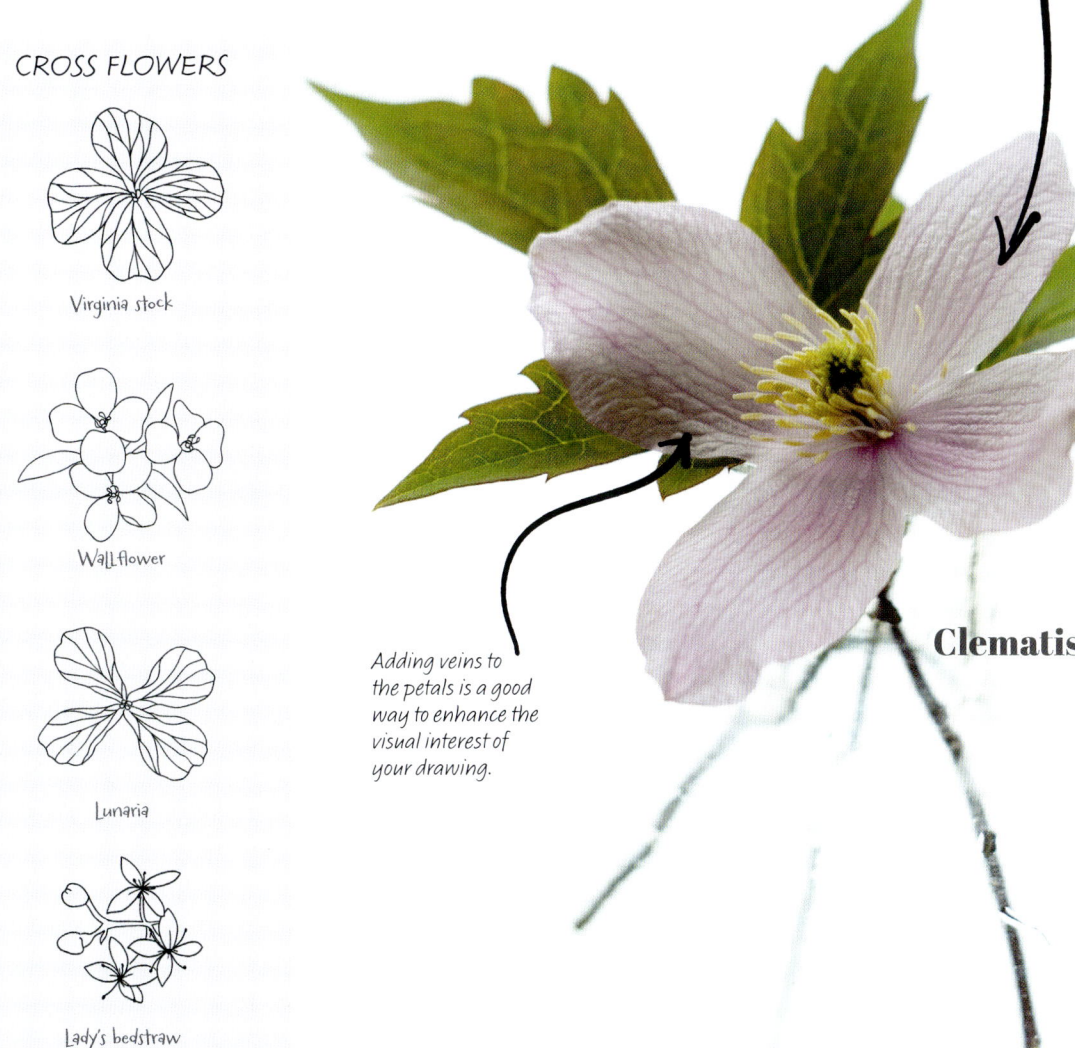

CROSS FLOWERS

Virginia stock

Wallflower

Lunaria

Lady's bedstraw

The petals are almost flat, so use shallow folds and gentle curves to create movement in your drawings.

Adding veins to the petals is a good way to enhance the visual interest of your drawing.

**Clematis**

# Strap (ligulate)

If the flower you're looking at reminds you of a daisy, chances are you're looking at a member of the Asteraceae family, the most popular example of ligulate flowers, with blooms made up of a vast number of thin, strap-like petals. These flowers are inflorescence, meaning they are made up of many smaller flowers, and in the Asteraceae family, each petal represents one tiny, individual flower.

Ligulates are among the most common flower subjects and, overall, fairly easy to draw.

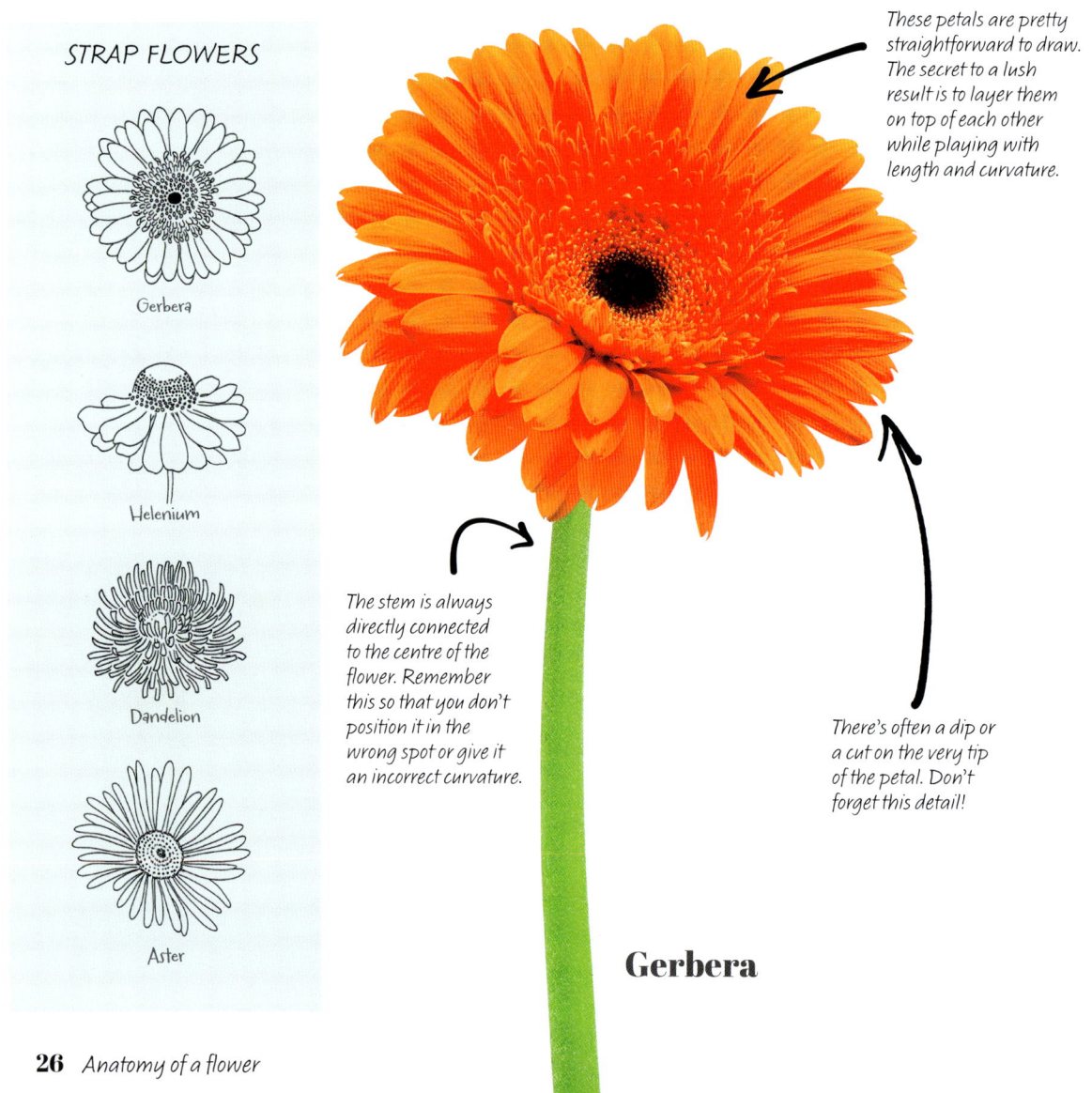

## STRAP FLOWERS

Gerbera

Helenium

Dandelion

Aster

These petals are pretty straightforward to draw. The secret to a lush result is to layer them on top of each other while playing with length and curvature.

The stem is always directly connected to the centre of the flower. Remember this so that you don't position it in the wrong spot or give it an incorrect curvature.

There's often a dip or a cut on the very tip of the petal. Don't forget this detail!

**Gerbera**

# Bell (campanulate)

Campanulate flowers are usually found in the Campanulaceae family, from the Latin word *campanula* which means 'little bell'. As the name suggests, these flowers are shaped like small bells, with a round base and elongated corollas and petals that curve outward slightly towards the end.

Drawing them can be fun but also challenging because they're often upside down, with the centre of the flower masked on the top and the petals developing towards the bottom.

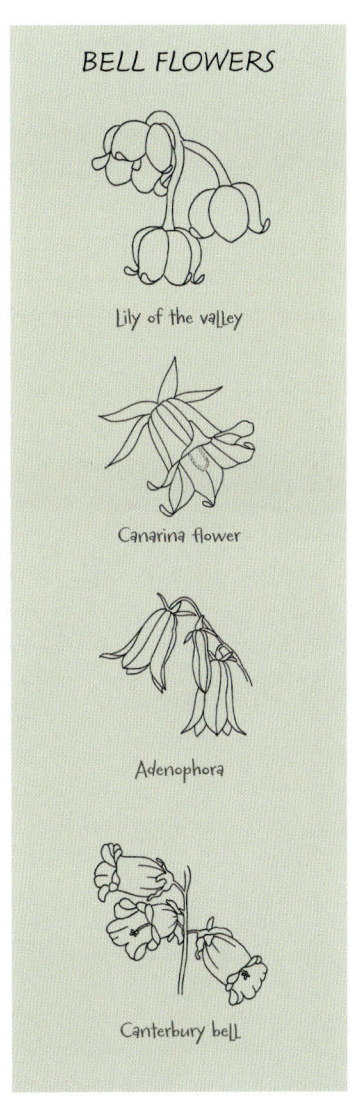

BELL FLOWERS

Lily of the valley

Canarina flower

Adenophora

Canterbury bell

These flowers are often in clusters, so pay attention to how they interact with each other . . .

## Lily of the valley

. . . how they overlap . . .

. . . and how they present as a whole.

27

# Funnel (funnelform)

The funnel shape features petals that are narrow at the base, widen gradually and then flare open. The shape is also called trumpet because of its resemblance to the musical instrument. It may sound unusual, but is actually a very common shape, and is actinomorphic in symmetry.

With funnel shapes the flower centre is not exposed. Nevertheless, when drawing them, consider where the centre would be and how each petal forms out from it.

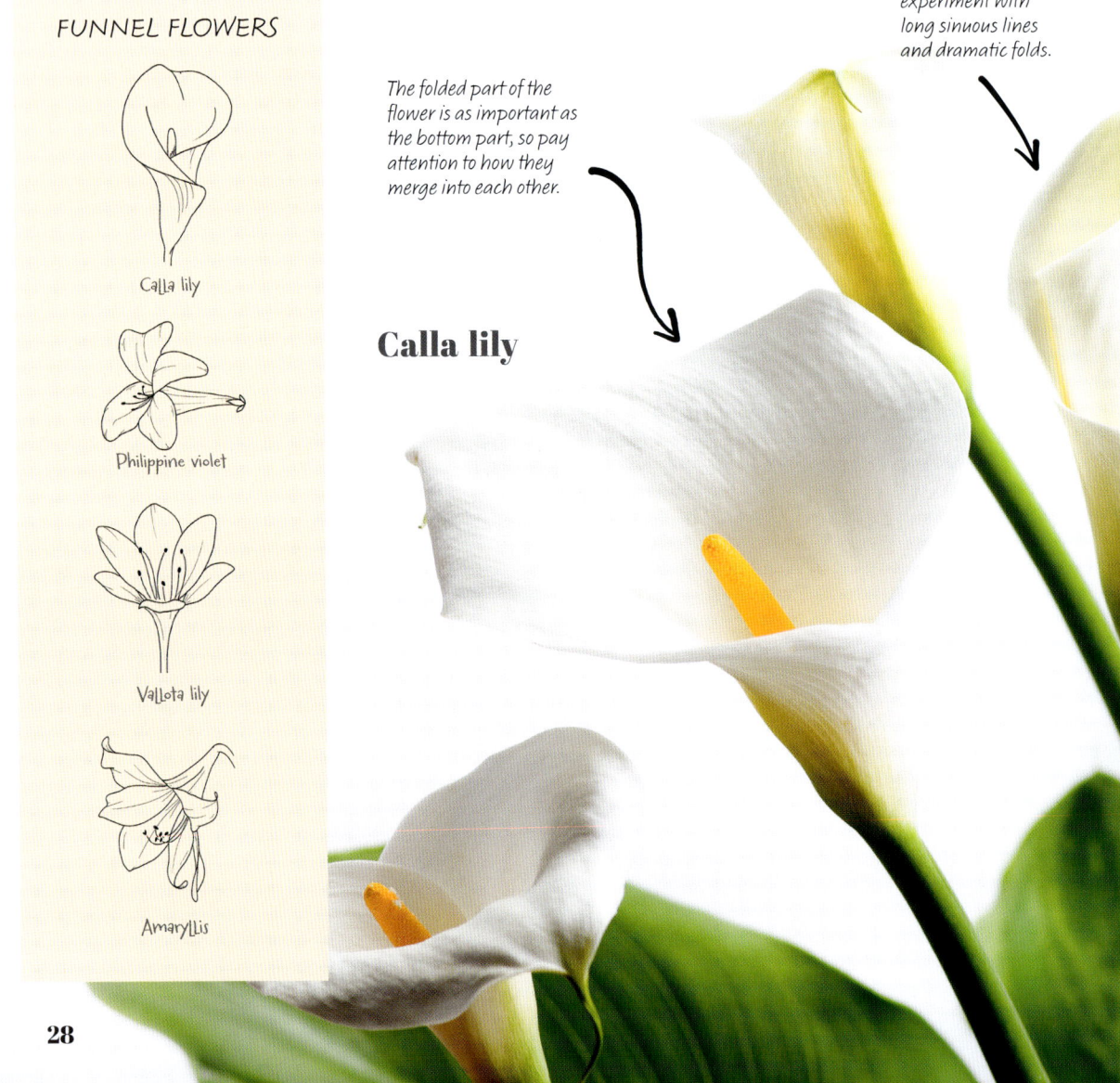

### FUNNEL FLOWERS

Calla lily

Philippine violet

Vallota lily

Amaryllis

*The folded part of the flower is as important as the bottom part, so pay attention to how they merge into each other.*

*Funnels are among the most dynamic flowers, great to experiment with long sinuous lines and dramatic folds.*

**Calla lily**

# Crown (coronate)

The distinctive feature of these flowers is the corona, an additional structure arising from the corolla or the outer edge of the stamens. There can be more than one corona in a flower, arranged in concentric whorls.

    These are not the easiest of flowers to draw since they combine different elements, shapes and types of symmetry. Always approach them one step at a time, remembering that everything is connected.

**Daffodil**

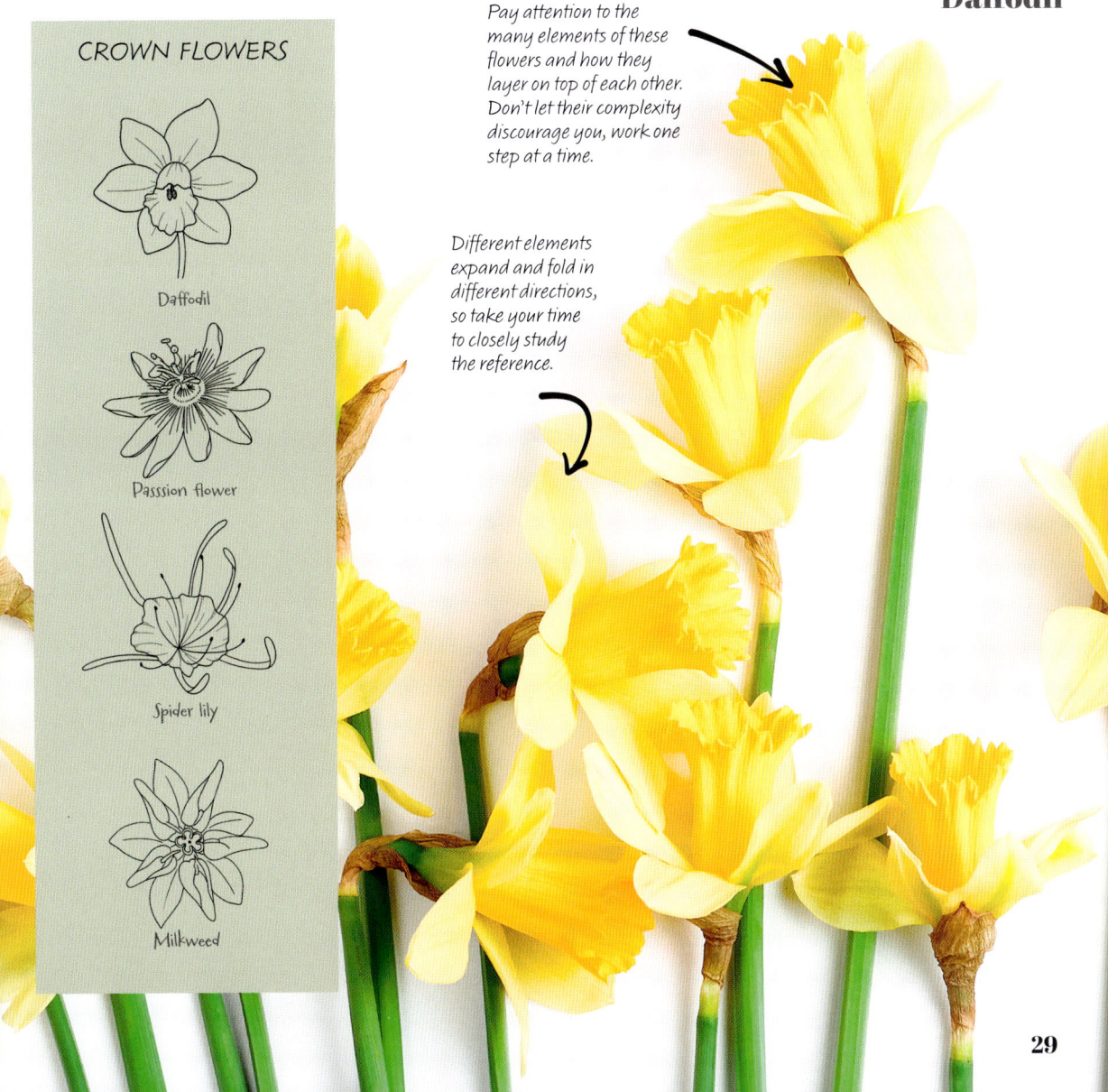

CROWN FLOWERS

Daffodil

Passsion flower

Spider lily

Milkweed

Pay attention to the many elements of these flowers and how they layer on top of each other. Don't let their complexity discourage you, work one step at a time.

Different elements expand and fold in different directions, so take your time to closely study the reference.

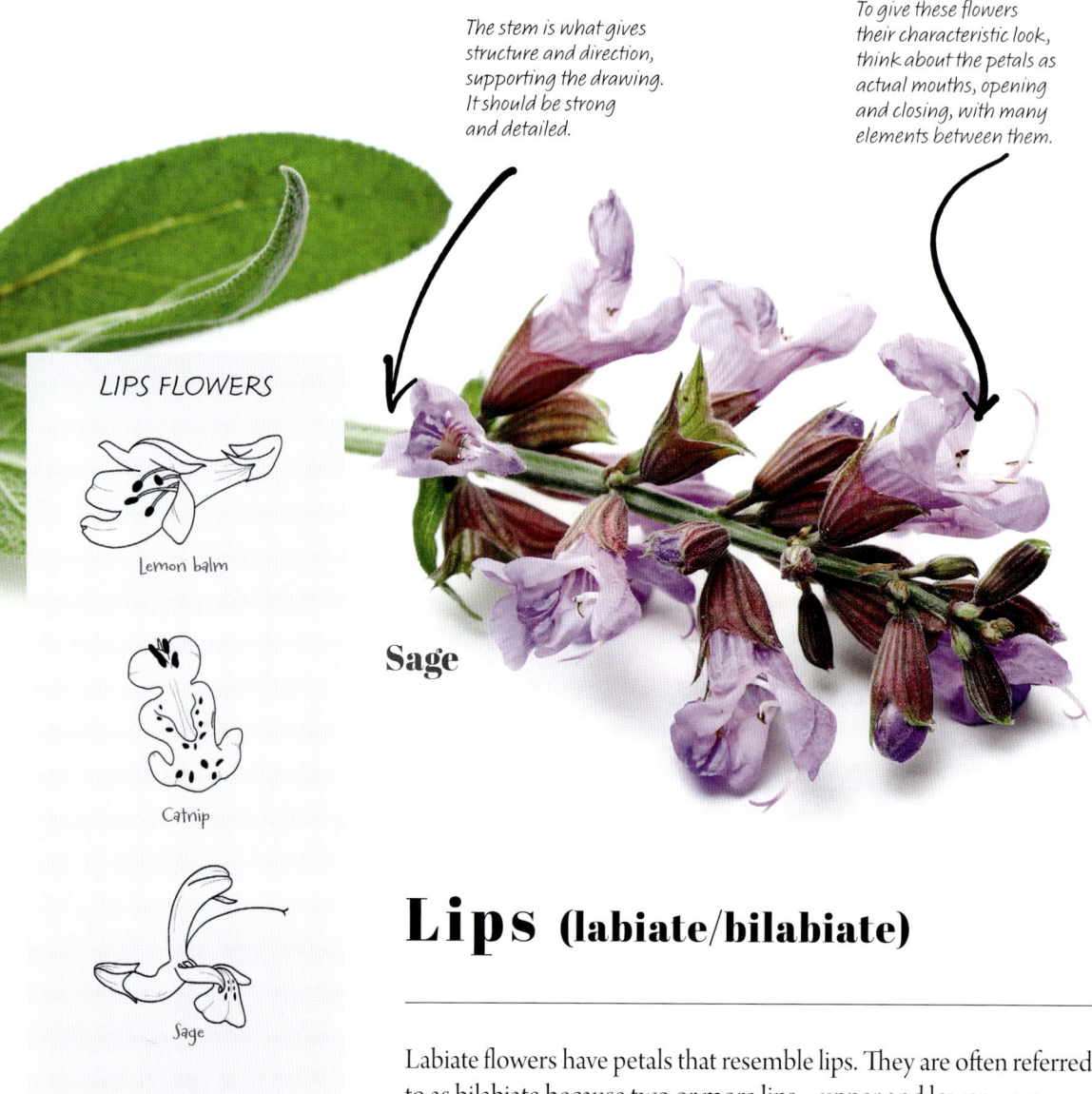

The stem is what gives structure and direction, supporting the drawing. It should be strong and detailed.

To give these flowers their characteristic look, think about the petals as actual mouths, opening and closing, with many elements between them.

**LIPS FLOWERS**

Lemon balm

Catnip

Sage

Red deadnettle

**Sage**

# Lips (labiate/bilabiate)

Labiate flowers have petals that resemble lips. They are often referred to as bilabiate because two or more lips – upper and lower – are fused at the base. Labiate flowers have bilateral (zygomorphic) symmetry. Almost all of the aromatic plants used in the kitchen have labiate flowers.

To avoid confusion while drawing labiate flowers, take some time to carefully study the reference and identify the different parts of the flower and how they connect to each other.

# Star (stellate)

Stellate flowers are almost flat, often – but not always – with five petals that spread out individually like a star. They're one of the most obvious instances of radial (actinomorphic) symmetry, with the exception of the orchid, which is a prime example of bilateral (zygomorphic) symmetry in flowers.

When drawing star flowers, start by identifying the different layers of the flower. To do this, imagine looking at it from directly above. Establish which petals are closest to you and how the flower develops under that first section. Identifying what's on top and what's below, and drawing the petals accordingly, is the key to success.

*STAR FLOWERS*

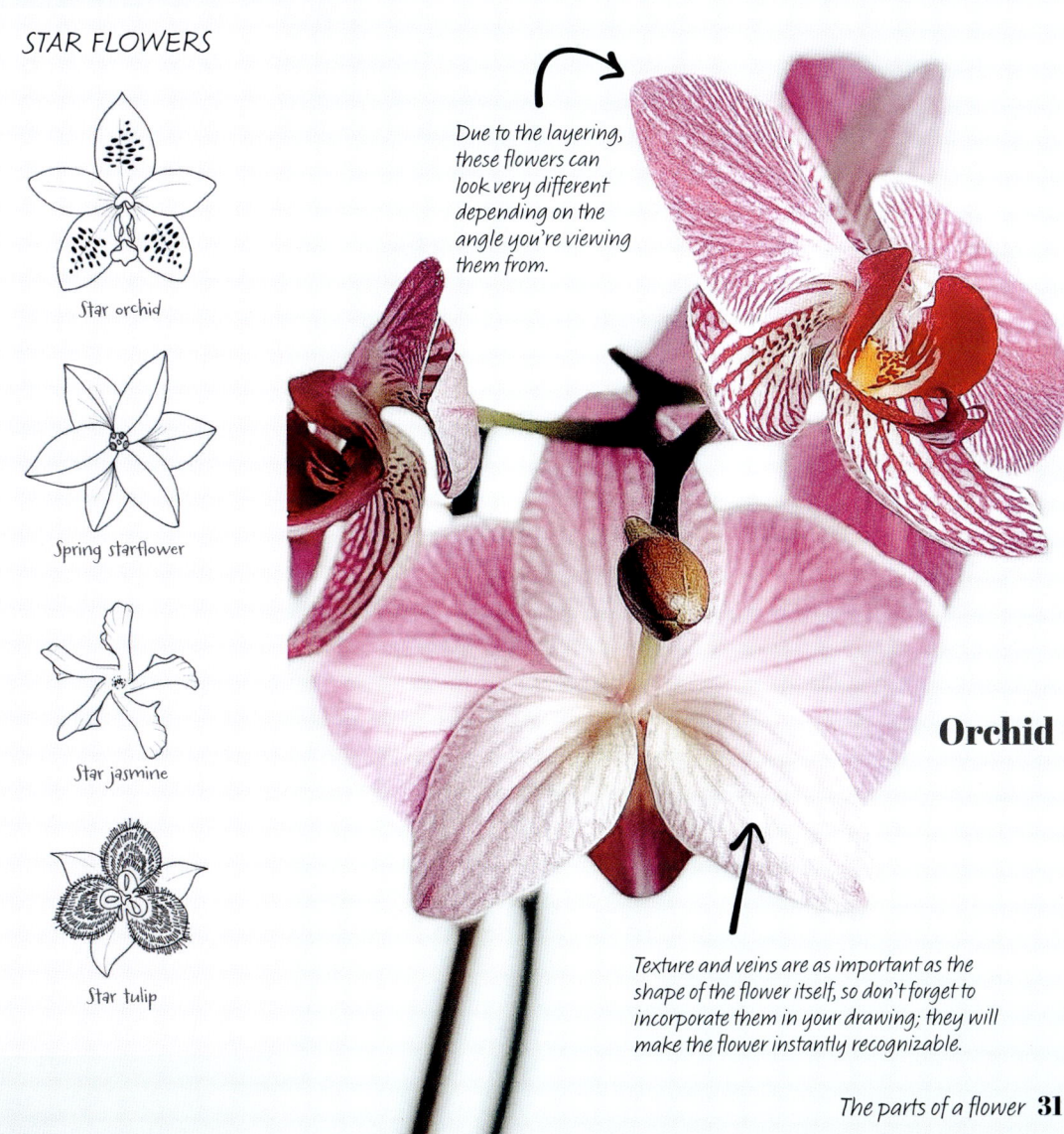

Star orchid

Spring starflower

Star jasmine

Star tulip

*Due to the layering, these flowers can look very different depending on the angle you're viewing them from.*

**Orchid**

*Texture and veins are as important as the shape of the flower itself, so don't forget to incorporate them in your drawing; they will make the flower instantly recognizable.*

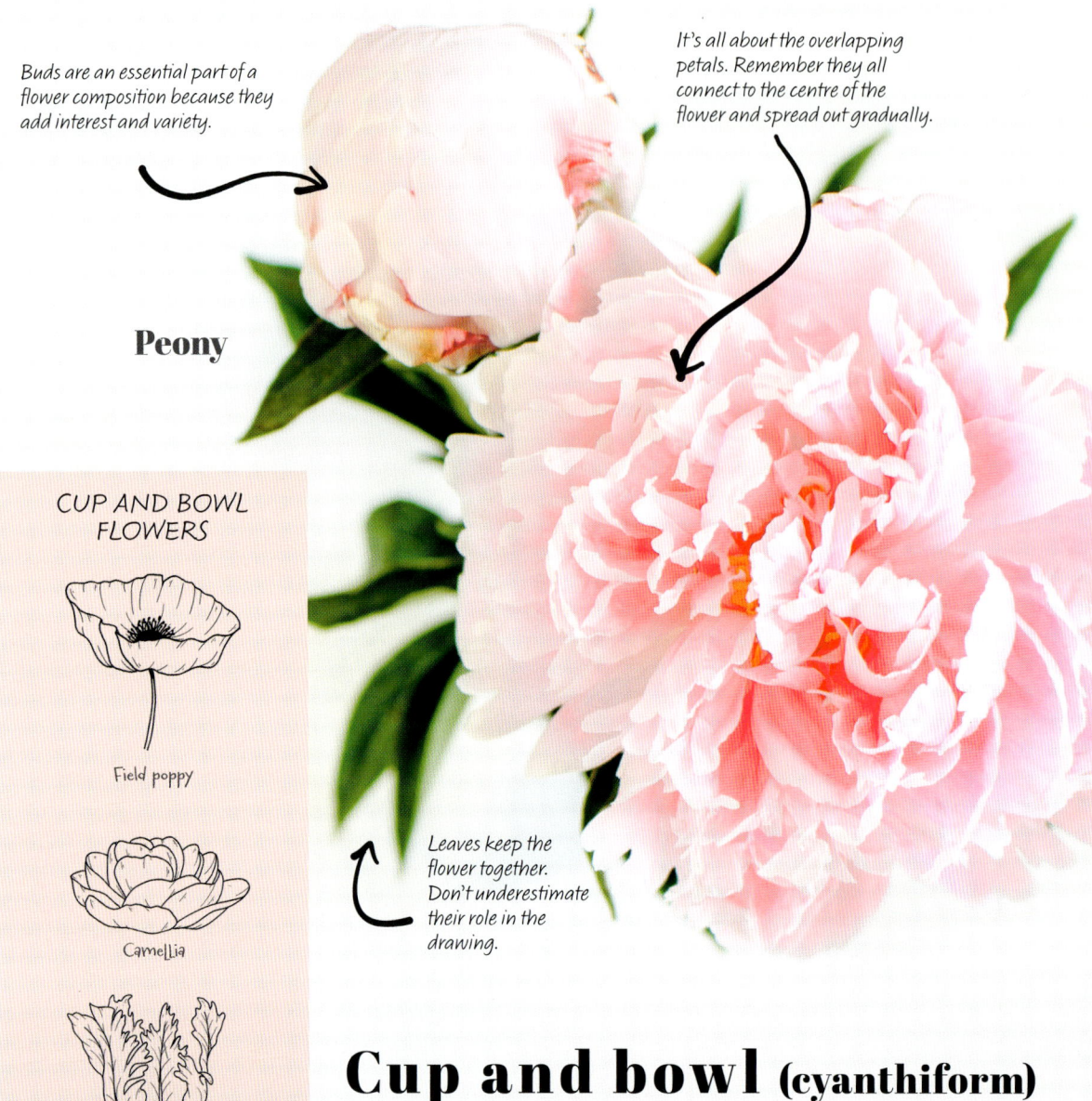

Buds are an essential part of a flower composition because they add interest and variety.

It's all about the overlapping petals. Remember they all connect to the centre of the flower and spread out gradually.

**Peony**

## CUP AND BOWL FLOWERS

Field poppy

Camellia

Black parrot tulip

Peony

Leaves keep the flower together. Don't underestimate their role in the drawing.

# Cup and bowl (cyanthiform)

This type of flower is basically half a sphere, varying from a tight cup shape to a wider, more open bowl. Just like a cup, the flower will form ellipses at the top and bottom. These flowers usually have radial (actinomorphic) symmetry.

It is important to maintain the sense of volume, so always identify the basic structure before drawing in the individual petals.

# Tubular (tubulate)

Tubular flowers have long, narrow petals that come together to form a little tube. The petals don't spread, and they barely open at the mouth. Some variations have very tight petals at the base but then flare open in a more distinct way. With their very unusual shape, these flowers are hummingbirds' favourites.

Drawing flowers that don't look like flowers can be challenging. Remember to keep the lines soft and organic, and that nothing in nature is perfectly straight, not even tubular flowers!

## TUBULAR FLOWERS

Trumpet honeysuckle

Mother of thousands

Foxglove

Brazilian fuchsia

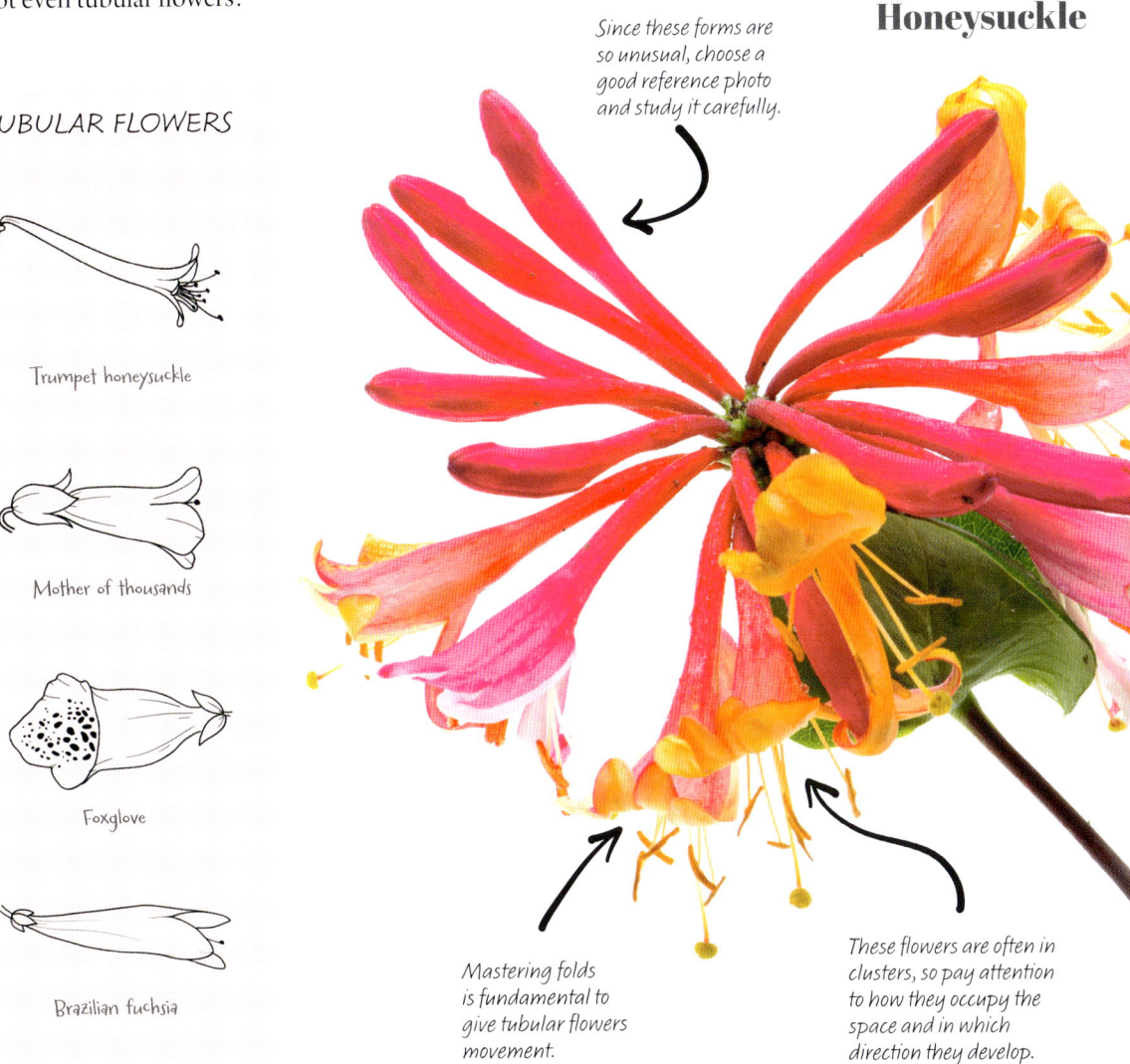

**Honeysuckle**

Since these forms are so unusual, choose a good reference photo and study it carefully.

Mastering folds is fundamental to give tubular flowers movement.

These flowers are often in clusters, so pay attention to how they occupy the space and in which direction they develop.

# Spherical

Spherical flowers are impressive blooms that have often been bred for bright and large petals, perfect for flower displays.
   They are challenging to draw because there are so many petals that overlap and require careful colour blending.

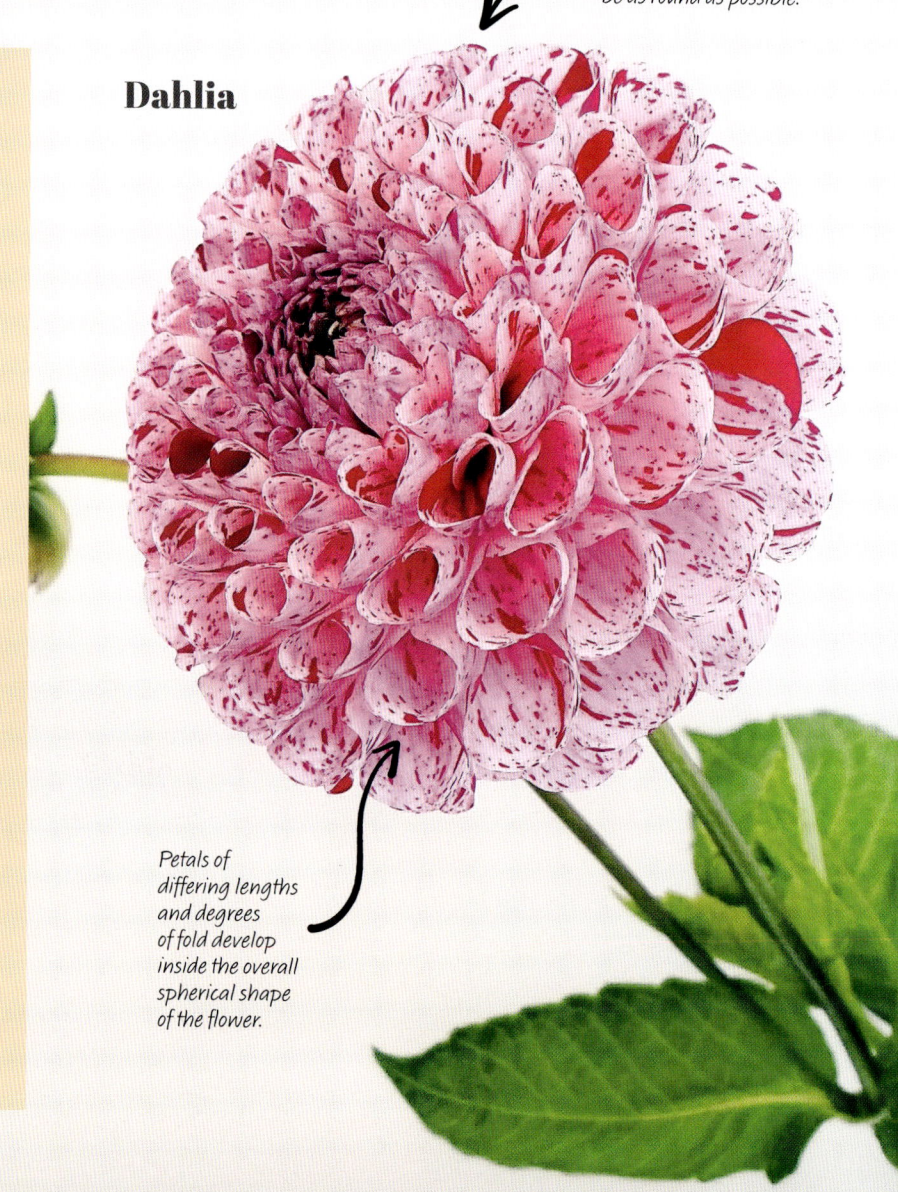

The most important aspect is the overall shape of the flower, which must be as round as possible.

**Dahlia**

Petals of differing lengths and degrees of fold develop inside the overall spherical shape of the flower.

### SPHERICAL FLOWERS

Double zinnia

African marigold

Mimosa

Double peony

# Multiheaded (inflorescence)

Multiheaded blooms are among the trickiest to draw because the whole is made up of many flowers. The overall shape may be a sphere, a spike, a cone or a tight ball shape, with florets that form the structure of the flower head.

When drawing, always start with the overall shape, then analyze the shape and arrangement of the individual flowers.

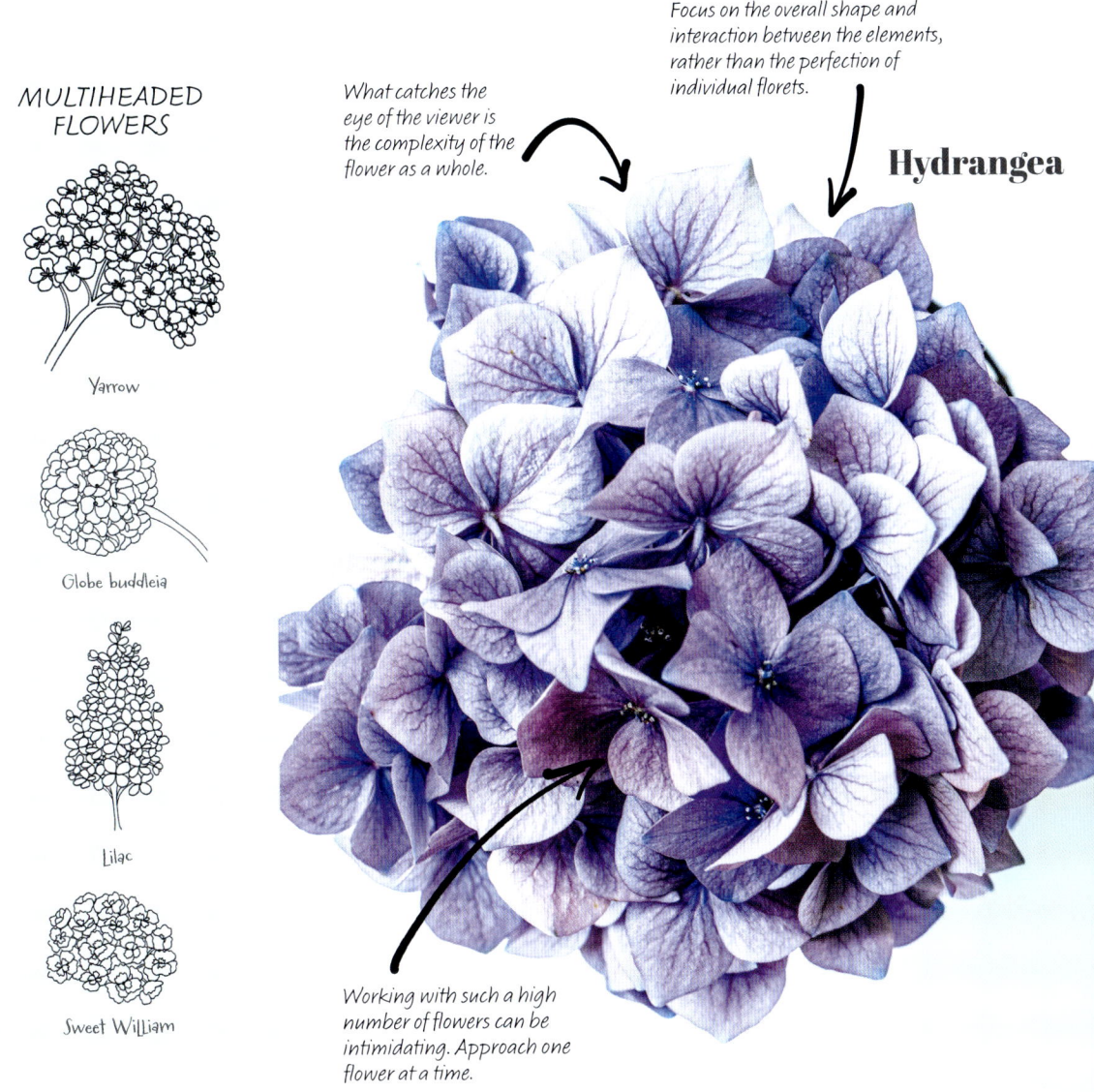

MULTIHEADED FLOWERS

Yarrow

Globe buddleia

Lilac

Sweet William

What catches the eye of the viewer is the complexity of the flower as a whole.

Focus on the overall shape and interaction between the elements, rather than the perfection of individual florets.

**Hydrangea**

Working with such a high number of flowers can be intimidating. Approach one flower at a time.

Chapter 2

# How to draw flowers

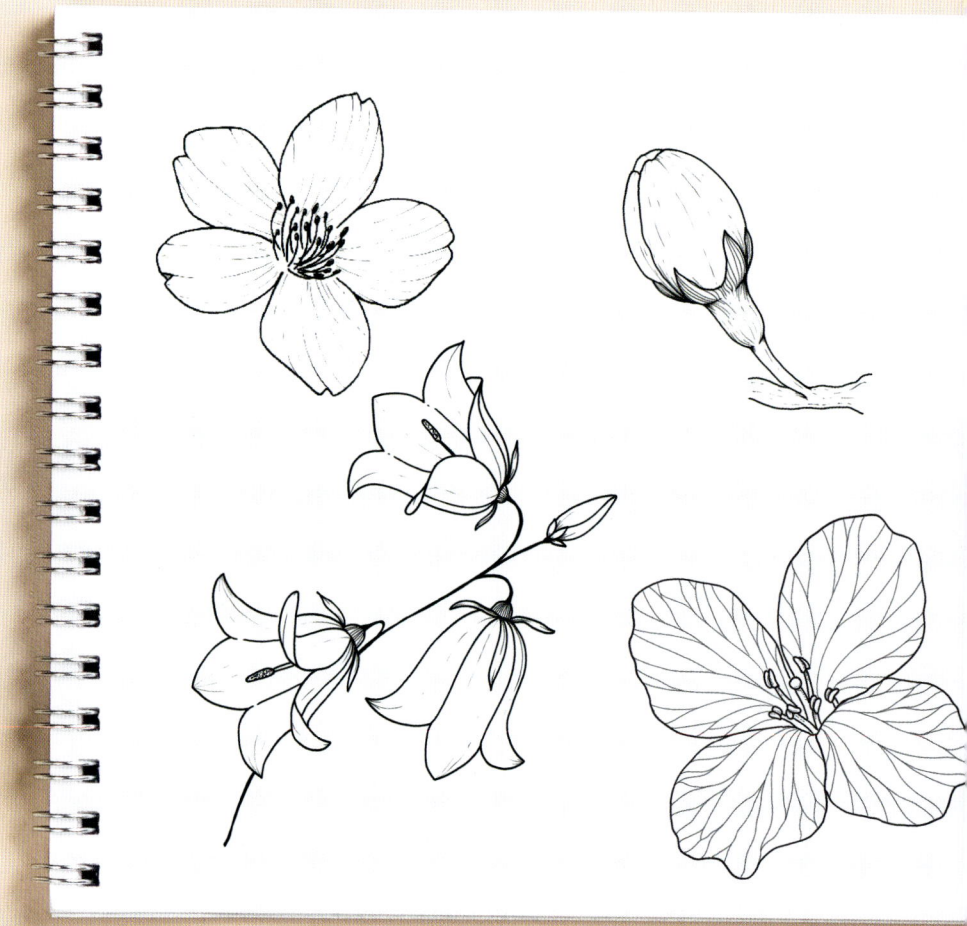

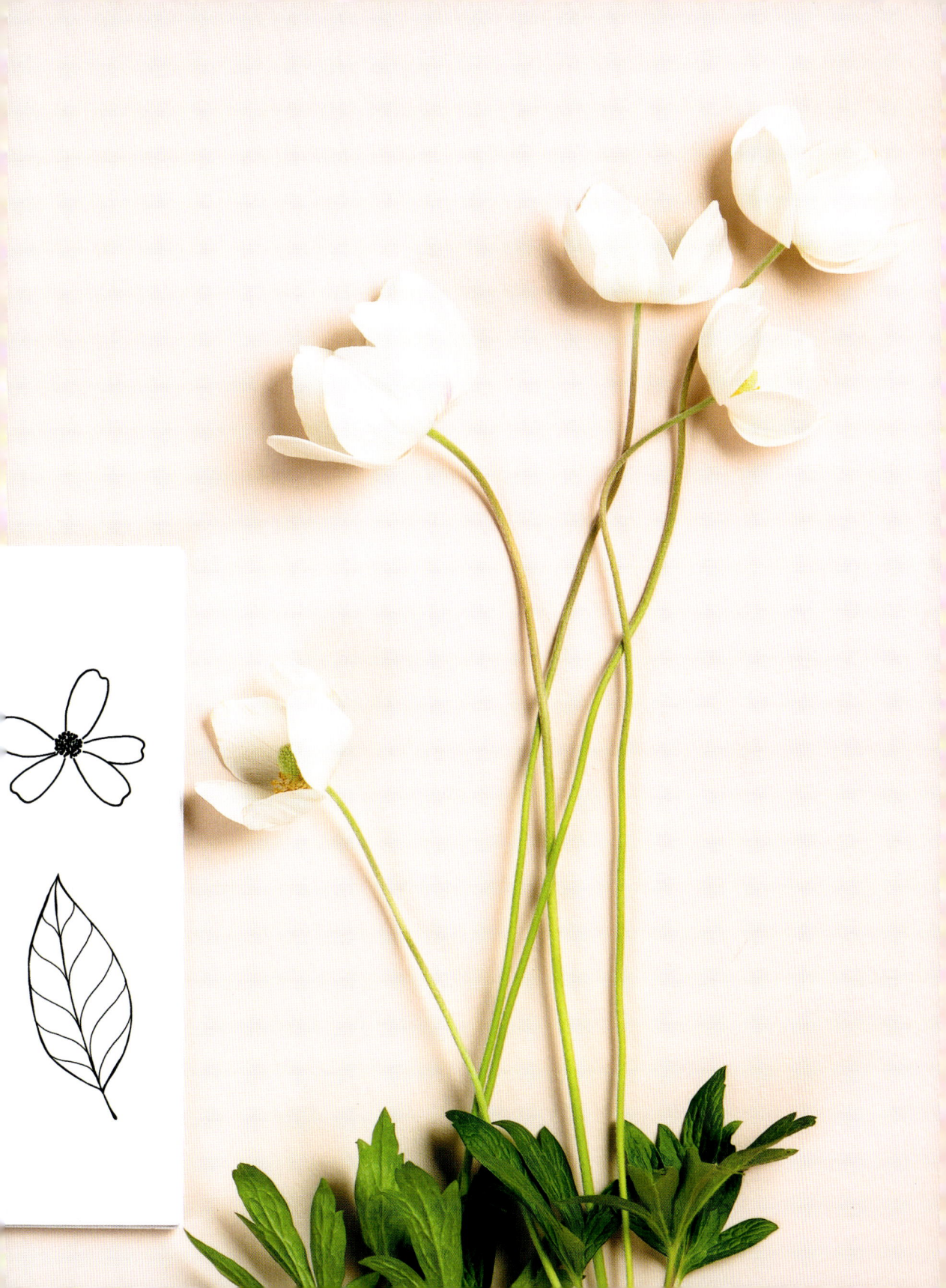

# Drawing curves

There's one simple rule to keep in mind when it comes to drawing flowers: there are no straight lines in nature. The wobblier the line, the more natural and organic your flower drawing will look. Hopefully this concept lifts some of the pressure off of you, helping you to approach your drawing in a more relaxed way.

The basics of botanical drawing come down to two simple 'lines': the single and the double curve.

## Single curves

The single curve looks like a C or a U. It curves but never dips, and can be drawn in many levels of roundness, from closed to more open variations – some almost look like straight lines. This is the go-to line in botanical drawing, the stroke you will use the most often.

Open single curves        Mid-depth single curves        Closed single curves

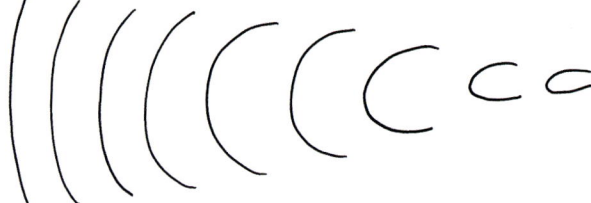

## Double curves

The double curve looks like an S. It has a double curve with different degrees of tightness, and is often used at the top of petals or in folds. This stroke gives movement and softness to your drawing and brings it alive.

Open double curves        Mid-depth double curves        Tight double curves

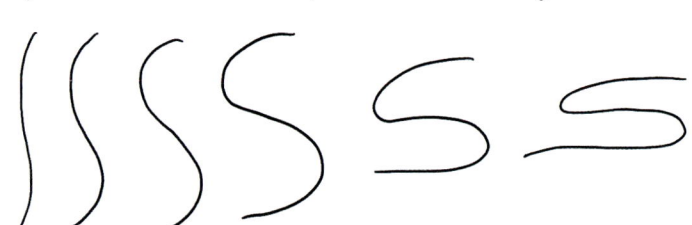

### BIANCA'S TIPS

- Try not to have a strong hold on your pen while drawing. The lighter the grip, the more natural and seamless the lines will look.

- Remember the 'no straight lines in nature' rule. If something looks odd with your drawing, but you can't pinpoint what it is, chances are there are some unintentional straight lines in there that are making your flower look stiff and unnatural.

# Tracing is learning

Although sometimes demonized in the drawing world, tracing is a spectacular process to help you understand how lines work and start to develop the muscle memory you need to tackle botanical drawing with confidence. Trace over photographs of different flowers as a practice, research or warm-up exercise. Remember to never claim a traced work as your own, but feel free to revisit any tracing for your own reference.

 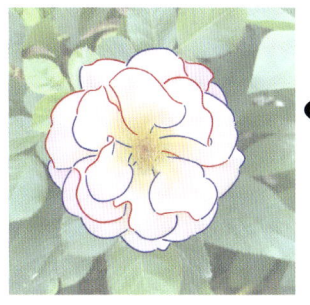

*A good way to get familiar with the curve and double curve is to trace the petals of a flower on a photograph, using different colours to identify which line is a curve and which is a double curve. In this example curves are drawn in blue, and double curves in red.*

# Your first flower

This simple, short project is the perfect introduction to botanical drawing for anyone that has never drawn a flower before.

*Make sure the stamens are different lengths and face in different directions.*

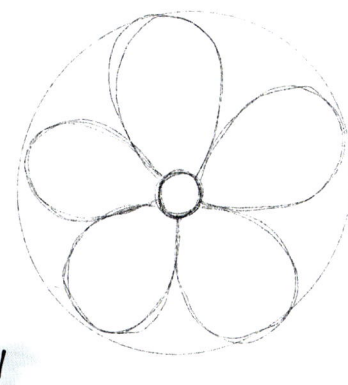

*1*

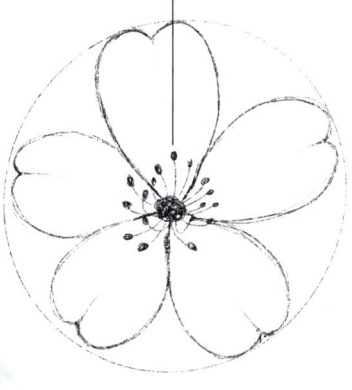

*2*

Draw a circle to the size of what will be your whole flower. In the centre of that circle draw a much smaller circle. Now draw five oval petals starting at the flower centre and curving evenly out to the bigger circle.

Draw a dip at the top of each petal so they are similar to heart shapes, then draw short curves from the central circle for the stamens. Add a tiny oval on top of each stamen.

# Shading

Once you have drawn the curves that form the outline of the flower, you can use shading techniques to give your drawing more depth, curvature and movement. Shading can be full, minimal or skipped entirely if outline-only is the style you're going for.

## Simple curves

The single curve is the basis for most petal and leaf shading, used in its many variations and different lengths. The one rule is that the lines all hypothetically connect to the centre of the flower, even if they don't physically meet the flower centre.

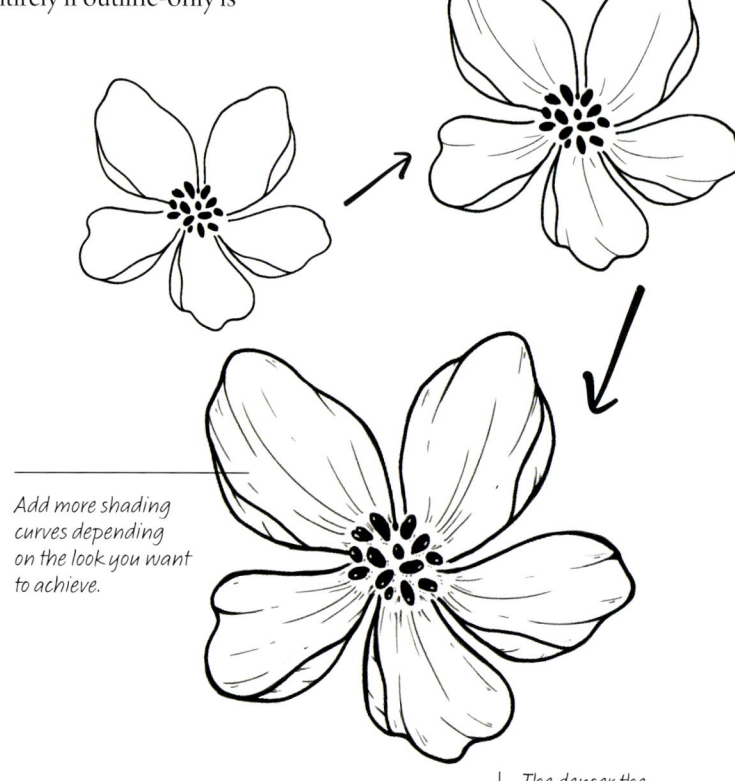

*Start with a few shading curves of differing lengths.*

*Add more shading curves depending on the look you want to achieve.*

## Stippling

Stippling involves using dots to indicate depth and value, and is another powerful shading technique.

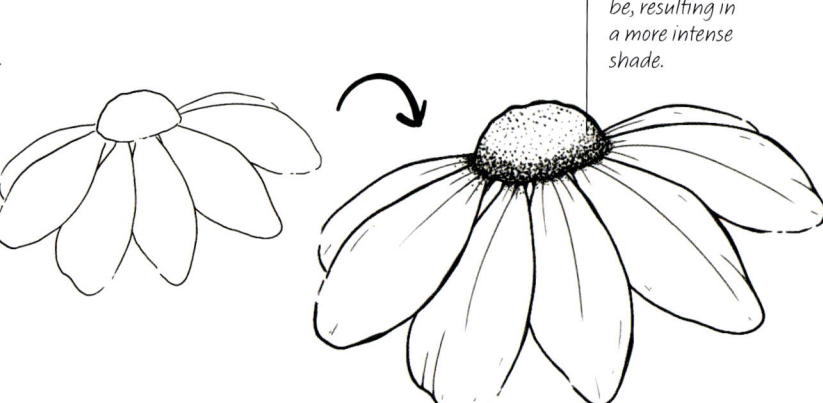

*The denser the area of stippling, the darker it will be, resulting in a more intense shade.*

# Shading in action

Shading techniques have enormous transformative powers, and can elevate any drawing. Getting the shading right can be difficult at first but, as with everything, practice makes perfect.

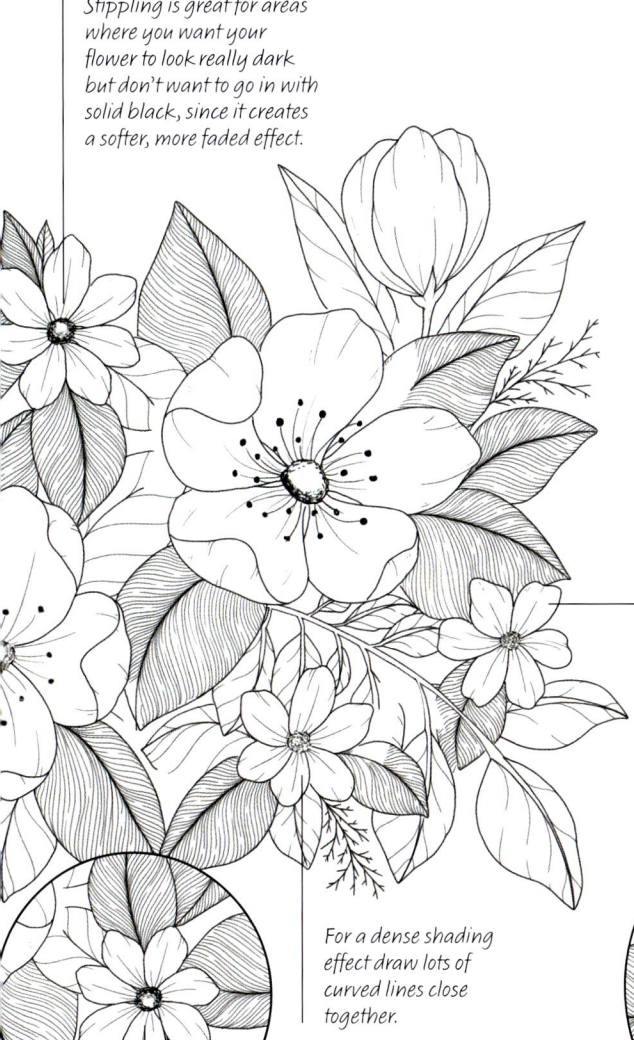

*Stippling is great for areas where you want your flower to look really dark but don't want to go in with solid black, since it creates a softer, more faded effect.*

*All shading lines hypothetically connect to the centre of the flower. Remember this when drawing lines that start from the upper edge of the petal.*

*For a dense shading effect draw lots of curved lines close together.*

*The darkest areas of a flower are usually around the centre. Draw shorter shading lines between longer ones in these areas.*

*Shading lines are thinner than the outline drawing, so change to a smaller nib.*

*A curve upwards gives a convex shape.*

*A curve downwards gives a concave shape.*

Shading **41**

# Let's start drawing

The following step-by-step projects for drawing a wide selection of popular and beautiful blooms will give you a thorough grounding in botanical art techniques. You will start with easier projects and build up to more challenging examples, with each flower focusing on a particular teaching point. Extra tutorials or examples give bonus lessons and explanations for other techniques to try.

**Cherry blossom:** *Prunus*
**44**

**Lady's smock:** *Cardamine pratensis*
**48**

**Daisy:** *Bellis perennis*
**52**

**Cosmos:** *Cosmos*
**56**

**Harebell:** *Campanula rotundifolia*
**60**

**Lily:** *Lilium*
**64**

**Hibiscus:** *Hibiscus*
**68**

**Daffodil:** *Narcissus*
**72**

**Poppy:** *Papaver*
**76**

**Foxglove:** *Digitalis*
**80**

**Pompom dahlia:** *Dahlia*
**84**

**Rose:** *Rosa*
**88**

**Hydrangea:** *Hydrangea*
**92**

**Peony:** *Paeonia*
**96**

**Leaves and Small-scale flowers**
**100**

# Cherry blossom (*Prunus*)

The cherry blossom is the easiest and most versatile flower you can ever draw. With its small petals and undefined centre, it's the perfect project for anyone that is starting their journey into botanical drawing. The key here is learning how to master the basic proportions of the elements, then beginning to apply shading techniques to show the direction of the petals.

   The cherry blossom is one of the first flowers to bloom in spring, making it a perfect subject for spring-themed spreads in your journal, or to brighten your walls with a touch of delicate art.

## Sketching notes

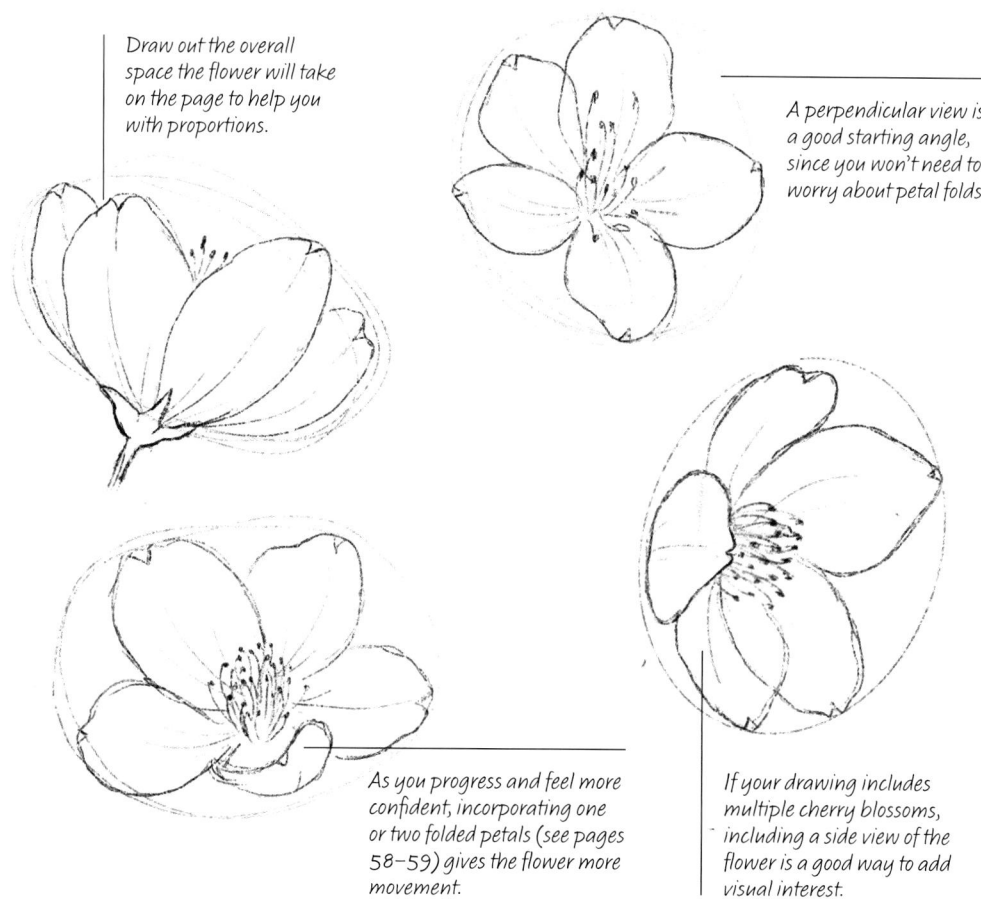

Draw out the overall space the flower will take on the page to help you with proportions.

A perpendicular view is a good starting angle, since you won't need to worry about petal folds.

As you progress and feel more confident, incorporating one or two folded petals (see pages 58–59) gives the flower more movement.

If your drawing includes multiple cherry blossoms, including a side view of the flower is a good way to add visual interest.

# Turn a simple flower into art

## MARKS

| | |
|---|---|
| ) | Open single curves for the stamens |
| • | Solid ovals for stamen tops |
| ) | Mid-depth single curves for petal edges |
| ⌄ | V-like dip for petal tops |

*The only thing the petals all have in common is the V-like dip at their tips.*

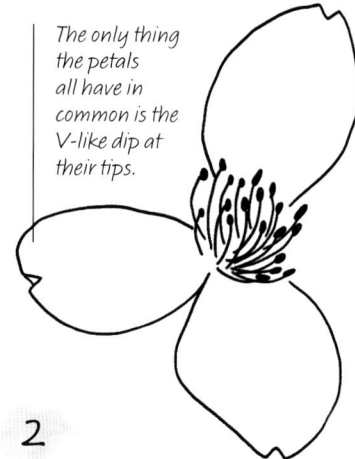

### 1

Start by drawing short curves with an oval on top to create the centre of the flower. Ideally, the overall shape would be able to fit into a circle.

### 2

Draw the top and bottom petals to give your base structure. Petals should be all the same length but don't need to look identical to each other.

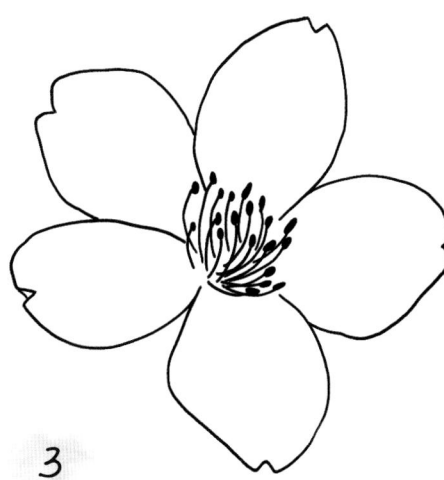

### 3

Tuck the two remaining petals on the sides underneath the first layer. This will create a three-dimensional illusion.

*The shading lines curve downward, towards the centre of the flower.*

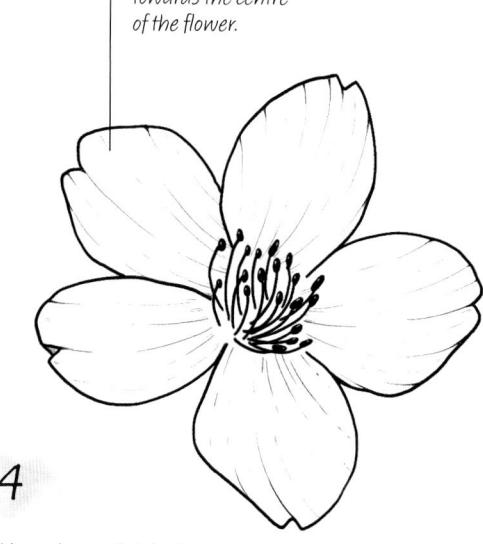

### 4

Add loosely parallel shading lines that hypothetically connect to the flower centre.

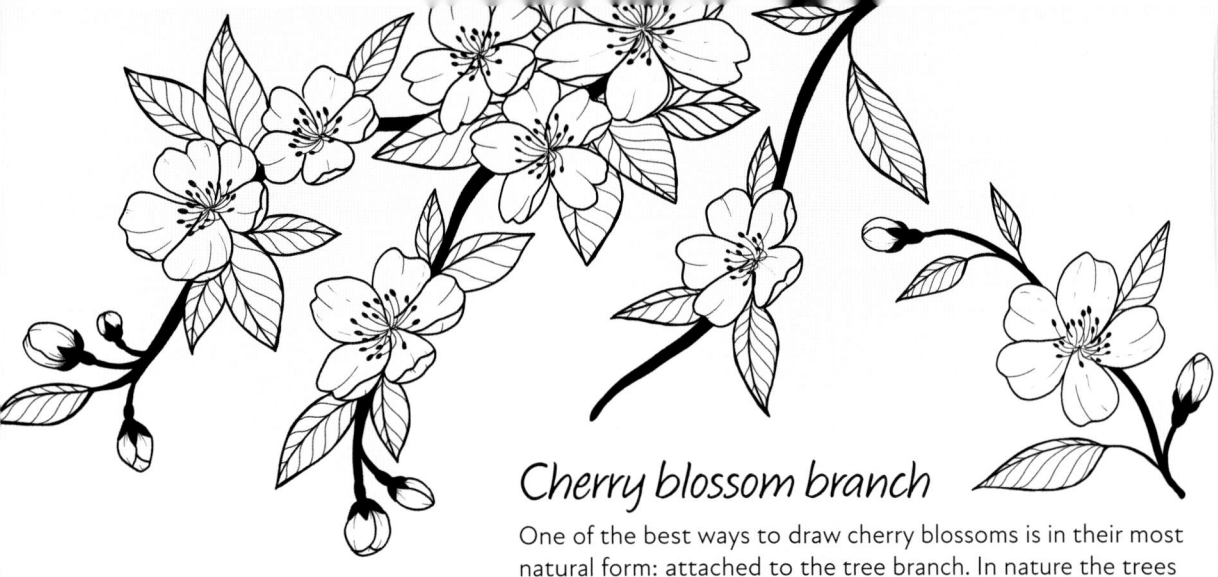

# Cherry blossom branch

One of the best ways to draw cherry blossoms is in their most natural form: attached to the tree branch. In nature the trees carry thousands of flowers for each bloom, creating a truly breathtaking view. My advice is to draw the basic shape of the branches first, then add the flowers, alone or in clusters, along with some buds and leaves.

# Cherry blossom buds

Adding buds to a drawing is a great way to introduce interest and variety.

## BIANCA'S TIPS

- The stamens are of different lengths and point in different directions.

- Make sure the lines of the V-like dip at the top of each petal are curved, not straight, as if you're drawing a very loose heart.

- Most cherry blossoms have concave petals, so draw your shading lines accordingly.

- Since the cherry blossom is a very small, delicate flower, be aware that overworking the shading could potentially add too much weight to your drawing.

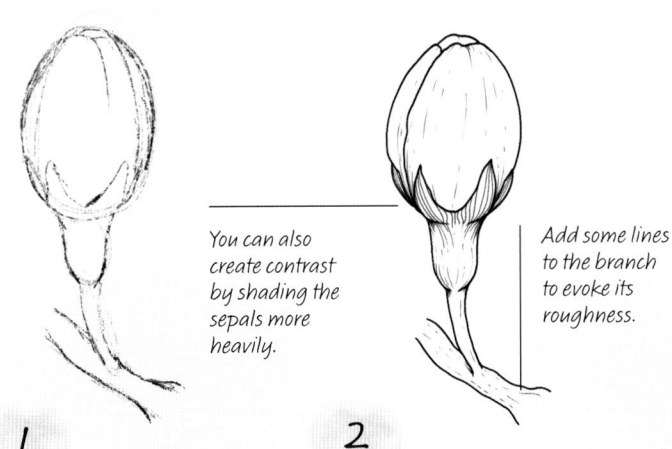

You can also create contrast by shading the sepals more heavily.

Add some lines to the branch to evoke its roughness.

**1**

Start with the basic elements: the elongated roundness of the cluster of petals, the pointy sepals that are still holding the flower closed, and the stem attached to the branch.

**2**

Now that the main shapes are down, draw some lines inside the bud to signal the overlapping of petals and add a few shading lines to accentuate the shape.

# Lady's smock
## *(Cardamine pratensis)*

The lady's smock is a small wildflower commonly found along riverbanks or in moist landscapes. They're also called cuckoo flowers because they bloom around the same time as the arrival of the cuckoos each spring in the British Isles. The most distinctive elements of the flower are its four-petal cross form and the strong veining of each petal.

Given their size and dainty appearance, a lady's smock drawing is perfect for gracefully decorating small spaces in your journal.

## Sketching notes

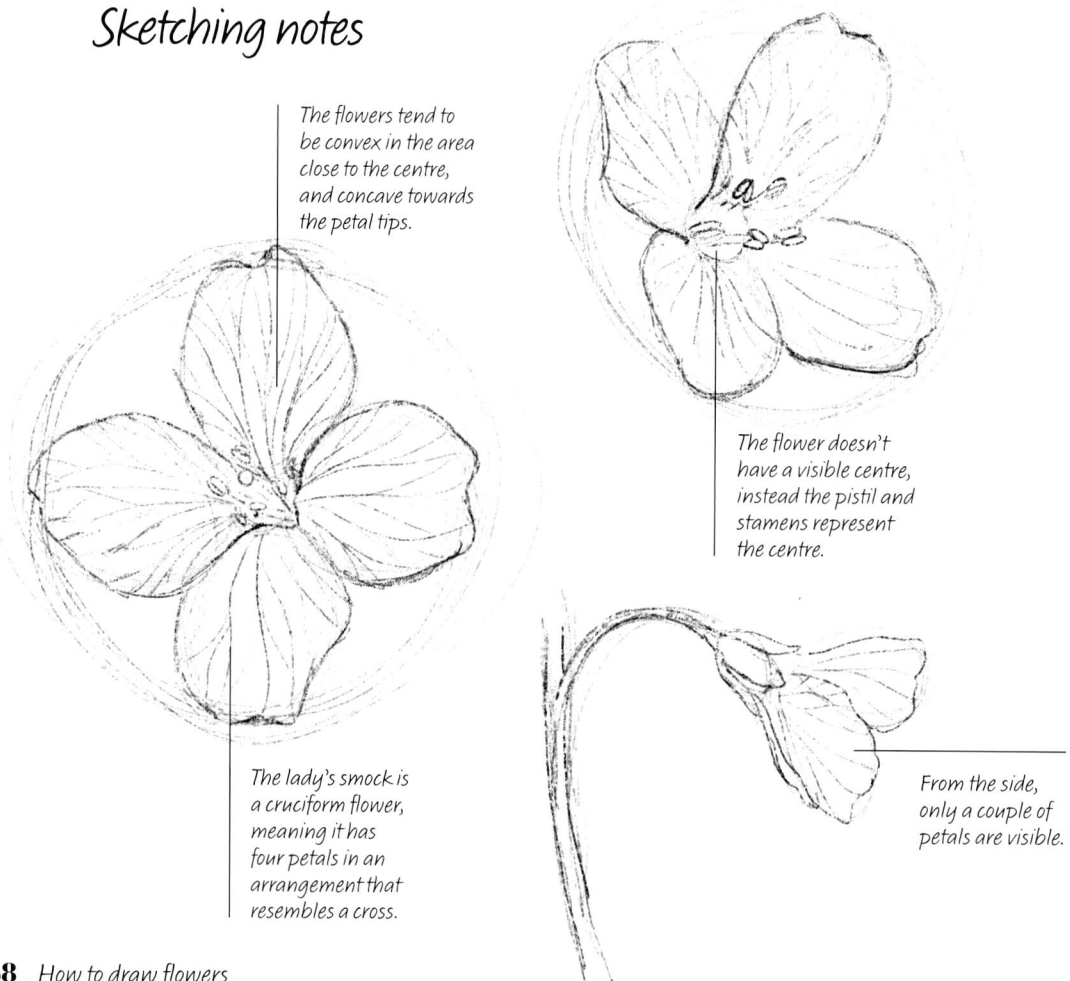

The flowers tend to be convex in the area close to the centre, and concave towards the petal tips.

The flower doesn't have a visible centre, instead the pistil and stamens represent the centre.

The lady's smock is a cruciform flower, meaning it has four petals in an arrangement that resembles a cross.

From the side, only a couple of petals are visible.

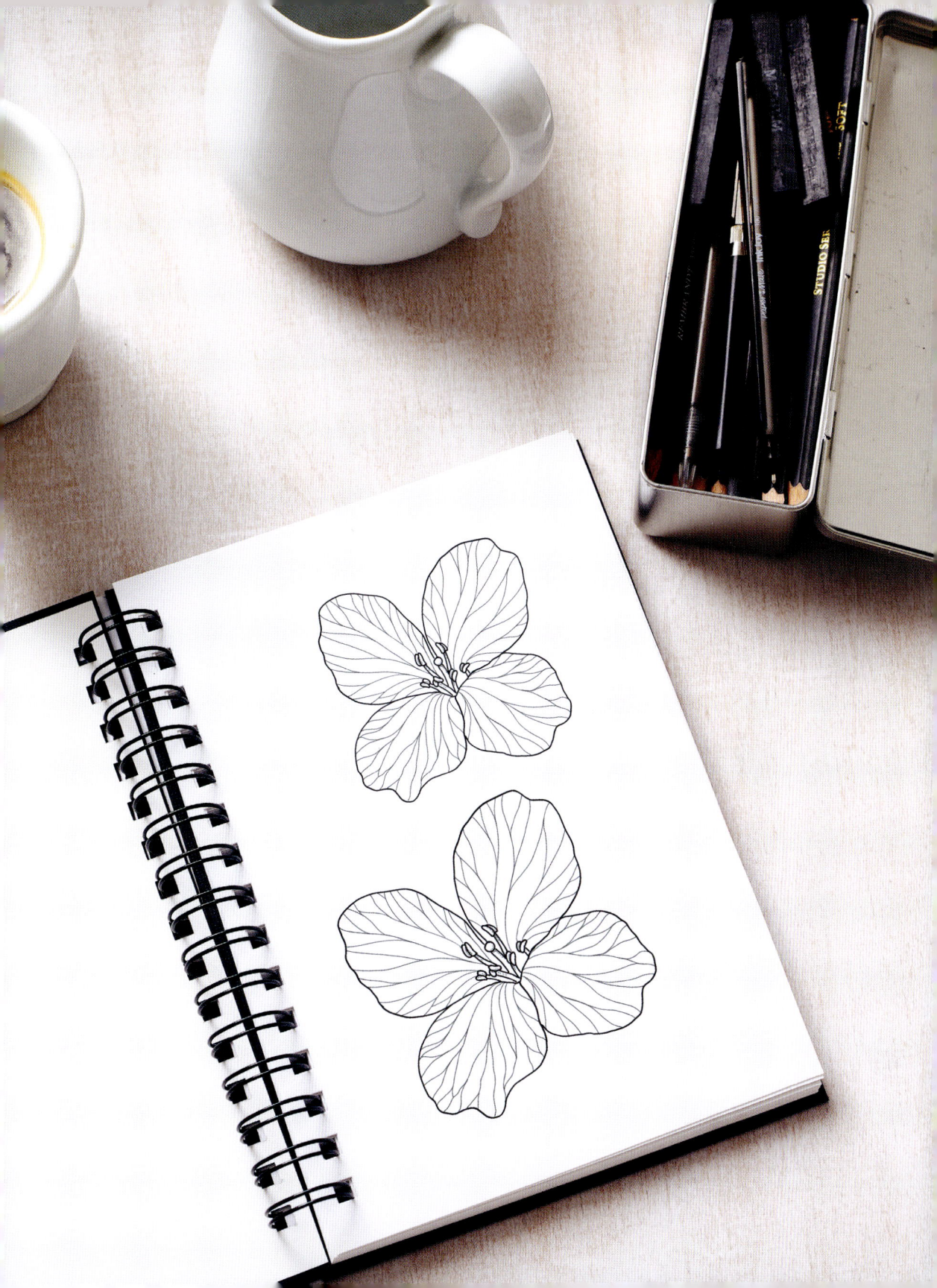

# Not shading, veining

The dip in each petal is similar to those of the cherry blossom's petals (see page 46).

(see page 46)

Since the centre is not visible, draw an oval guideline – that can be erased later – from which the pistil and the stamens peek out. The pistil consists of a simple circle with two lines for its body. The stamens surrounding the pistil are similar but, instead of a circle, they have two small ovals on top.

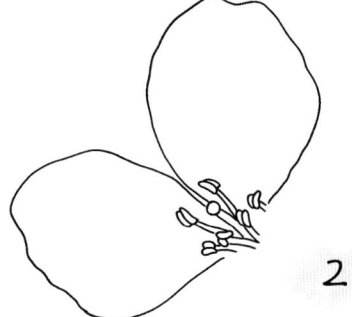

**2**

Construct the petals around the central elements, starting with the top petal and the one to its left. Each petal is a rounded diamond shape with a gentle dip at the tip.

## MARKS

Parallel curves for the body of the pistil and stamens

A circle tops the pistil, two ovals top each of the stamens

Curved dip for petal tips

Soft double curves for the veining

**3**

Add the remaining two petals to complete the cross shape.

*You can also add light stippling to the pistil and stamens.*

## BIANCA'S TIPS

- Lady's smocks are tiny flowers, so remember to consider the proportions when adding them to compositions with other flowers.

- In nature the flowers grow arranged in a circle at the top of the stem, with a few of them also growing along its length.

- The veining patterns are similar to butterflies' wings, and unique to each petal. This is where having a reference photo can really help you.

- The colour of the flower is a pale lilac/pink or, in rare cases, white.

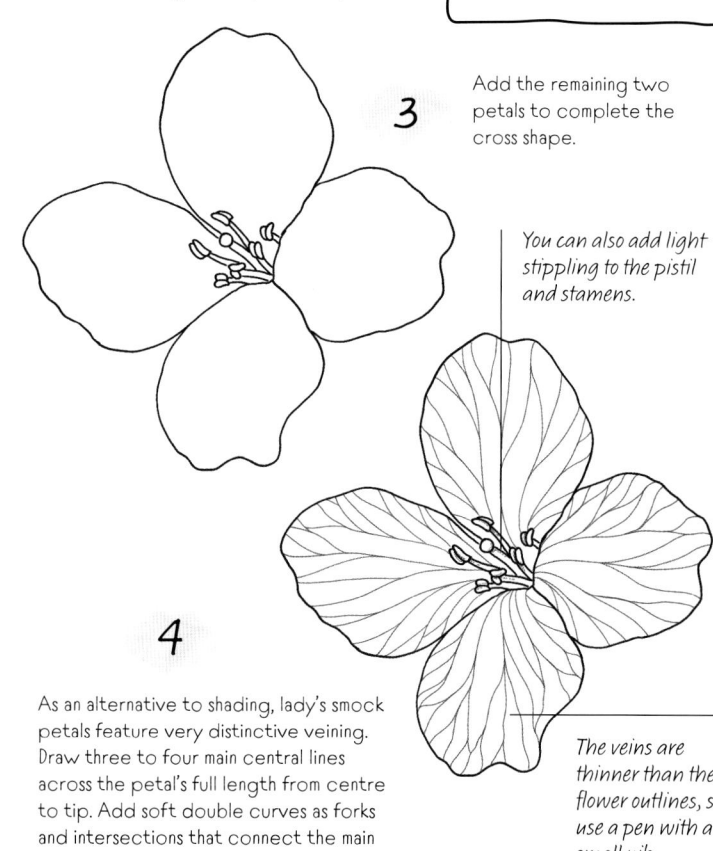

**4**

As an alternative to shading, lady's smock petals feature very distinctive veining. Draw three to four main central lines across the petal's full length from centre to tip. Add soft double curves as forks and intersections that connect the main veins to the petal edges.

*The veins are thinner than the flower outlines, so use a pen with a small nib.*

# Flat colouring with gouache

Colouring a flower doesn't have to involve complex blending and shading. Flat colouring is a method of playing with solid and uniform brushstrokes to create a flat layer of colour. Here depth and details are created by using different shades of colour and strategically placing it in specific areas in order to bring the drawing to life.

Since opacity is a distinctive feature of gouache, it is the perfect medium for experimenting with flat colour.

### EXTRA KIT

- Mixed-media or watercolour paper
- Gouache paints: lilac, yellow, dark lilac, brown
- Small brush
- Mixing palette

## 1

Dampen a small brush with water and activate the lilac gouache paint on the palette, being careful not to mix in too much water. Once the gouache is flowy but still opaque, paint one petal at a time using big, bold strokes to evenly fill the whole area. Leave to dry completely.

## 2

Activate the yellow gouache paint and colour the central elements. Add some yellow dots at the base to fill the remaining blank space. Let the piece dry completely.

## 3

Activate the dark lilac gouache for the veins. Painting these thin lines might seem daunting, but don't let perfectionism hold you back. This is not a realistic piece so you can choose to add fewer lines to give the overall veined effect.

## 4

Finish by applying a little brown paint to the tips of the stamens to give dimension.

*Since gouache is completely opaque, once you have applied the first layer of colour the sketching lines will no longer be visible. If you feel you need more guidance, lightly draw the pistil and stamens back in in pencil before colouring.*

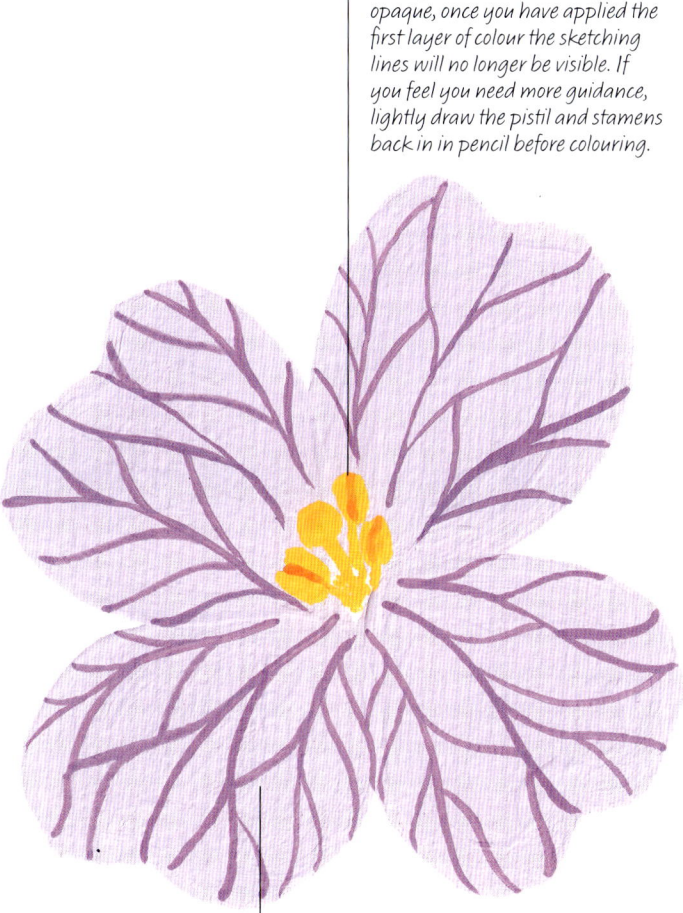

*If you have a water brush, the sturdy bristles can help you to work more precisely.*

# Daisy *(Bellis perennis)*

The daisy, in its simplicity, has an everlasting nostalgic appeal and never fails to stun the viewer with its beauty and immaculate petals. Daisies are fairly easy to draw, although they do present the challenge of overlapping petals, which means that at times the whole of the petal is not visible because it's covered by another petal, so you can only see a fragment peeking out. Remember to draw one petal at a time, no matter if it's fully or only partially visible, and to think in layers, drawing what's on top first then proceeding gradually downward.

The daisy is April's birth flower, so add it to handwritten birthday cards for loved ones born in spring.

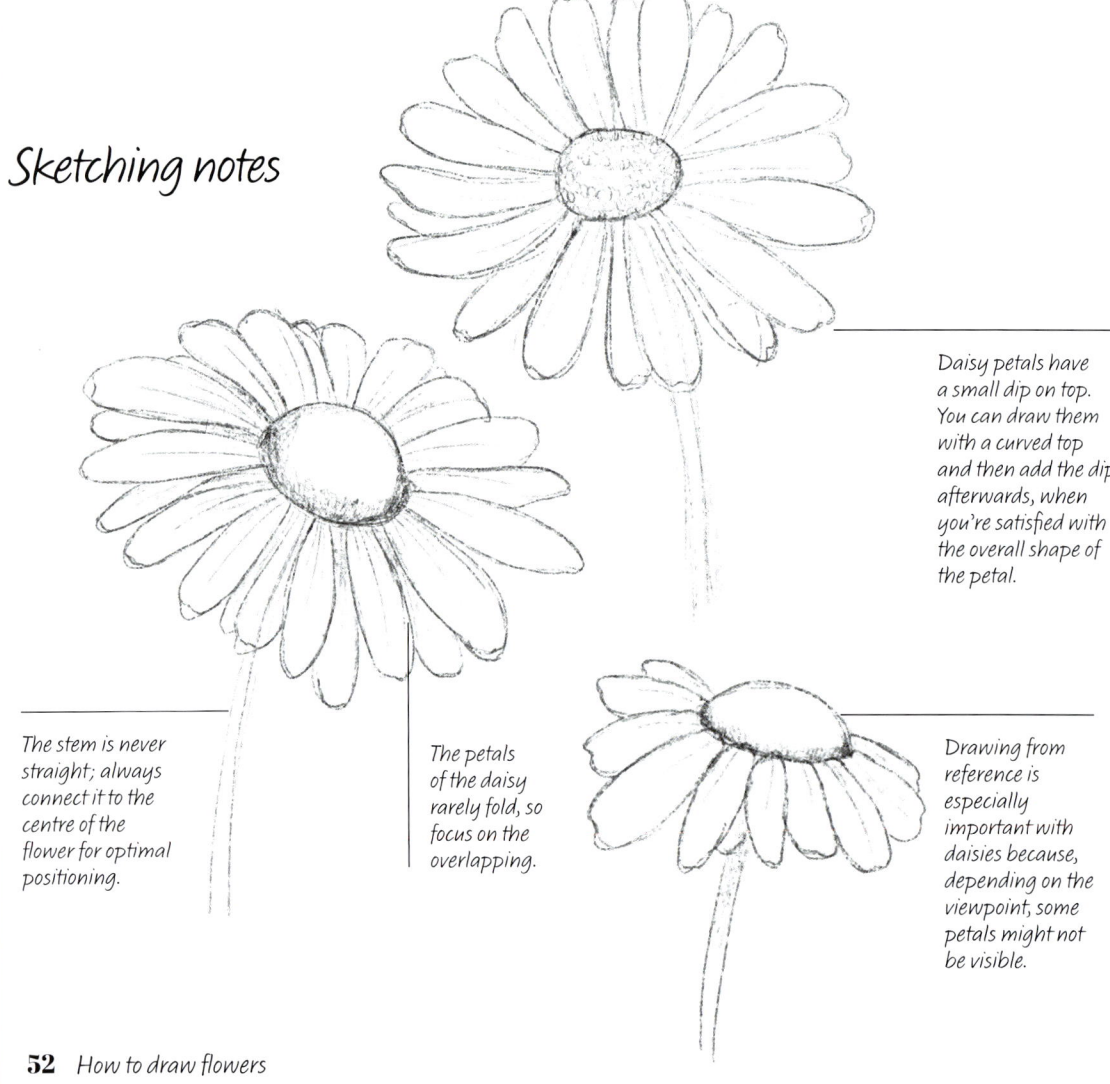

## Sketching notes

Daisy petals have a small dip on top. You can draw them with a curved top and then add the dip afterwards, when you're satisfied with the overall shape of the petal.

The stem is never straight; always connect it to the centre of the flower for optimal positioning.

The petals of the daisy rarely fold, so focus on the overlapping.

Drawing from reference is especially important with daisies because, depending on the viewpoint, some petals might not be visible.

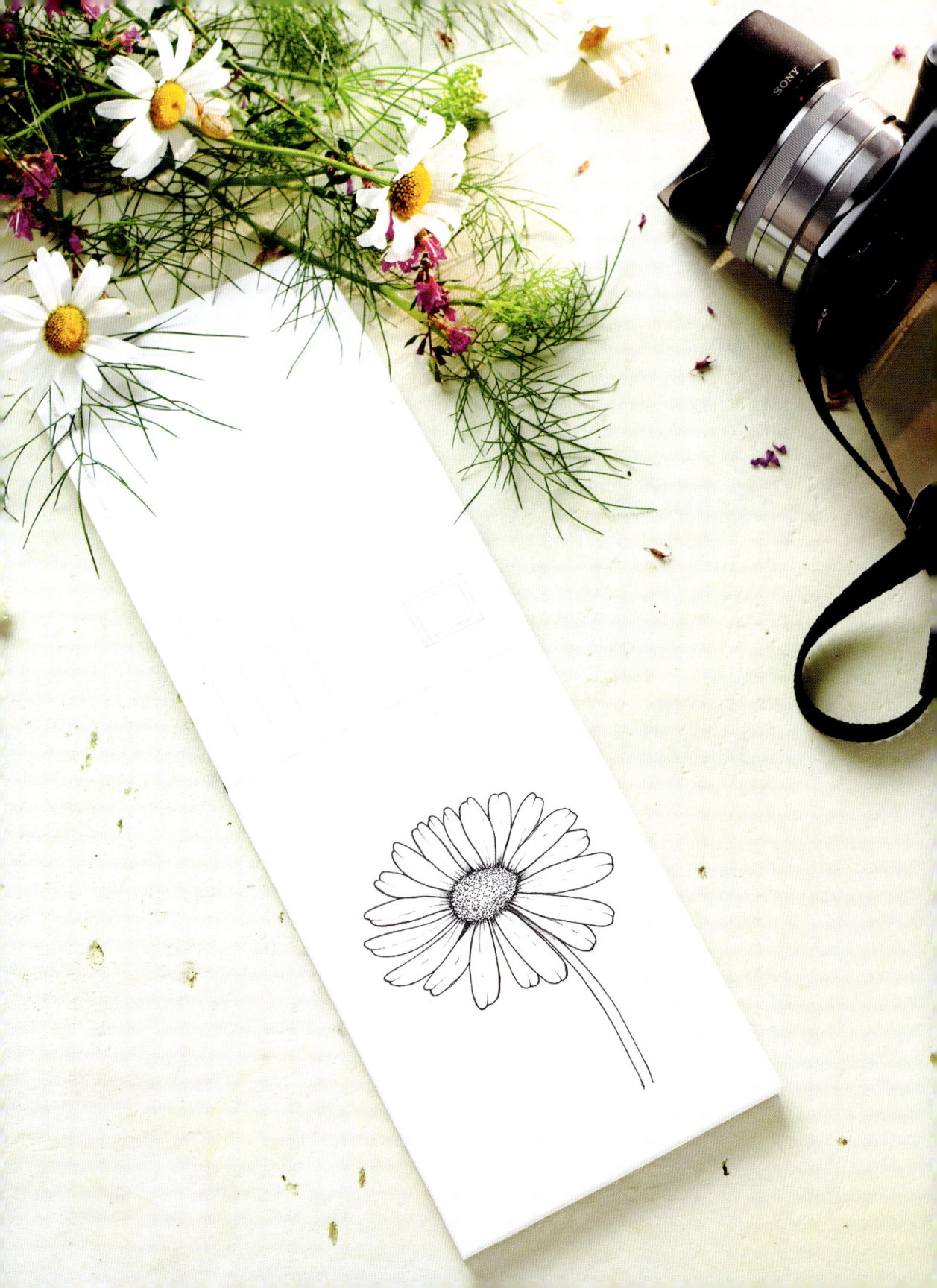

# The art of overlapping petals

## MARKS

- Wobbly oval centre
- Open single curves for petal edges
- Long open curves for stem edges
- Curved dip for petal tops
- Stippling

### BIANCA'S TIPS

- All the petals should be roughly the same length.
- Don't space the petals evenly, since this will give your drawing a sense of stiffness.
- If your half-hidden petals don't look right, try drawing the whole petal in pencil and then ink only the part that is visible.
- The centre of the daisy can be shaded in a variety of ways. If you're keeping your drawing in black and white, consider heavily shading the centre to create a contrast between it and the crisp white petals.

**1**

Draw the centre of the flower in the shape of a wobbly oval.

**2**

Draw the first layer of petals, the ones that sit on top of the flower and are fully visible. The long petals always have a slight curvature to them. Give the tip of each petal a small curved dip.

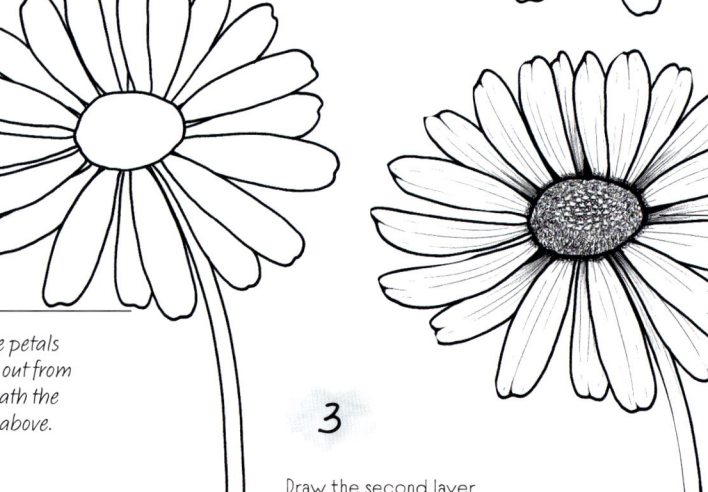

*These petals peek out from beneath the ones above.*

**3**

Draw the second layer of petals directly under the first, filling the gaps left by the first layer. Draw two parallel curves for the stem.

*It's a good time to practise your stippling.*

**4**

Add shading and details. You might want to really enhance the parts where the petals overlap, and around the centre, to give your flower a three-dimensional look.

# White petals on white paper

It's easy to draw white petals when using an ink pen, which clearly defines the shape, but what if you want to draw white petals without a border? Markers can help.

**BIANCA'S TIP**

- To be more precise, you can sketch your drawing lightly on paper before starting with the markers, so that you have a rough guide. Be careful not to go too heavy with the pencil lines, so your marker lines will fully cover them.

## 1

Scribble light yellow lines and dots to create a rough idea of the centre, leaving some white space for highlights. Go in only on one side of the centre with the darkest shade of yellow to create a shadow. If you're fast enough, the colours will bleed nicely into each other.

*Markers, especially the ones with brush tips, allow you to create thick and thin lines that give the petals immediate dimension.*

## 2

Repeat with another layer of dark yellow if you need to intensify particular areas.

## 3

For the petals, use the lightest grey possible and draw only the shadows of the petals, using the white of the paper as the main source of colour.

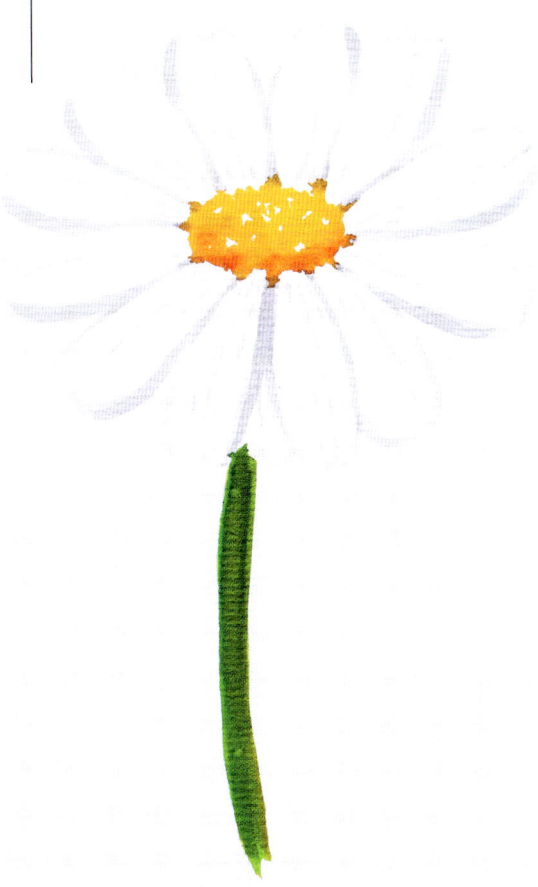

## 4

You can then add stems with a dark green marker and the drawing is complete.

---

*EXTRA KIT*

- Watercolour paper

- Markers (brush markers work well): light yellow, dark yellow, light grey, dark green

*Daisy: Bellis perennis* **55**

# Cosmos *(Cosmos)*

Cosmos are beautiful and truly versatile flowers that are relatively quick to draw but always make a great impact. Drawing this flower will also teach you one of the most important skills to master in order to make your flowers look as realistic as possible: how to draw folds.

Folds occur when the petal doesn't lay flat but folds towards the centre of the flower, or outwards away from the centre, meaning that the whole body of the petal is not immediately visible. Folds can also be apparent on the side of petals, especially with deep, cuplike flowers.

Cosmos rarely present dramatic folds, which makes them the perfect subject to practice your fold drawing, before moving to more complex flowers.

## Sketching notes

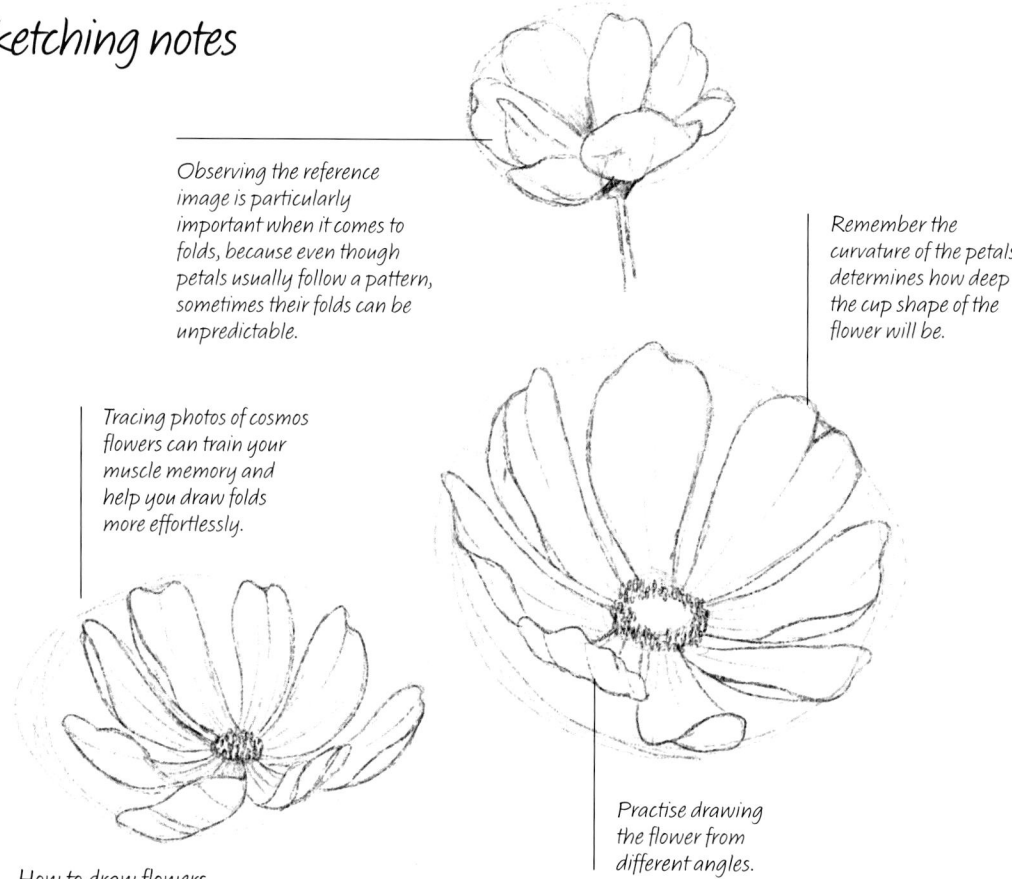

Observing the reference image is particularly important when it comes to folds, because even though petals usually follow a pattern, sometimes their folds can be unpredictable.

Remember the curvature of the petals determines how deep the cup shape of the flower will be.

Tracing photos of cosmos flowers can train your muscle memory and help you draw folds more effortlessly.

Practise drawing the flower from different angles.

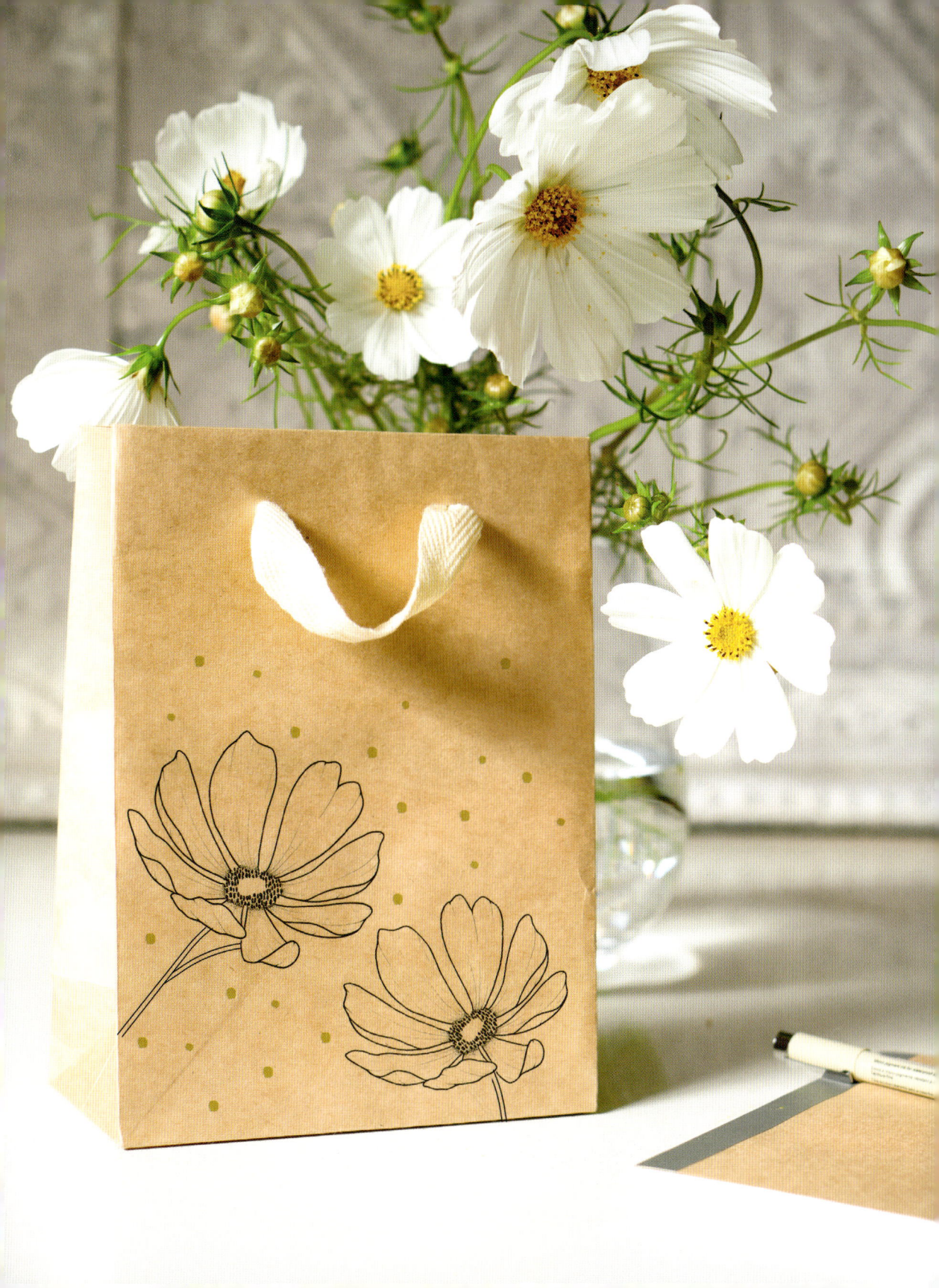

# Folding petals

*The dots don't need to be even or precise, they just need to look organic.*

## 1

Start by drawing the centre as a series of small, elongated dots that follow an imaginary oval shape.

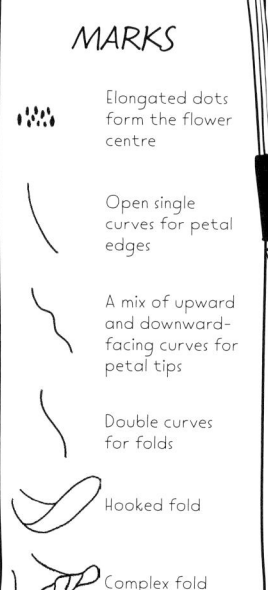

### MARKS

 Elongated dots form the flower centre

Open single curves for petal edges

A mix of upward and downward-facing curves for petal tips

Double curves for folds

Hooked fold

Complex fold

*Most of the petals have curved peaks at their tips.*

## 2

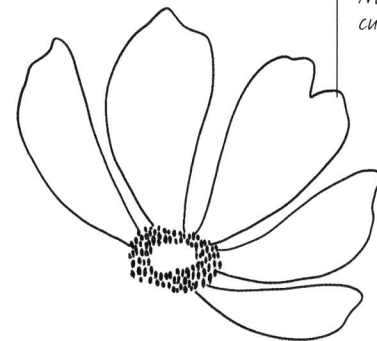

Cosmos flowers have a single layer of petals. Start by drawing the ones that don't fold – they're usually the ones in the back, further away from the viewer – in this case the two biggest petals. Add thinner petals on either side of the initial petals.

## 3

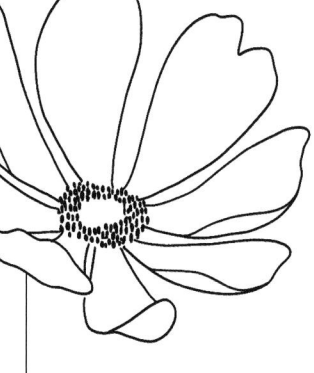

Add a long double curve fold to the four petals on either side of the nonfolded petals (see opposite). Draw one petal at the bottom of the flower using the hook fold method detailed opposite, and the final petal using the complex fold method.

*Pay attention to where petals and folds overlap.*

## 4

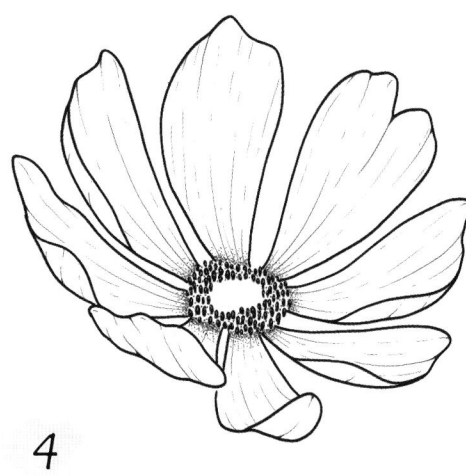

Folds help create visual interest in a flower drawing, so shading can be toned down to the bare minimum, or avoided completely, without making the flower look dull or naked.

# Double curve fold

This method is a simple fix if any petals look disproportionate compared to the others: adding a side fold usually saves the drawing.

**1** Draw a curved petal as you normally would . . .

**2** . . . then add a long double curve on one side of the petal, making it look like it's raised up.

**3** Make sure your shading lines follow the direction of the petal curves.

# Hooked fold

Constructing the petal around the fold may seem intricate at first but, as you practice, you will develop the muscle memory needed to draw the first two steps in one continuous motion, making it look more organic.

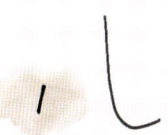

**1** Start by drawing a hooklike curve as the side of the petal . . .

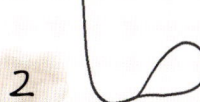

**2** . . . then add a drop shape at the end of the curve to indicate the folded part of the petal.

**3** Add another line slightly off the top to form the second side of the petal.

**4** Ensure any shading lines follow the direction of the curve.

# Complex fold

Use this technique when the folded part of the petal is almost the only visible part.

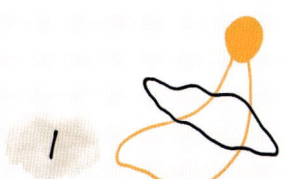

**1** Imagine how the petal would look if it was not folded (orange lines).

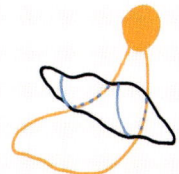

**2** Draw a guide (blue lines) to indicate the curvature of the petal as if it was folded, and draw your fold around it. It doesn't need to be precise, it just needs to make visual sense.

**3** Looking closely at your reference will help you understand this process better.

# Harebell
## (*Campanula rotundifolia*)

Small and dainty, the harebell is one of the most common wildflowers and can be found pretty much everywhere in the northern hemisphere. With its signature bluish-purple colour, it is one of the most unmistakable woodland flowers.

Harebells have a thin and slightly curved stem with the signature bell shape hanging upside down, and the pointed petals facing sideways or downwards.

Harebells are the perfect complementary flowers for any bouquet, but can also be used on their own if you're after a simple motif.

## Sketching notes

*Depending on the point of view, you may or may not see the inside of the flower.*

*The most important thing you should strive for is to convey the bell shape of the flower.*

*The petals have strong three-dimensional veining, which gives structure to the flower itself.*

*The petals tend to have a dagger tip, some pointier than others.*

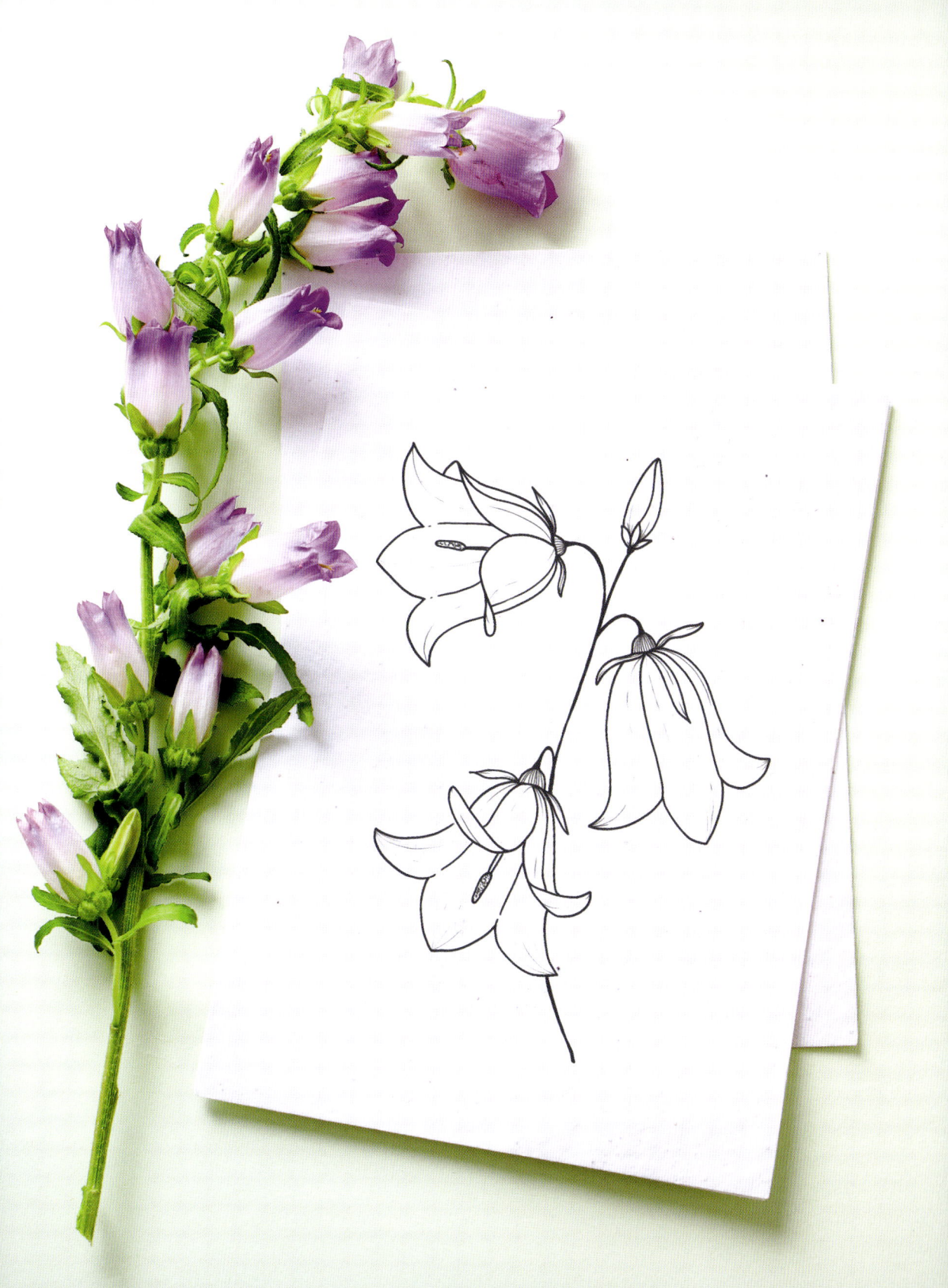

# Drawing an upside-down flower

## MARKS

Upside-down U with curved ends for the top of the flower

Pointed curves for the petals

Hooked fold

Double curves for shading

This curved line for the stem

### 1

Start with a simple bell shape, with the ends tilted up. You can draw it in one continuous line or one side at a time.

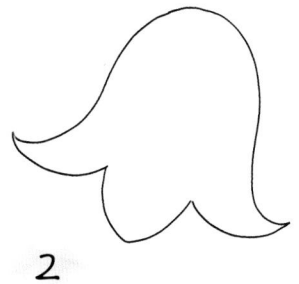

### 2

Connect the two ends with four curved lines to create three pointed petals.

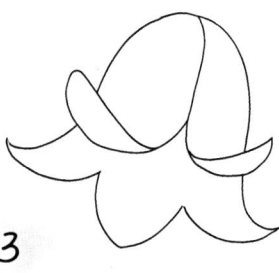

### 3

Add two outward-folding petals on top of the base drawing, like two small curtains opening to show the inside of the flower.

*The elements of the sepal look like small pointed leaves.*

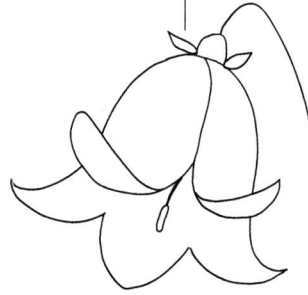

### 4

Add the remaining part of the flower: the pistil, the sepals, the receptacle which is at the very top of the flower and the thin stem.

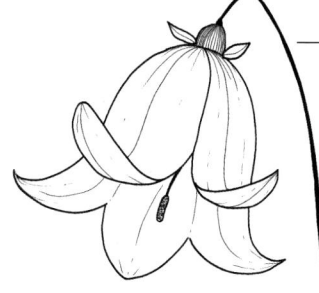

*Thicken the stem to give it more dimension.*

### 5

Shading can help you accentuate the roundness of the harebell, especially at the top where it's attached to the receptacle, and at the folds.

# Three flowers, one stem

Harebells often feature a number of buds on the same stem. To draw them takes planning, a stage that also gives you the chance to experiment with drawing the same flower from different points of view.

It's a good idea to start with a reference picture to have a better idea of how the flowers are positioned along the stem and which parts are visible to the viewer.

Compositions like these could easily be used as a border in a journal to accompany text-heavy spreads. They're also perfect for naturally vertical products like cards or bookmarks.

## 1

Draw the stem first. A long, curved line is usually enough. It's better to keep it simple and not accentuate the curves too much.

## 2

Decide where to position flowers on the stem. Three is usually a perfect number to give variety without overcrowding the piece.

## 3

Now experiment with drawing the same flower from different perspectives, aiming to keep the size of the flowers consistent.

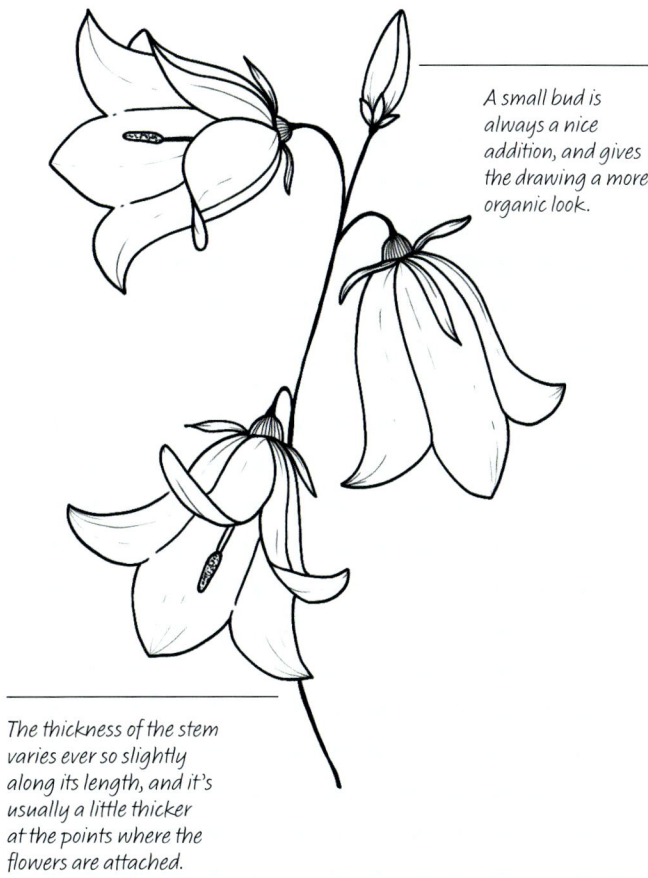

*A small bud is always a nice addition, and gives the drawing a more organic look.*

*The thickness of the stem varies ever so slightly along its length, and it's usually a little thicker at the points where the flowers are attached.*

# Lily *(Lilium)*

With botanical art you often start by drawing the flower's centre, but what should you do when the flower has no visible centre? Simply put, you start from the centre!

Even if it's not visible, it doesn't mean the centre isn't there, and you need to use your sketching guides and understanding of the mechanics of the flower to replicate it on paper, remembering that everything is attached to the 'invisible' centre.

The lily is a perfect example of this kind of challenge, and it's a beautiful flower to practise drawing. Lilies are versatile subjects because they come in so many different colours and patterns, making them the perfect subject for a single-flower piece of art.

## Sketching notes

Lilies have a very distinctive pistil surrounded by stamens. Remember to draw them both and don't mix them up.

Start by figuring out where the centre of the flower is, even if it's not visible.

Especially on the side view, lilies are masters of folds, so take your time to construct the petals accordingly.

If you're not yet comfortable with folds, go for a slightly tilted top view.

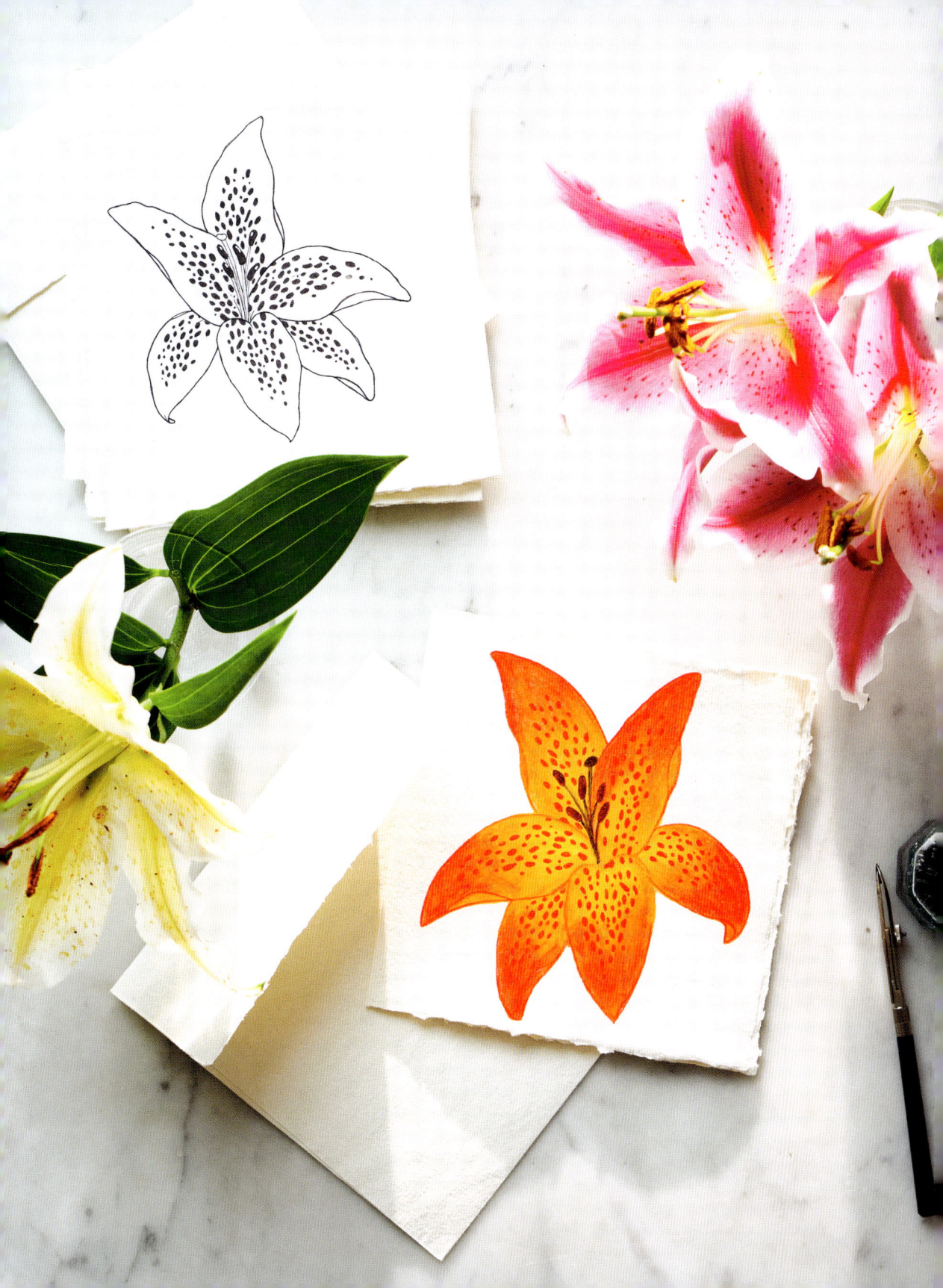

# Drawing from an 'invisible' centre

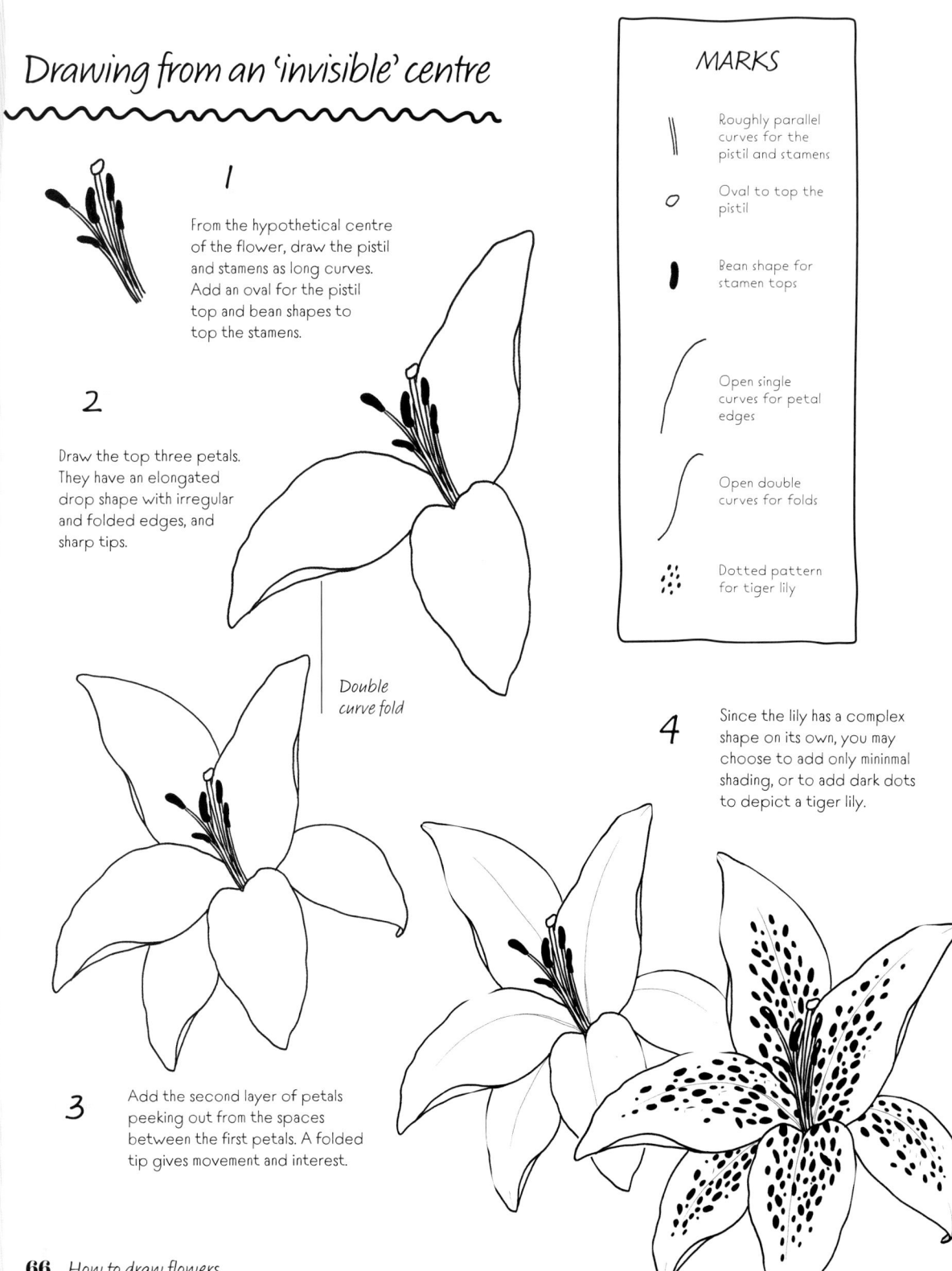

## MARKS

‖ Roughly parallel curves for the pistil and stamens

o Oval to top the pistil

❙ Bean shape for stamen tops

) Open single curves for petal edges

)) Open double curves for folds

∴ Dotted pattern for tiger lily

### 1

From the hypothetical centre of the flower, draw the pistil and stamens as long curves. Add an oval for the pistil top and bean shapes to top the stamens.

### 2

Draw the top three petals. They have an elongated drop shape with irregular and folded edges, and sharp tips.

Double curve fold

### 3

Add the second layer of petals peeking out from the spaces between the first petals. A folded tip gives movement and interest.

### 4

Since the lily has a complex shape on its own, you may choose to add only mininmal shading, or to add dark dots to depict a tiger lily.

# Softness and detail with watercolour pencils

There are many ways you can use watercolour pencils but, as a beginner, my advice is to start colouring with dry pencils on dry paper, being careful not to be too heavy-handed, since harsh pencil strokes will be harder to blend once water is added. It is also a good idea to work in layers.

## 1

Start by using a dry base colour for all the petals, then add a darker shade in the inner corners and deepest parts of the flower.

## 2

Once the base colour is laid out, blend it together using water. Start with a small amount and add more if you prefer a more watery effect. Be careful not to add too much, otherwise the paper could tear. Wait for this first layer to dry completely before proceeding.

## 3

With the next layer, colour in the smaller details, such as the dots on the petals, the pistil and the stamens. To make them smoother, add a little water and blend the colour in.

## 4

Sharpen your pencils while you wait for this layer to dry, then go in again to deepen the colours and add as much detail as you like.

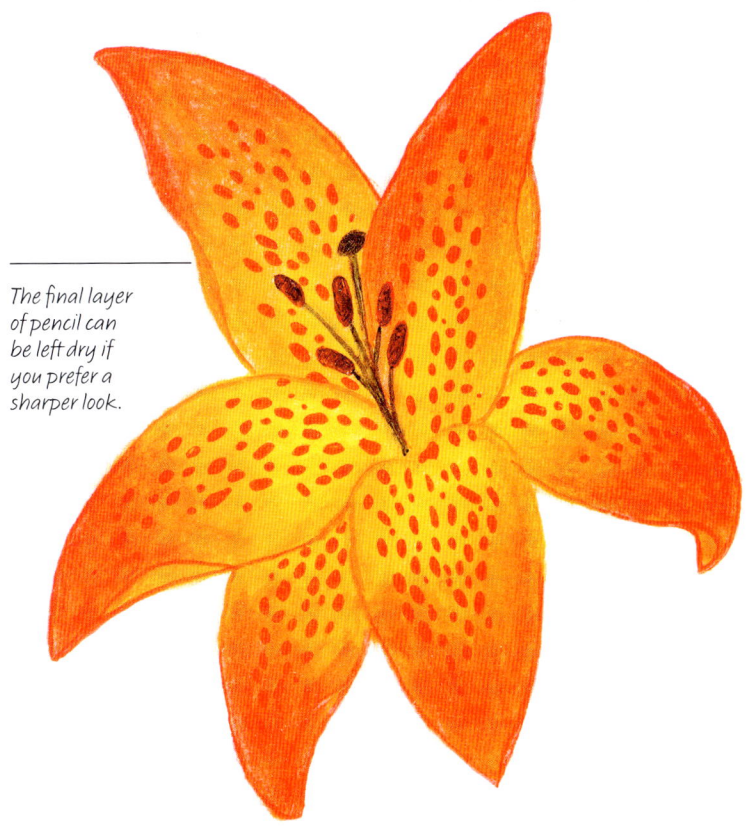

*The final layer of pencil can be left dry if you prefer a sharper look.*

## BIANCA'S TIPS

- The single pistil is long and has a small, round top, while there are multiple stamens with dark, elongated tops.

- The petals on the second layer are usually the ones with the most dramatic folds.

- Research different kinds of lilies and have fun decorating the petals according to the various species.

# Hibiscus *(Hibiscus)*

Hibiscus enchants the viewer with its exotic look and reminiscences of tropical holidays. It behaves like a classic funnelform flower, but what makes it special is its large combined pistil and stamen in a single structure, that shoots out from the centre of the flower, making this flower immediately recognizable.

Hibiscus are usually big, making them the perfect statement flower for any composition. As with the lily (see pages 64–67), the centre of the flower is not exposed, but the single long stamen gives a grounding point for your composition.

Nothing gives a journal spread more of a tropical vibe than hibiscus flowers, which will soon be your go-to for summer decorations.

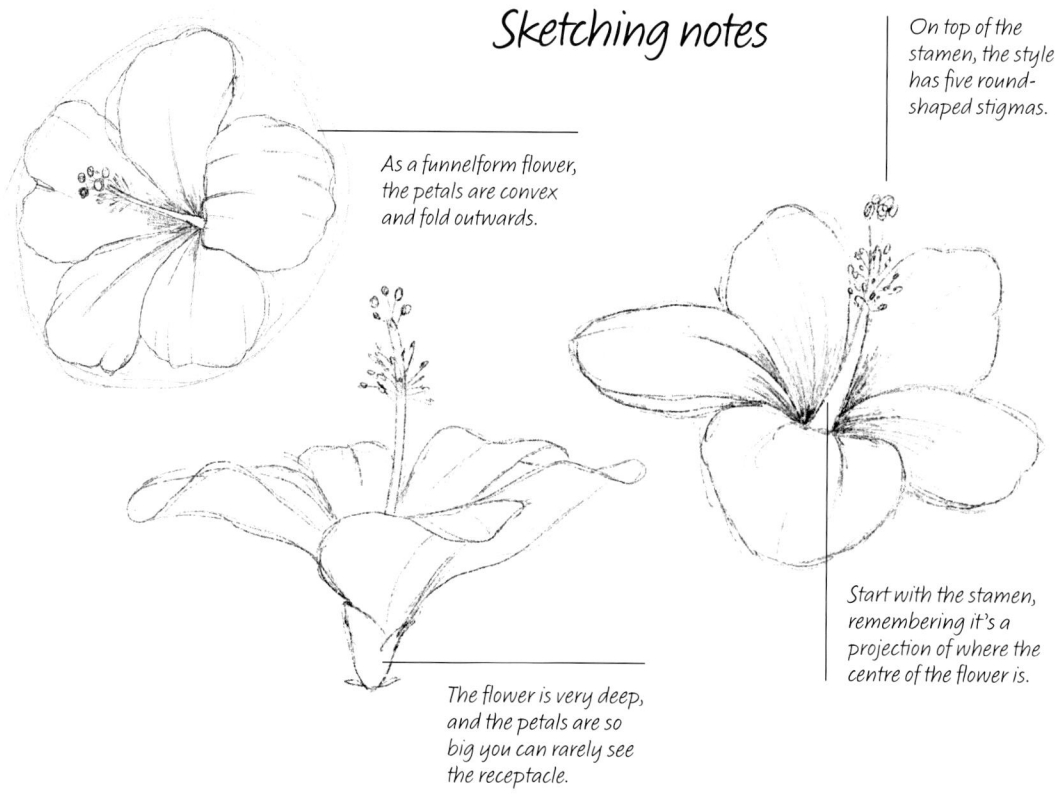

## Sketching notes

On top of the stamen, the style has five round-shaped stigmas.

As a funnelform flower, the petals are convex and fold outwards.

Start with the stamen, remembering it's a projection of where the centre of the flower is.

The flower is very deep, and the petals are so big you can rarely see the receptacle.

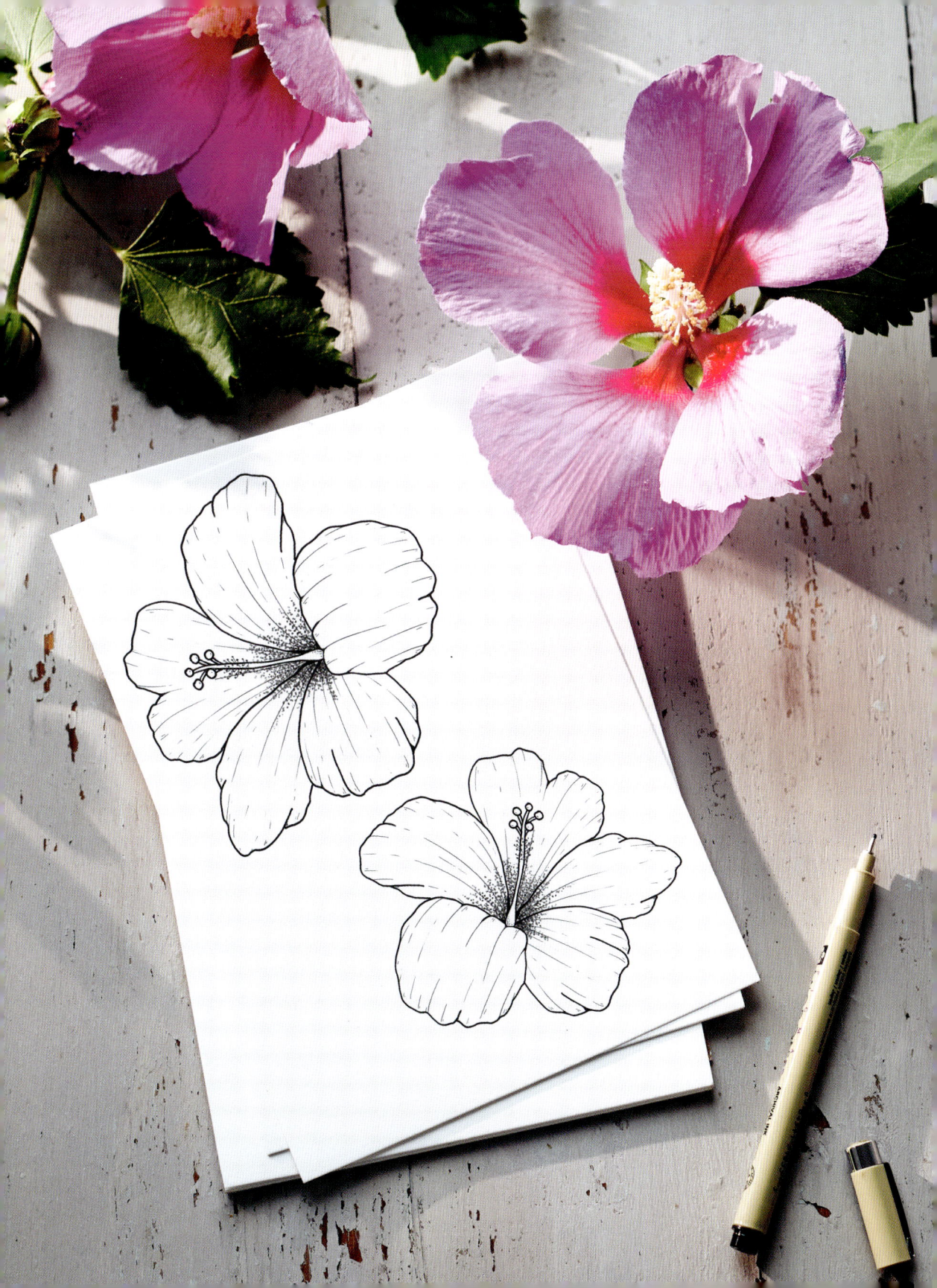

# The centre a different way

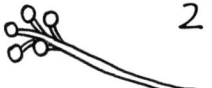

*1*

Start with the centrepiece of the flower by drawing a long tube with a droplike bottom.

*2*

Add five circles attached to the central structure by thin lines.

## MARKS

Roughly parallel lines with a teardrop shape connecting them to start the central feature

Short parallel lines topped with circles for the stigmas

Mid-depth curves for petal edges

Thin lines and dots for detailing on the stamen

The petals are all attached to the central structure and their shape narrows dramatically at that point.

Finish your drawing with as many shading lines as you like.

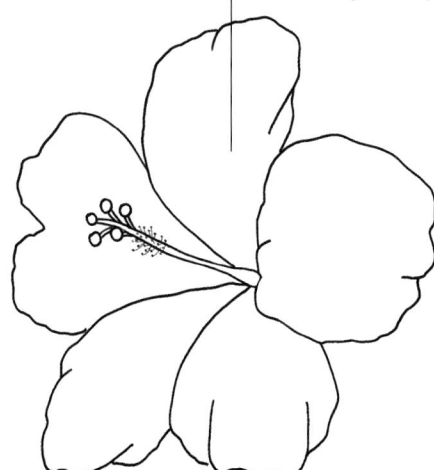

*3*

Add the five petals with their ruffled edges. With the general outline of the flower complete, switch to a smaller nib to add the details. Starting with the stamen, draw random small dots in the upper half of the centre and connect them with thin lines.

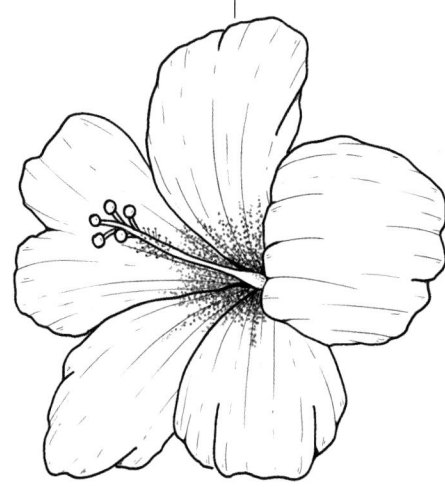

*4*

The petals of most hibiscus flowers have very dark bottom sections, contrasting with the lighter colour of the outer edges. You can portray this through stippling, creating darkness and the illusion of depth.

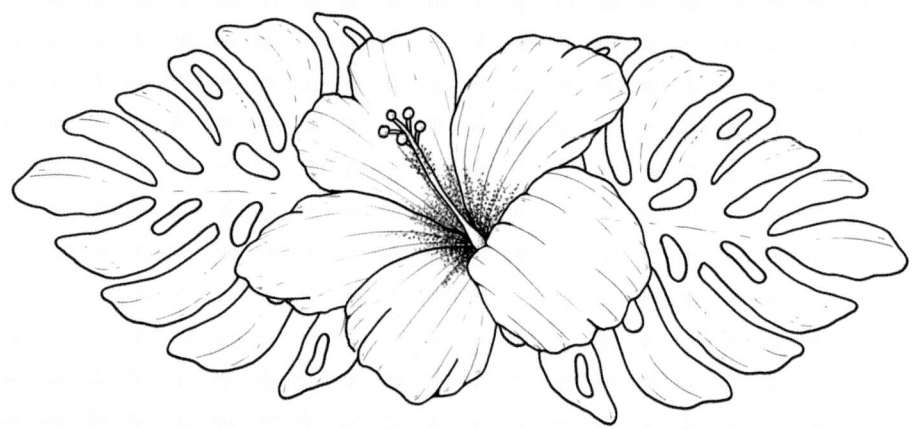

# Hibiscus' best friend: the monstera leaf

Hibiscus flowers and monstera leaves are often paired in tropical flower compositions because they encapsulate the essence of lush, exotic landscapes. The monstera leaf is actually pretty easy to draw and, thanks to its characteristic features, can add volume and interest to any drawing.

*1*

Start with a heart shape. It doesn't need to be perfectly symmetrical.

*Add the holes where you feel your leaf is particularly heavy and would benefit from carving out some space.*

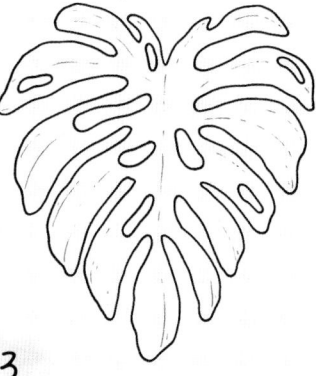

*Use a reference photo to guide where you draw the leaf splits, or go with the flow to create your own unique leaf.*

## 2

To draw the monstera's distinctive splits, start at the top of the leaf and draw back over the curve of the heart a little, then work in towards the middle of the heart to create an elongated rectangular shape with soft corners. Repeat the process all the way around the heart, working one side and then the other.

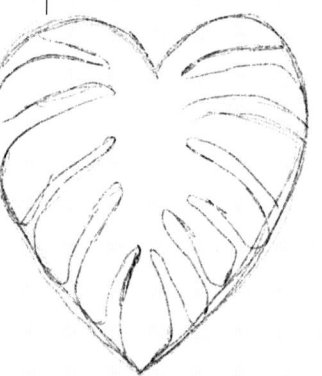

## 3

Once you're happy with your basic shape, ink it in and add the signature holes inside the leaf. Add light shading to accentuate the curves of the leaves.

# Daffodil *(Narcissus)*

Tall and bright, daffodils grow in large groups as the temperature starts to warm soon after winter. These interesting flowers are distinctively composed of two different parts: the petals on the bottom that develop horizontally, and the corona shooting out vertically in the centre. Combining these two different parts can seem challenging at first but, as always with flowers, it's a matter of understanding the dynamic of the elements.

Daffodils are among the first flowers to bloom in spring, as well as being March's birth flowers. The words of renowned poet William Wordsworth 'And then my heart with pleasure fills / And dances with the daffodils,' make a perfect quote to add to your daffodil drawing.

## Sketching notes

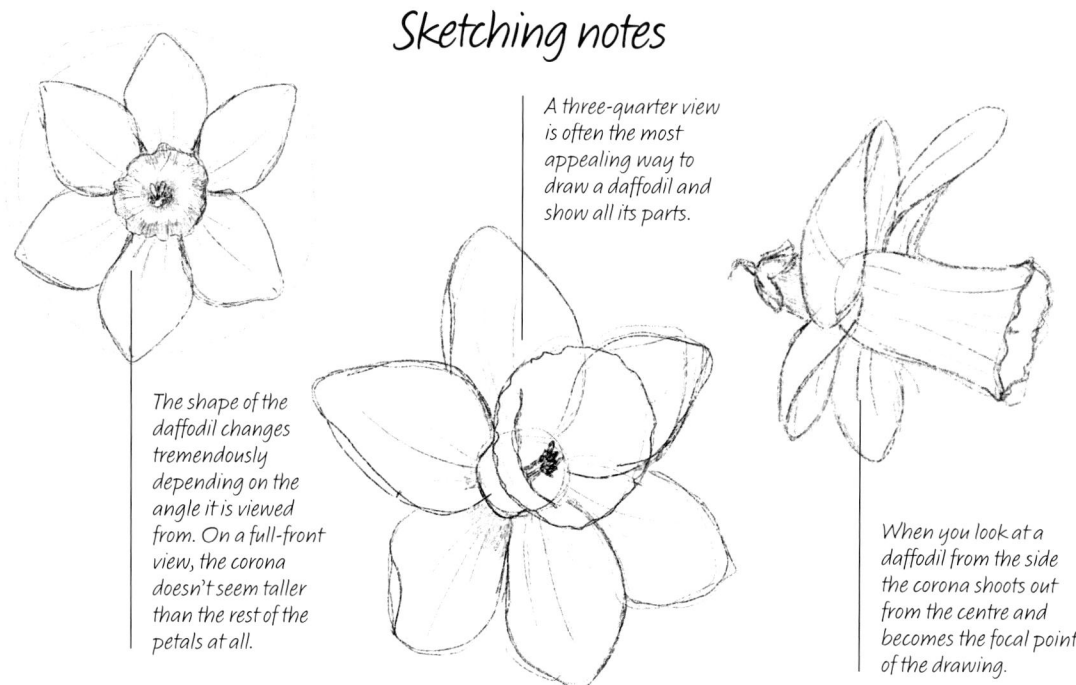

A three-quarter view is often the most appealing way to draw a daffodil and show all its parts.

The shape of the daffodil changes tremendously depending on the angle it is viewed from. On a full-front view, the corona doesn't seem taller than the rest of the petals at all.

When you look at a daffodil from the side the corona shoots out from the centre and becomes the focal point of the drawing.

# Combining elements

## 1

Start by drawing the corona in the form of a circle with irregular edges.

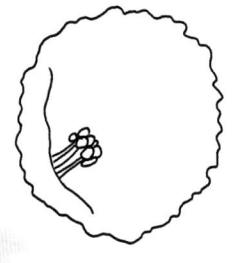

## 2

Draw an extended double curve (triple or quadruple) to one side of the circle to indicate the fold of the corona. Draw the pistils peeking out from this line.

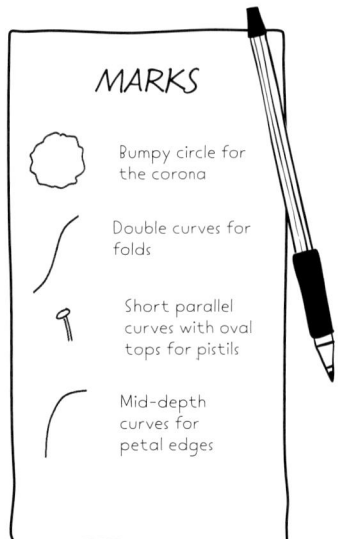

### MARKS

Bumpy circle for the corona

Double curves for folds

Short parallel curves with oval tops for pistils

Mid-depth curves for petal edges

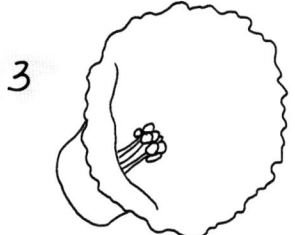

## 3

Imagine extending the line of the pistils behind the corona to establish the position for this part of the flower. Draw it as a rounded rectangular shape.

### BIANCA'S TIPS

- Daffodils are unforgiving flowers – they won't accommodate changes of mind midway through the drawing – so choose the orientation of the drawing wisely before starting to sketch.

- The petals tend to have a wide body with a pointy tip.

- Being confident with shading lines is key to giving every part of the flower the correct curvature.

- Petals and corona come in a variety of colour combinations, so have fun researching all the different daffodil varieties.

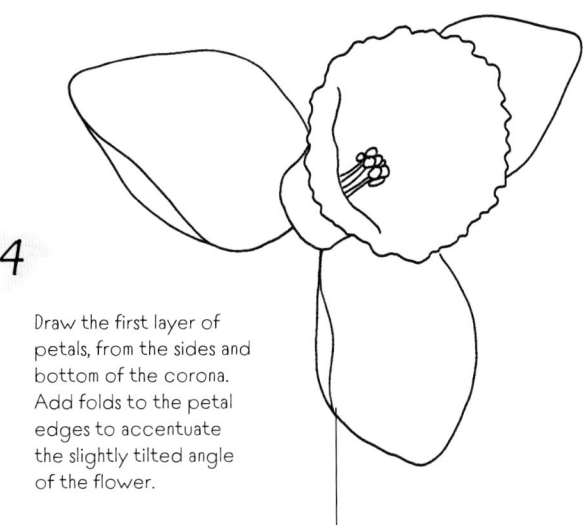

## 4

Draw the first layer of petals, from the sides and bottom of the corona. Add folds to the petal edges to accentuate the slightly tilted angle of the flower.

Double curve fold

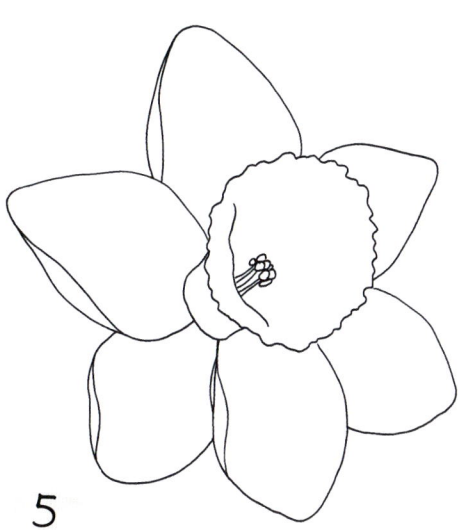

**5**

Fill the gaps with three new petals
coming from behind the first petals.

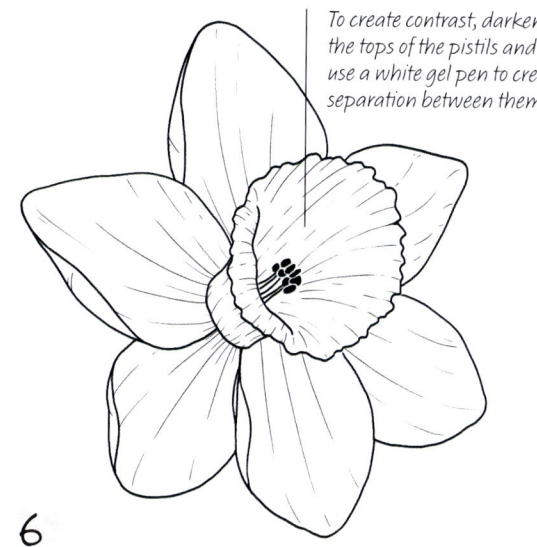

*To create contrast, darken
the tops of the pistils and
use a white gel pen to create
separation between them.*

**6**

The flower outline is complex, so you may want to
stop there, or use minimal shading. If you're aiming
for a more realistic look, switch to your smaller nibs
and accentuate the curvature and hollowness of the
petals with shading.

## Contrast with colour

These daffodils have been coloured with alcohol markers using a warm
palette of yellow, orange and green (see page 87 for a tutorial on using
alcohol markers). In this example the dark orange centre creates contrast
in the flower.

*Reapplying the
same colour on
top of the fully
dried previous
layer creates
shadows and
dimension.*

*Following the shading
lines of the drawing
when colouring.*

# Poppy *(Papaver)*

Tall but delicate, the poppy is composed of four to six petals with a distinct centre and an abundance of dark stamens, which contrast with the papery petals. The challenge here is in conveying the folding, paper-thin petals while working with essential shapes and simple elements.

The poppy is August's birth flower, so why not use some to add a splash of colour to summer spreads in a journal? With their long stems and delicate blooms, they're perfect for decorating borders, especially if you're aiming for a country feel in your summer designs.

## Sketching notes

*Let the centre of the flower be seen, and try to enhance the shape and distance between the petals.*

*A slightly tilted, top-down view shows all of the poppy's beautiful elements. Remember to enhance the cup shape of the centre.*

*If you're drawing the poppy from the upper side view, start with a bowl shape and ensure the petals cover most of the centre.*

*To create movement, add some outward folds.*

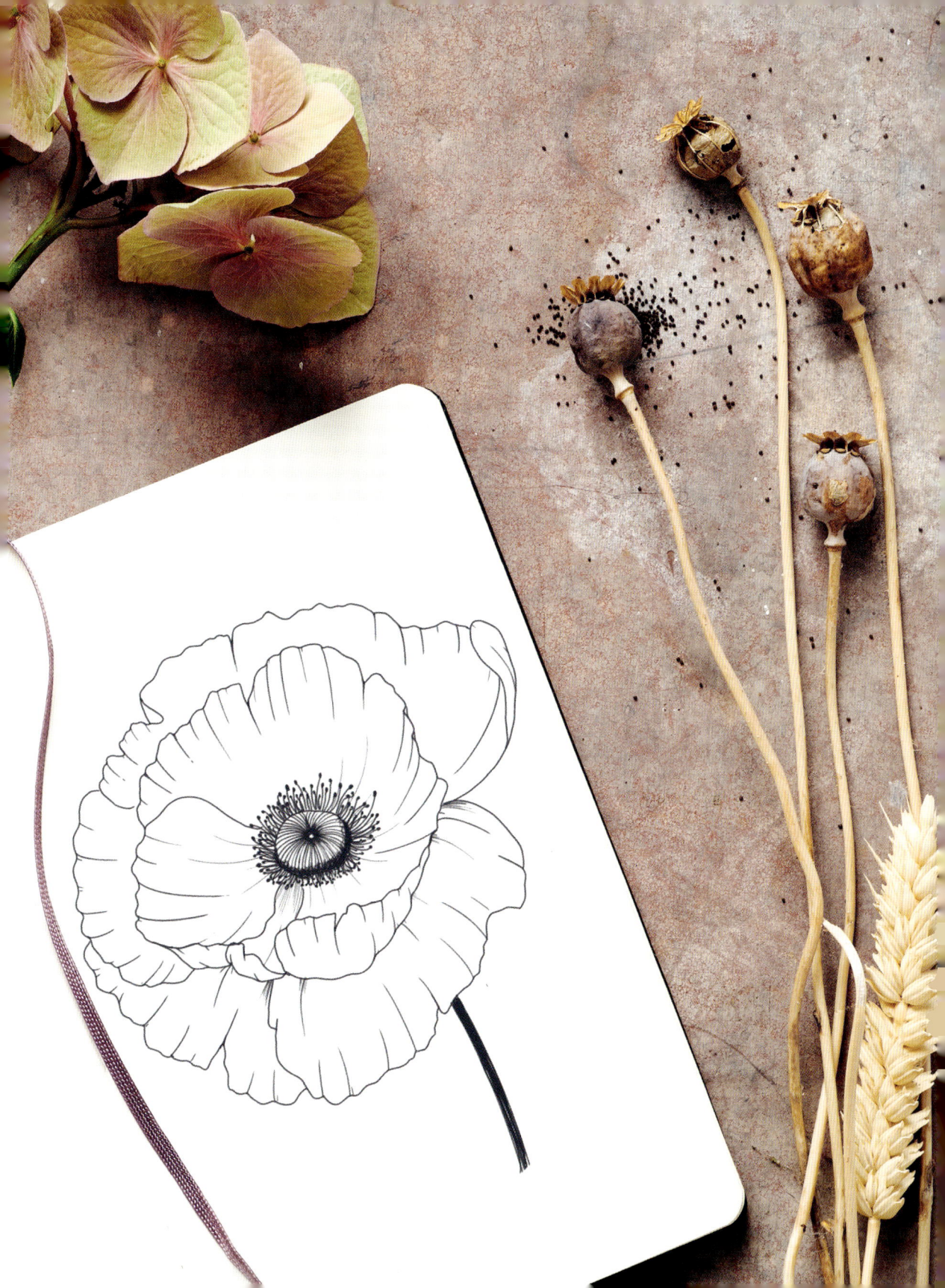

# The essence of shapes

## 1

Draw an irregular circle with a much smaller one inside it. It doesn't need to be perfectly in the centre: placing it slightly higher or to one side will help with realism.

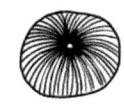

## 2

Starting from the outside circle, draw curved lines that connect it to the central circle. Leave some space between them but, at the same time, keep it irregular.

## MARKS

 A small circle within a larger, irregular circle to start the flower centre

 Short curves to fill out the centre

 Curves with dotted ovals for the stamens

 Jagged lines for petal edges

 Double curves for folds

*Exaggerate the petal's jagged edges.*

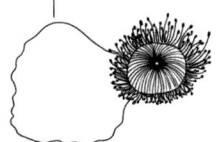

## 3

Add the first petal on the left side of the centre. It should be as wide as it is high, without being too circular.

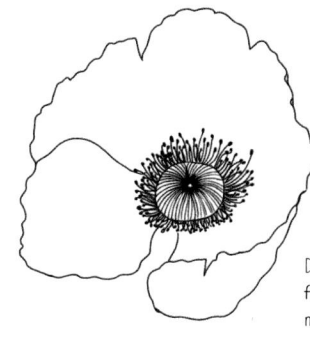

## 4

Draw a large central petal, starting from the top side of the first petal and making an almost full circle, leaving a small gap between the two petals.

*As usual, the petals have irregular edges, and you can also add splits in them.*

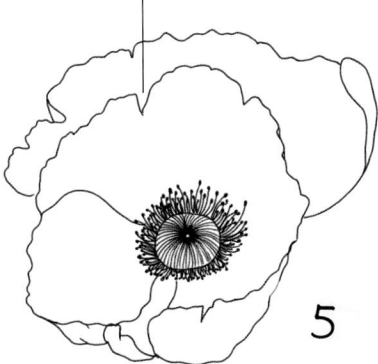

## 5

Fill the gap between the two previous petals with another petal. This is not really a separate petal but a crooked part of the central one that creates more interest in the core of the drawing. Add the back petal, creating a fold on the right side and a recess on the opposite side.

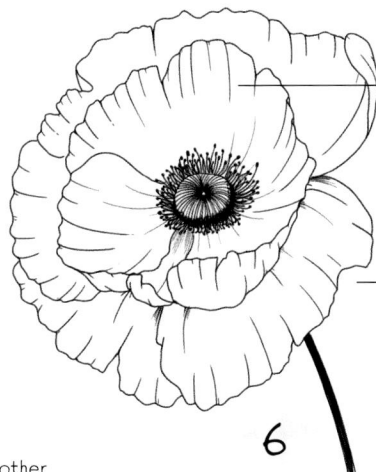

*The shading lines show the curving nature of the petals, concave and convex.*

*The outer petals are longer than they are wide, and have an almost rectangular shape.*

## 6

Following the same principles, add the remaining three petals. The left petal folds towards the centre, while the other two petals fold outwards and away from the centre. Add shading lines to bring the flower to life.

# A modern splash of loose watercolour

A loose watercolour technique can give a modern and fresh pop of colour to your flowers. It's a painting technique that focuses less on detail and realistic colouring, but instead is a more expressive and dynamic way of painting, giving just an idea of colours and shapes.

## EXTRA KIT

- Watercolour paper
- Watercolour paint
- Watercolour brush
- Palette
- Water
- Cloth

## 1

Choose a limited colour palette – in this case two shades of red – and a big brush for an effortless result. You might like to think about where you'd like your colours to go and how you'd like them to interact before applying.

## 2

Load the brush with as much water as possible, then mix it with paint on a palette until you have a very diluted version of your colour. Once you've reached your perfect colour-to-water mix, apply the paint with bold strokes.

## 3

When painting in loose watercolour, the edges don't matter, so have fun splashing the colour out of the limits of the pen drawing. You can also hold the brush over the paper and tap the handle to create spatters..

## 4

Repeat the strokes and spatters with your other colours, but be quick, since the best results are achieved when working with wet paint applied over wet paint so that they mix and blend together instead of layering one on top of the other. If you accidentally add too much paint or water, quickly lift the excess off with a cloth.

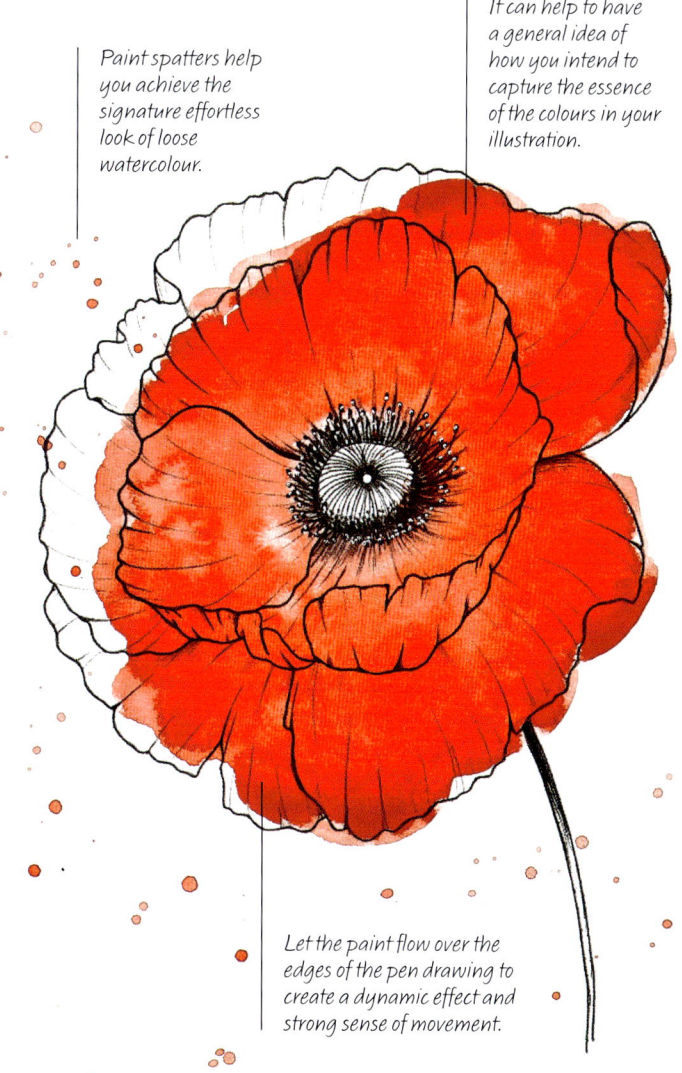

*Paint spatters help you achieve the signature effortless look of loose watercolour.*

*It can help to have a general idea of how you intend to capture the essence of the colours in your illustration.*

*Let the paint flow over the edges of the pen drawing to create a dynamic effect and strong sense of movement.*

# Foxglove (*Digitalis*)

The foxglove is a tall and sturdy flower spike with tubular blooms hanging from it like elongated bells. The flowers grow in layers one on top of the other, with the bigger ones on the bottom and the smaller ones on top. Foxgloves are beautiful but also poisonous, so be careful when spotting them in the wild.

Since they develop vertically, foxgloves are the perfect choice to embellish cards, as full-page designs or as a decoration between the two pages of a journal spread to divide them in a unique way.

*Foxgloves change dramatically in appearance depending on your point of view, so it's important to study them from all angles.*

## Sketching notes

*From the side view the opening is barely visible, and what stands out the most is the long, tubular shape of the flower body.*

*From a slightly tilted-up view, the most prominent feature is the large central opening of the flower with the signature dark spots on the inside.*

*The classic view of a foxglove is straight ahead, from where you can see the elongated body, the wide opening of the flower with the dots, the sepals and where the flower attaches to the stem.*

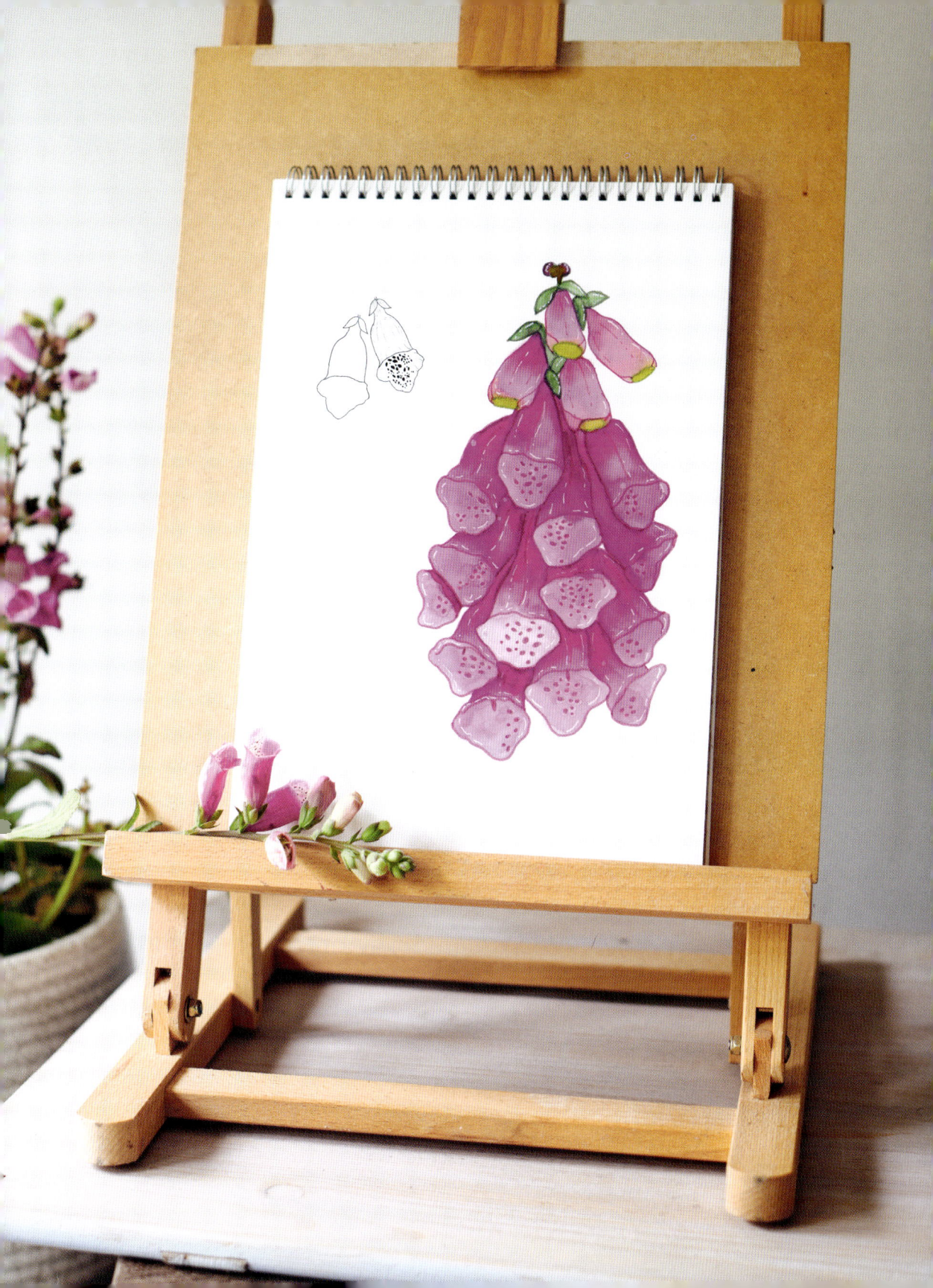

# The importance of the point of view

Organic oval with triangular protrusion at the base for the opening

The sepals are formed of an oval with one pointed end

Solid spots of varying sizes for the flower pattern

### 1

Start by drawing a pair of almost mirror-image double curves to form the body of the flower. Think about this flower as one single unit, since all the petals are fused together.

*This is a fluid shape that always dips lower at the bottom.*

### 2

Add the outline of the opening under the two curves. The shape resembles an ellipse with irregular edges and a deep triangular dip in the bottom half.

*Extend the Step-1 curves to meet the sepals if necessary.*

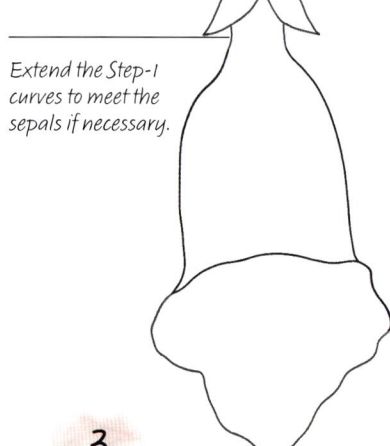

*Vary the size of spots to create visual interest.*

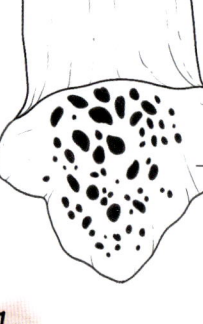

*Use shorter, directional lines to highlight the naturally outward-folding petals and their ruched edges.*

### 3

Move to the top of the drawing to add two sepals, shaped like small, pointy leaves, and two thin parallel lines to depict the part where the flower attaches to the stem.

### 4

Add the distinctive dark spots inside the flower opening. Use shading curves to accentuate the natural roundness of the flower, especially in the top half.

# Blending with water-based markers

Using water-based markers with a brush and water you can achieve a light and shade gradation on your flowers.

*1*

Using the purple water-based marker, colour the top section of just one flower. It is up to you how far down the flower you go, but definitely do not colour the opening – mouth – of the flower.

*2*

Dip a small brush in water, remove the excess by patting on a clean cloth and go over the colour you've just applied, blending it out to fill the rest of the flower, making sure to keep the most dilute purple for the mouth, the lightest part of the flower.

*3*

Repeat Steps 1–2 on a flower that is not adjacent to the first one, so you can keep a crisp, dry edge. Repeat for all the flowers.

*4*

Use a green marker and the same technique on the sepals. Use very light green in the closed mouths of the smaller flowers at the top.

*5*

Use a clean brush dipped in water to draw small circles inside the mouth. This technique will lift some of the existing colour and create a halo effect.

*6*

Use markers for the outlines and shading: pink for the flowers and the dark dots, and green around the sepals and closed mouths of the top flowers. This step will even out any bleed the colour might have, and create a clearer boundary between each flower.

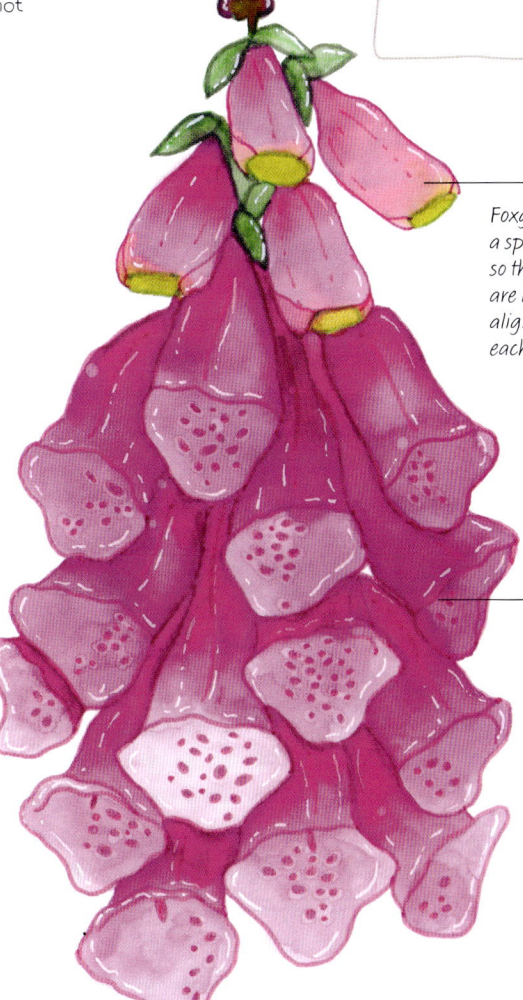

*Foxgloves grow in a spiral pattern, so the flowers are not perfectly aligned on top of each other.*

*The purple pigment in water-based markers can dry much faster than other colours, so act quickly to blend it as soon as it touches the paper, otherwise it might be difficult to activate it with water.*

*7*

Add thin highlights along the body and on the edges of the opening with a white gel pen.

# Pompom dahlia
## *(Dahlia)*

The rounded shape of the pompom dahlia can pose a challenge to the botanical artist, since the petals don't develop in a flat or cup shape, but fold in on each other, creating small tubes. Imagine taking a sheet of paper and folding it to mimic a telescope: that's how the petals of the pompom dahlia behave. The tubular petals are then distributed in layers, smaller and more packed towards the centre and opening up towards the bottom of the flower.

This flower is perfect if you're looking for an unusual bloom that will capture the interest of the viewer with its intricate beauty.

## Sketching notes

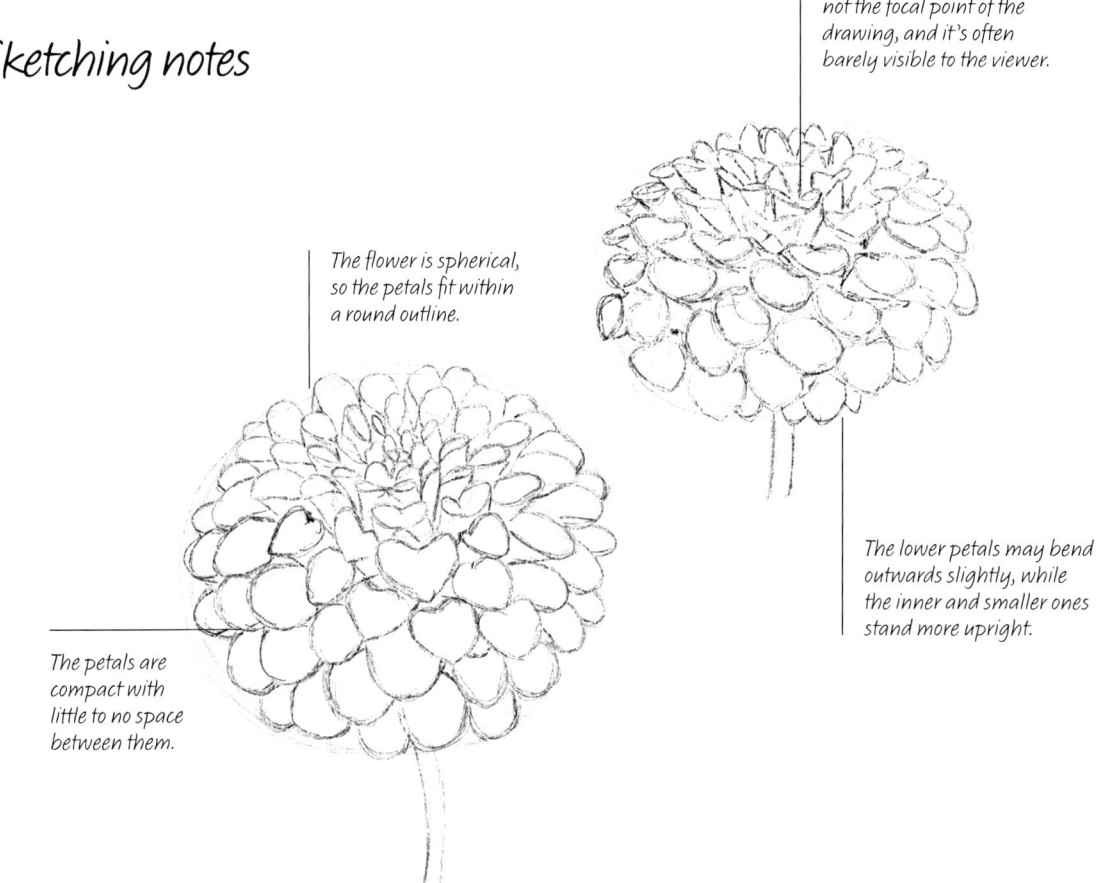

The centre of the flower is not the focal point of the drawing, and it's often barely visible to the viewer.

The flower is spherical, so the petals fit within a round outline.

The lower petals may bend outwards slightly, while the inner and smaller ones stand more upright.

The petals are compact with little to no space between them.

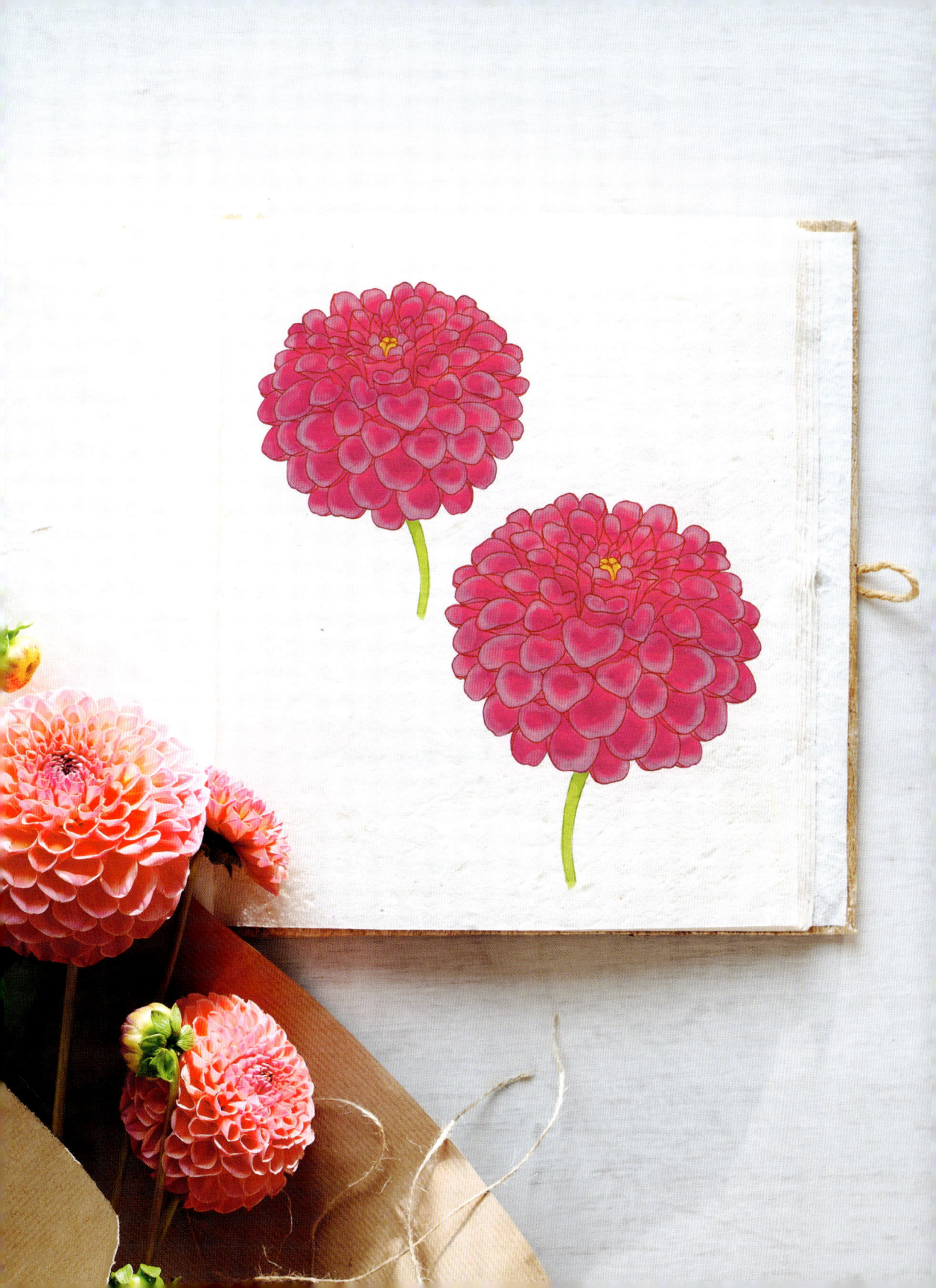

# When folding gets extreme

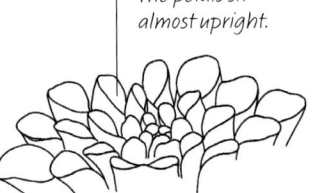

**1**  Start by drawing the cluster of petals at the very top of the flower. Here the petals are small, closed and sit tightly together.

**2**

From there the petals gradually open and get larger, resembling small tubes with slightly bent edges.

*The petals sit almost upright.*

**3**

Add the next layer of petals below the first. Here the petal shapes are similar to those in Step 2, but the petals open up more. The petals facing the viewer have a soft, heart-shaped opening, and are not as upright as the previous layer.

*The petals tilt at roughly 45 degrees.*

**4**

For the final layer the petals are more open with a small dip at the top. They're still heavily concave so be sure to add visible folds on the sides. Add curved parallel lines for the stem.

**5**

Use small strokes to accentuate the roundness of the opening of the tubes by shading parallel to the edge of the petal – instead of from the centre of the petal. Add small perpendicular shading lines coming from the top of the petal to highlight the small dip there.

# Layering colours with alcohol markers

The shadows inside each of the folded petals give this bloom its signature three-dimensional look, and using alcohol markers is an alternative to using watercolours or water-based markers to create the effect of the shadow seamlessly blending into the adjacent lighter parts of the petal. Use alcohol markers in a well-ventilated space and, since they have a tendency to bleed through the paper, make sure to protect your work surface.

### EXTRA KIT

- Paper suitable for alcohol markers (ideally with a bleed-proof coated back)
- Alcohol markers: yellow, pink, green
- White gel pen for highlights
- Red ink pen for outlines

## 1

Start by colouring each part of the flower with a single colour: yellow at the flower centre; pink for the petals; and green for the stem. Use light strokes to avoid oversaturation, and don't worry if you get streaks: as soon as the colour sets into the paper it will lay perfectly flat.

## 2

Once dry, apply the same colours again, but only in areas of shadow. Focus on the top of the stem, the side and hollow part of the petals and the top sections of the centre. Work by small increments instead of colouring too dark too soon.

## 3

Let dry again, then ascertain whether there are areas that need another coat to further deepen the shading.

## 4

Once you're happy with the colouring, use a white gel pen to add highlights to the edges of the petals. Finish by accentuating the outline with a red ink pen, which will harmonize well with the pink.

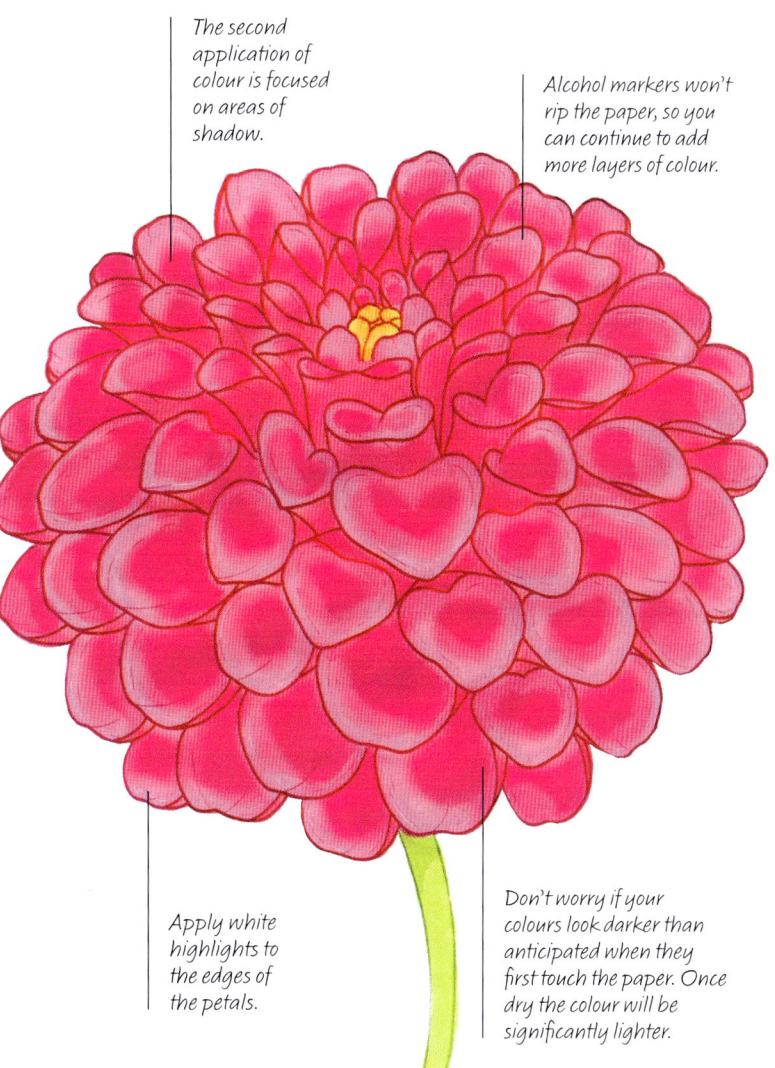

*The second application of colour is focused on areas of shadow.*

*Alcohol markers won't rip the paper, so you can continue to add more layers of colour.*

*Apply white highlights to the edges of the petals.*

*Don't worry if your colours look darker than anticipated when they first touch the paper. Once dry the colour will be significantly lighter.*

*Pompom dahlia: Dahlia* **87**

# Rose (Rosa)

Roses are the queens of the garden and, despite being one of the flowers we're the most exposed to during our lives, they're also arguably one of the trickiest subjects to draw. Part of the fascination we have with these flowers might come from the fact that we can't fully grasp the dynamics of their beauty, because we are overwhelmed by the number of petals they have and how tightly they interact with each other. There's no way to sugarcoat it: drawing roses is difficult, and there is nothing in their design to make the illustrator's job easier. However, that doesn't mean they're impossible. The key here is to work in small increments, be patient with yourself and trust the process.

Once you've mastered the technique, be sure to include roses in all your romance-related art, since they are a universal symbol of love and affection.

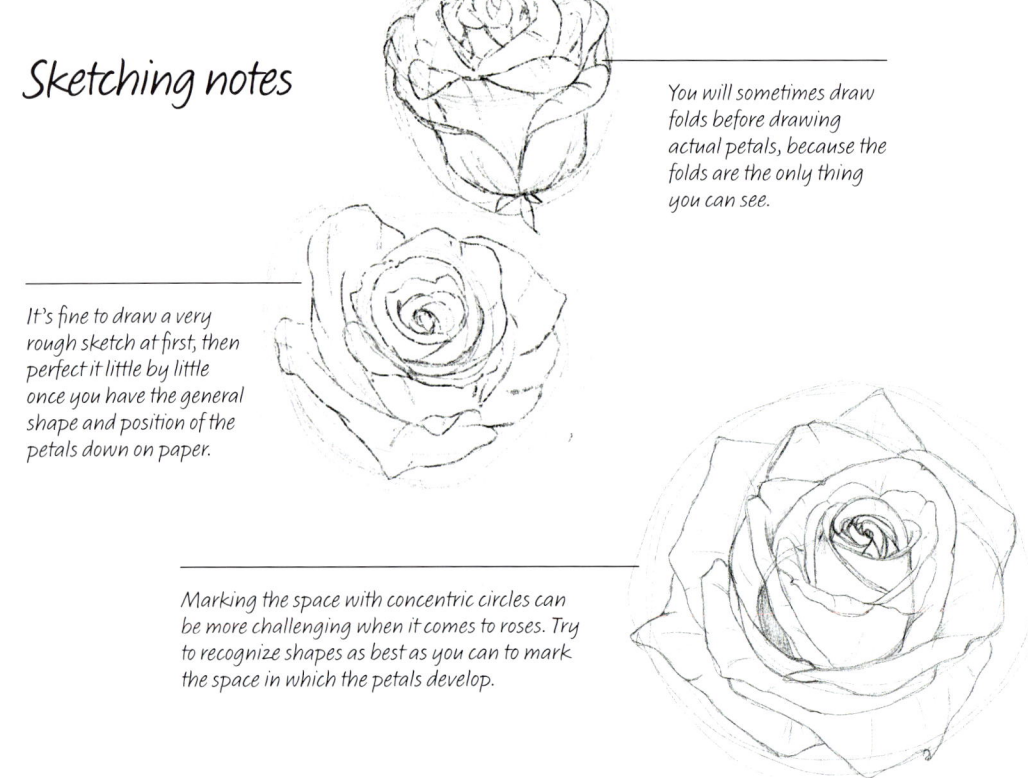

## Sketching notes

You will sometimes draw folds before drawing actual petals, because the folds are the only thing you can see.

It's fine to draw a very rough sketch at first, then perfect it little by little once you have the general shape and position of the petals down on paper.

Marking the space with concentric circles can be more challenging when it comes to roses. Try to recognize shapes as best as you can to mark the space in which the petals develop.

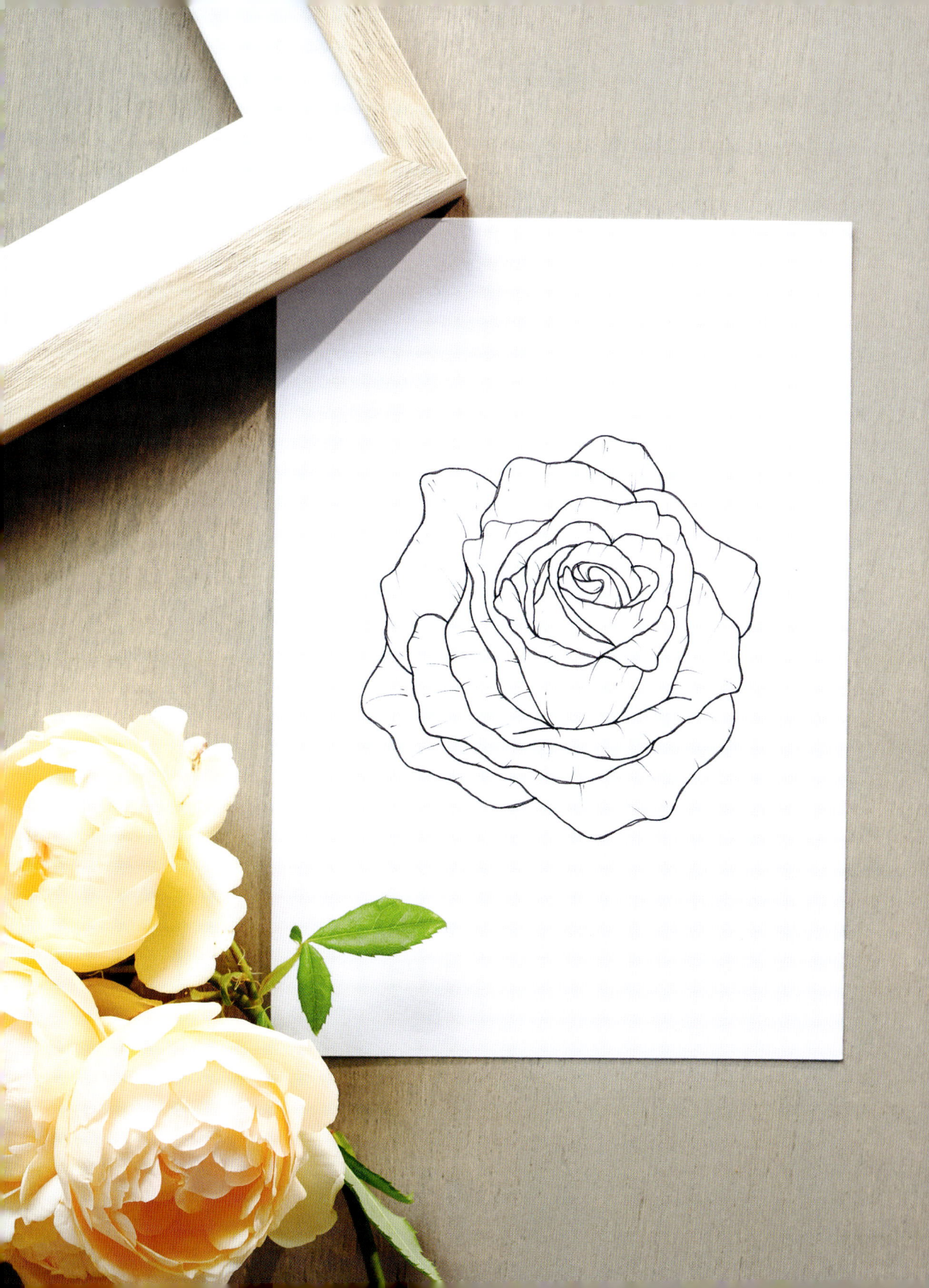

# Patient layering

## MARKS

 Mid-depth single curves to build up the petal shapes

 Wavy lines for the edges of the larger petals

More waves as the petals get larger

Double curves for folds

**1** Start with the central, tightest whorl of petals. Draw a curve with a small drop at the end.

**2** From the drop, draw three more curves: a short one that connects the drop to the line; a long one that goes all the way around; and another short one in the opposite direction.

*This short line connects the long line to the spiral.*

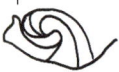

**3** Close this gathering of petals with a long, wobbly line that connects the three loose ends of the lines drawn so far. Add another small line to close the gap on the left.

*This petal wraps around the central whorl.*

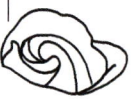

**4** From the far left, draw a curve with some dips to encapsulate everything you've drawn so far.

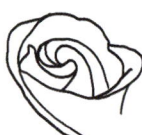

**5** From the side of the big back petal, draw a thin curve running diagonally across the drawing and a short line coming down from the other side, indicating that what was drawn before was actually the fold of the petal underneath.

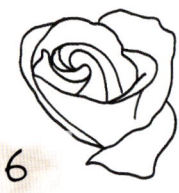

**6** Create another wraparound petal, this time on the right side and with another small fold underneath it.

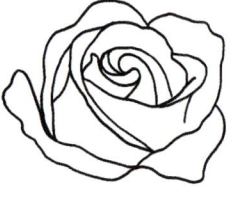

**7** Move to the other side and make a short curve coming down from the long diagonal fold, suggesting the plump shape of the very centre of the rose. Draw another wraparound petal with a fold on the opposite side.

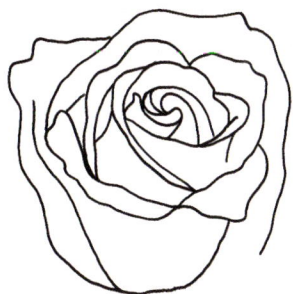

**8**

The method is to draw folds and work your way down on the petals, so continue wrapping petals tightly around the centre, moving a little lower to show how tall and protruding the central part of the rose is.

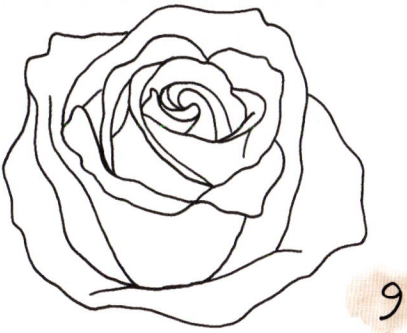

**9**

Now the drawing looks like a rose. Add more thin petals on the side. From now on, only the tips of the petals will be visible, so that's what you will be drawing.

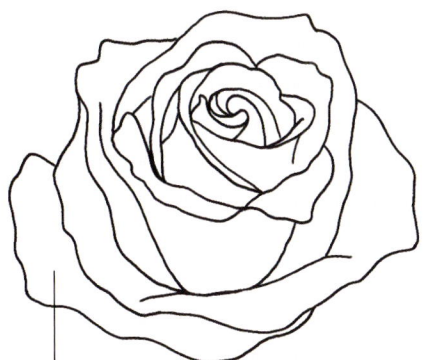

**10**

Add another round of petals. Keep them long and wobbly.

Each petal should occupy approximately one-quarter of the overall circumference of the drawing.

*The curves now tend to be a little pointier.*

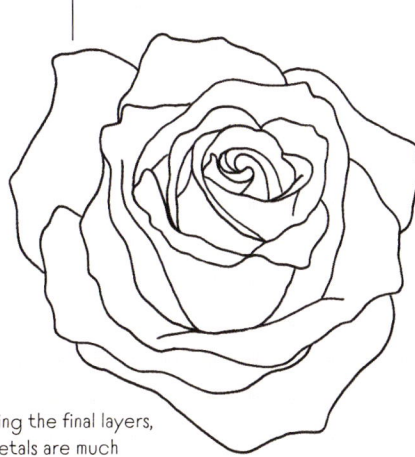

**11**

You're reaching the final layers, where the petals are much smaller in length but overall wider in dimension.

### BIANCA'S TIPS

- Rose petals sit together very tightly, so sometimes all you will see is a sliver of petal.

- The central whorl of petals is often the trickiest and most time-consuming part of the drawing.

- Standard rose petals always fold outwards.

- Roses are challenging but don't be afraid of them. As with every other flower drawing, they only need practice.

**12**

After all of this work, shading is probably the last thing on your mind! You can omit it entirely, switch to a smaller nib and work with very thin and sparse shading lines or take the challenge up a notch and go full shading. The choice is yours.

# Hydrangea (*Hydrangea*)

The hydrangea is a large shrub that grows in many gardens across the globe, and it's one of the most common multiheaded flowers, meaning that it's not a single flower but a round-shaped cluster of many small flowers. Recreating the shape of one of the small flowers is not difficult at all; what challenges the artist is how many and how closely packed together they are, taking the overlapping of petals to a whole new level. Nevertheless, drawing a hydrangea is a rewarding experience, offering a chance to really capture how intricate nature can be. The whole process can be helped by sourcing a high-resolution reference photograph and following it as diligently as possible.

The hydrangea has a strong stem and broad leaves, which makes it a perfect centrepiece flower for cards, wall art and any designs that favour a vertical layout.

## Sketching notes

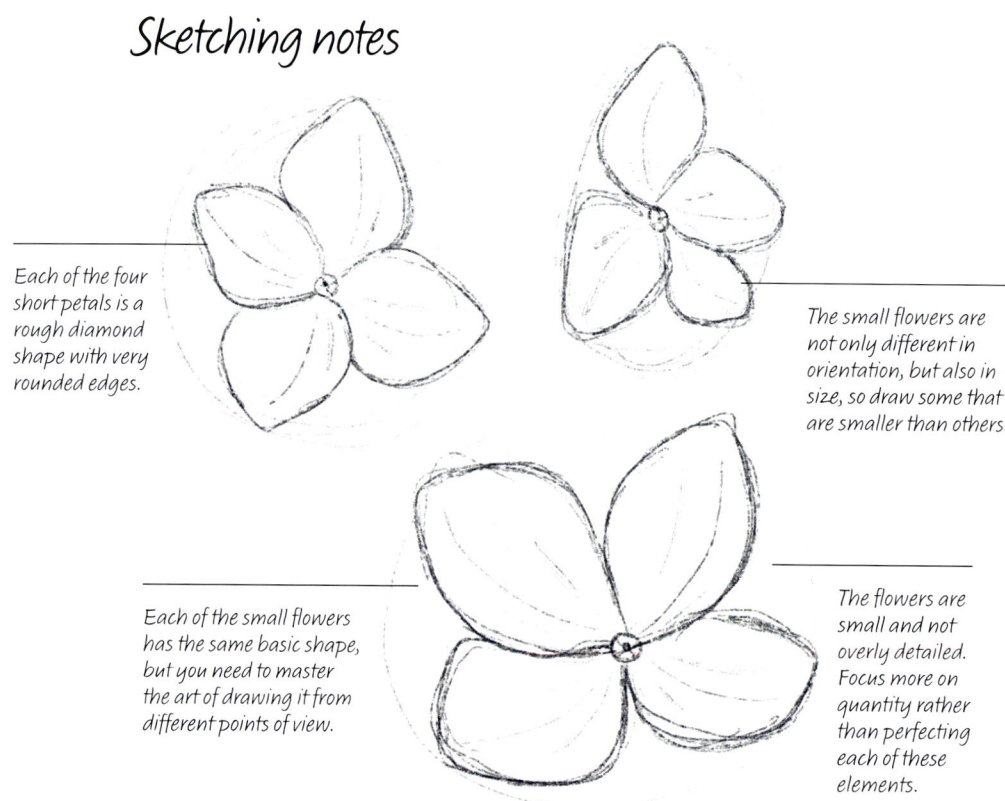

Each of the four short petals is a rough diamond shape with very rounded edges.

The small flowers are not only different in orientation, but also in size, so draw some that are smaller than others.

Each of the small flowers has the same basic shape, but you need to master the art of drawing it from different points of view.

The flowers are small and not overly detailed. Focus more on quantity rather than perfecting each of these elements.

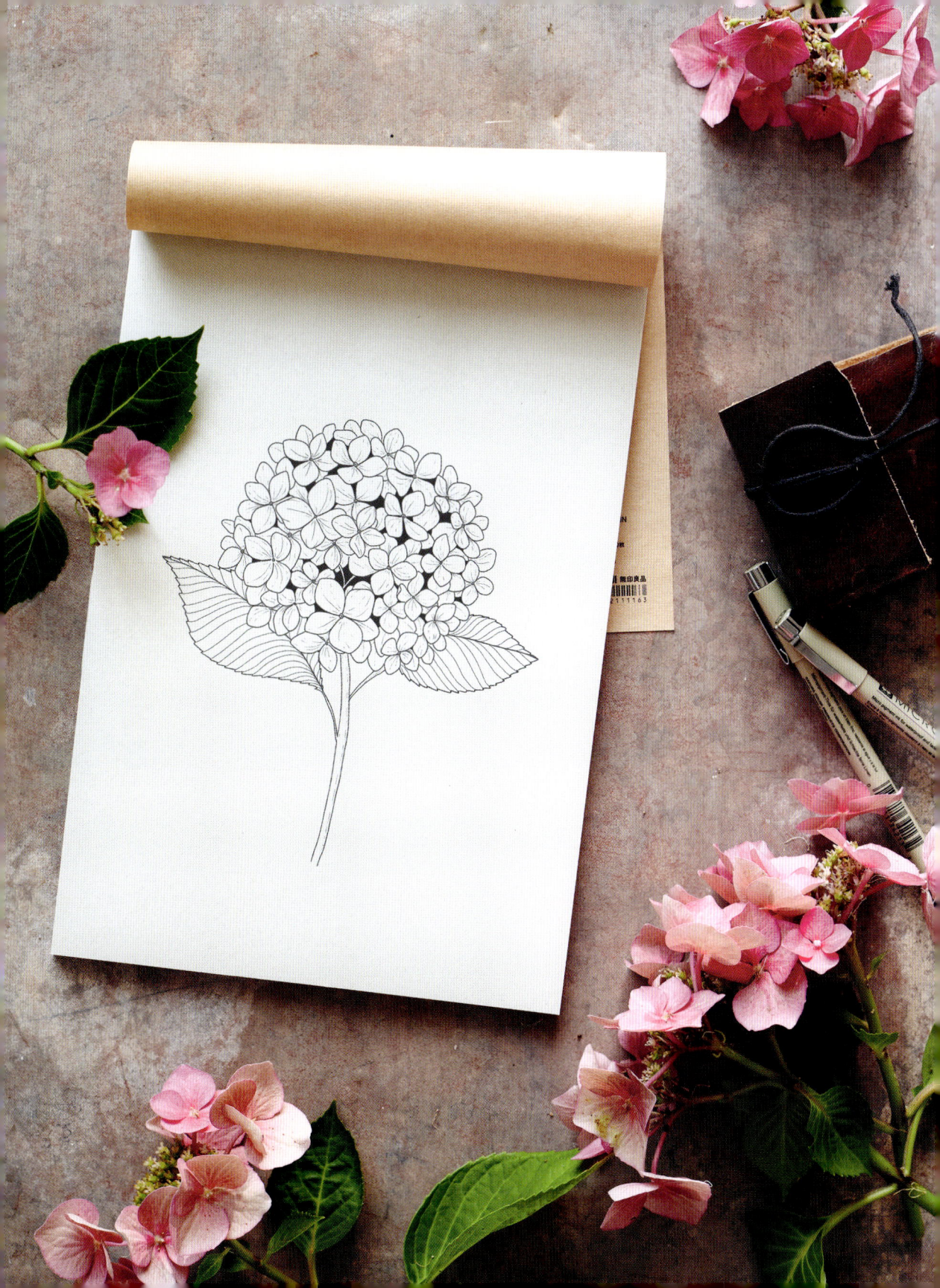

# Drawing a flower made of flowers

## MARKS

( )  Open curves with a wider belly for the petal shapes

O · ×  Tiny circles with a cross inside make up the smaller flowers' centres

ʃ  Zigzag lines to depict the edges of the leaves

## 1

Since it's such a structurally layered plant, drawing a hydrangea calls for a more extensive planning phase than with other blooms, in order to make sure you know exactly where to put the flowers to achieve the overall round shape. In pencil, first draw an irregular large circle, then place small circles inside it to position the outermost layer of flowers. Leave some gaps in between to allow space for the lower level to peek through.

*To help you establish the success of the composition, draw in the stem and a couple of leaves to frame the drawing.*

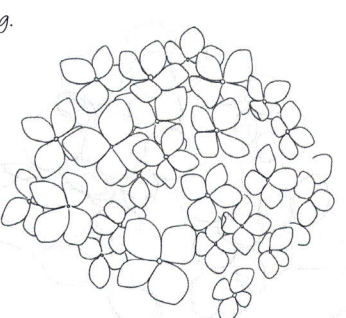

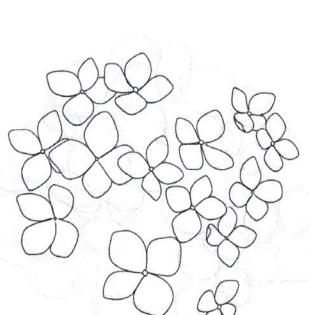

## 2

The flower itself is not difficult to replicate, you just need a good dose of patience and trust in the process. Start by drawing the flowers that are fully visible, turning and folding the petals according to their position. The flowers at the front will be more open, while the ones towards the edges will turn upwards, backwards or sideways.

## 3

Draw in the flowers immediately beneath those drawn in Step 2. Not all of their petals will be visible. Add some that overlap with the previous layer. At this stage there will still be some gaps in the overall composition of the whole flower head.

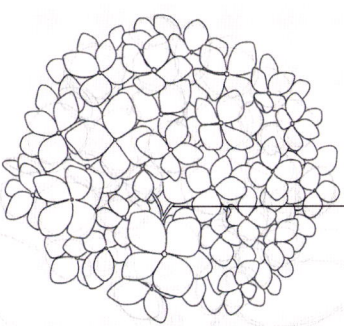

*Draw some of the
smaller stems
that are visible
within the bigger
flower head.*

4

Now that most of the small flowers
are in place, it's time to fill the gaps.
This time you can only draw petals
here and there, peeking out from
between other flowers and along
the edge of the drawing. Add more
and more petals until you're satisfied
with the lushness of your hydrangea,
while also trying not to overdo it or
overcrowd the drawing.

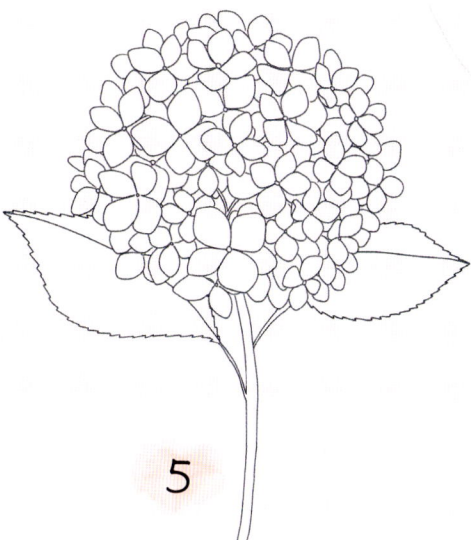

5

Once you're happy with the flower
head, draw the outline of the saw-edged
leaves and the thick stem.

## BIANCA'S TIPS

- Despite how big the flowers are,
  hydrangea branches are often
  very light, so try to convey this
  through your drawing.

- When distributing the single
  flowers, try not to create a
  perfect pattern but scatter
  them in small clusters to obtain
  a more organic effect.

- Remember that the success of
  this drawing is in how the flower
  looks as a whole, rather than
  how perfect each one of the
  small flowers is.

- For the leaves, let the shading
  line connect the central vein to
  the dip of each one of the small
  spikes of the zigzag edge.

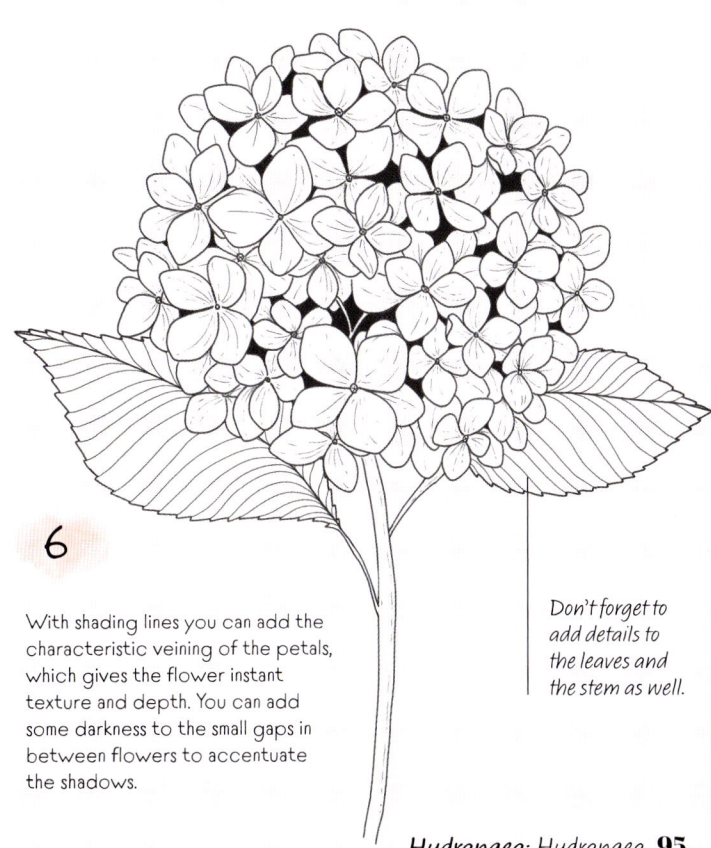

6

With shading lines you can add the
characteristic veining of the petals,
which gives the flower instant
texture and depth. You can add
some darkness to the small gaps in
between flowers to accentuate
the shadows.

*Don't forget to
add details to
the leaves and
the stem as well.*

*Hydrangea:* Hydrangea **95**

# Peony *(Paeonia)*

With their big petals, plump shape and blush colours, peonies have quickly grown in popularity and are now among the most chosen flowers for luxurious bouquets. They're soft and fascinating, with petals so tight in the centre it seems as if they're hiding a secret that your eyes can't see.

When it comes to botanical illustration, peonies are a common yet complex subject. They ask you to remember all the main botanical drawing techniques – how to work with shapes, how to overlap and fold petals, how to work without an exposed centre and how to deal with a multilayered flower – so drawing them requires all your focus and patience. Let's take everything you've learned and put it into action drawing your first beautiful peony.

## Sketching notes

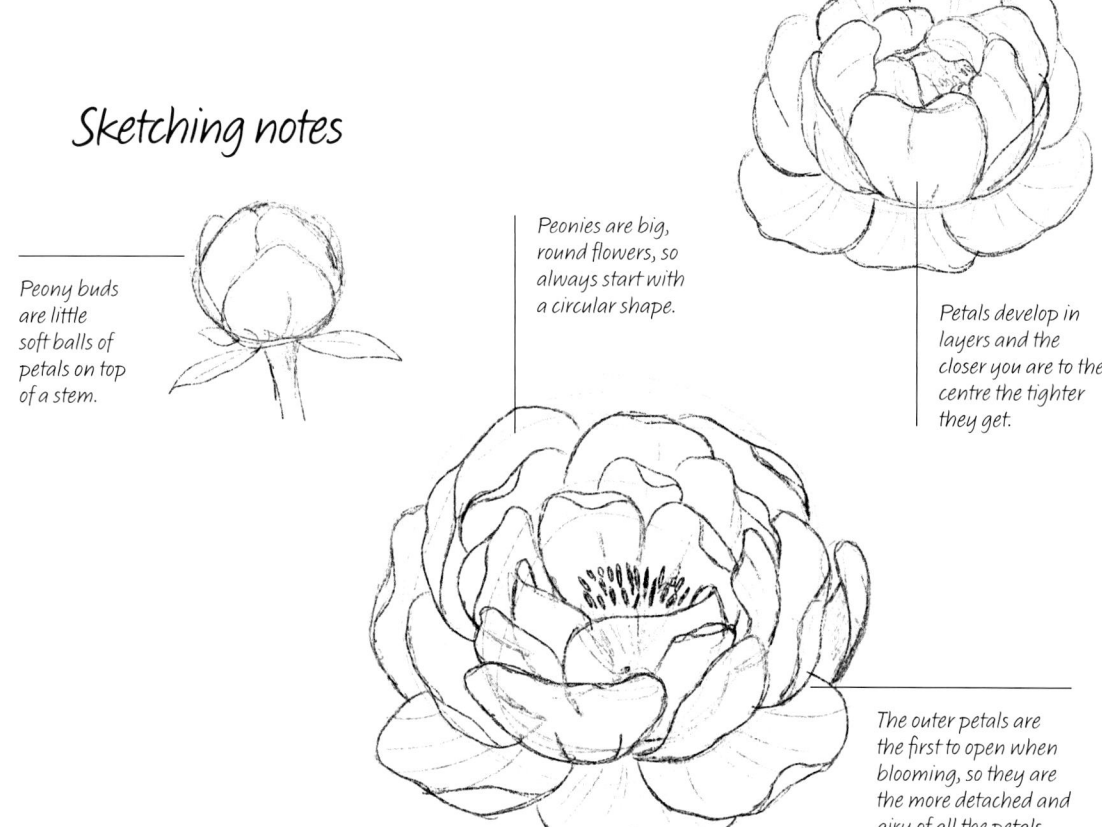

Peony buds are little soft balls of petals on top of a stem.

Peonies are big, round flowers, so always start with a circular shape.

Petals develop in layers and the closer you are to the centre the tighter they get.

The outer petals are the first to open when blooming, so they are the more detached and airy of all the petals.

# Combining botanical drawing techniques

*1*

Since the true centre of the peony is hidden, start by drawing an oval around which you will construct the innermost petals. Those petals are small and all face towards the centre, so will have four different angles.

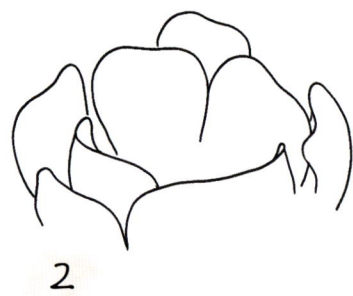

*2*

Add four more petals for the next layer, keeping in mind the curvature of each one.

## MARKS

Shallow dips at the top of the petals

Double curves for folds

Short lines with drop tips for the stamens

## BIANCA'S TIPS

- Peony petals develop in layers and are small and tight when close to the centre, becoming fewer and bigger with each outward layer.

- Some peonies have an exposed yellow centre, while others don't – it depends on the type of peony and its stage of blooming.

- Peonies are significantly bigger than most flowers, so keep that in mind when arranging them in a drawing with different kinds of flowers.

- Be aware that drawing a very rounded central whorl of petals with open leaves to the sides could result in a cabbage-looking peony!

*3*

Continue adding petals around the previous layers. These petals will be bigger and more open each time. In some cases you'll only see the back, the front or the side of the petal.

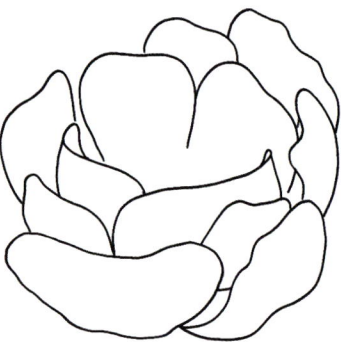

*Make sure to maintain a generally spherical shape.*

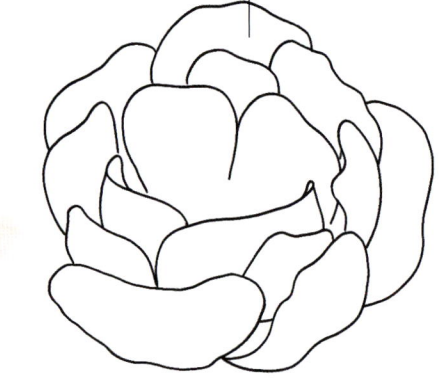

*4*

Continue wrapping petals around petals.

**5**

The petals are bigger now and, at this point, only peek out from the main body of the flower.

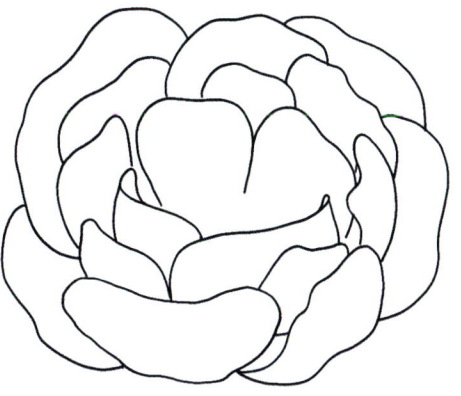

*The peony is a very tight flower, so petals tend to overlap and fold onto each other.*

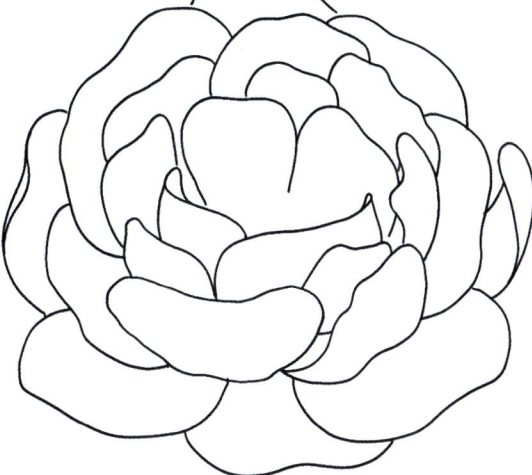

**6**

Add the outermost petals, which will be significantly flatter and more open than the others, providing a base for the whole flower.

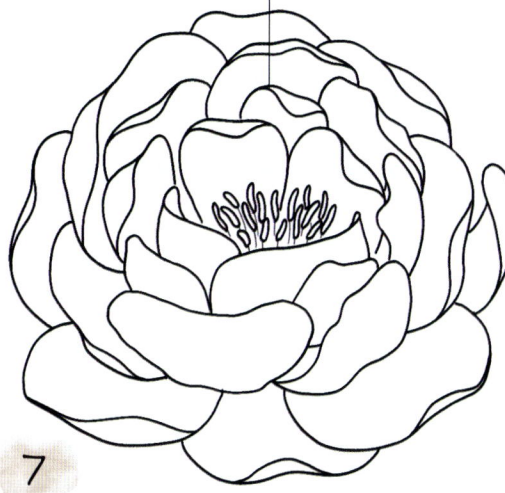

**7**

When you're satisfied with the shape and positioning of the petals, add folds to create movement. It's also time to add the stamens peeking out from the centre of the peony.

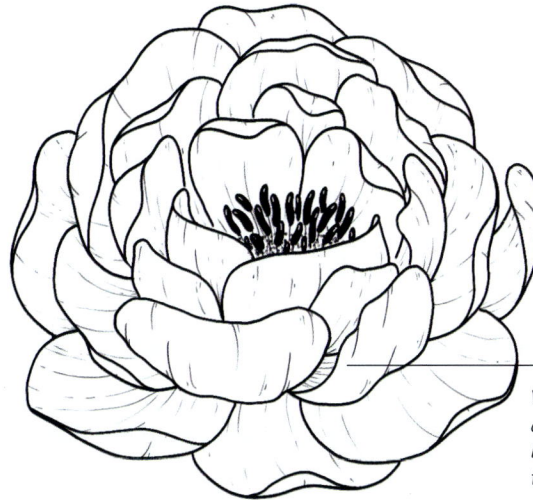

**8**

Switch to a smaller nib and work the shading with as much detail as you wish.

*With so many overlaps, completing your peony can be a good exercise in shading to create depth.*

# Leaves

Leaves are the essential companion to your flowers. Both in nature and in bouquets, flowers always come with greenery, so they should in your drawings too. You can add leaves, individually or on stems, to all compositions, from single blooms to borders and patterns, to make them look full and balanced.

Leaves are usually considered in the sketching phase, so that you can decide on optimal size, placement and quantity. However, a leaf or two can also be added in the final stages of the drawing, for example, if you notice a gap or negative space you'd like to fill.

## Don't leave your flowers lonely

Leaves are significantly faster and easier to draw than flowers and, since they're not the focus of the drawing, can be repeated in the same style over and over again without looking redundant or boring.

*A light touch of watercolour can instantly lift your leaves.*

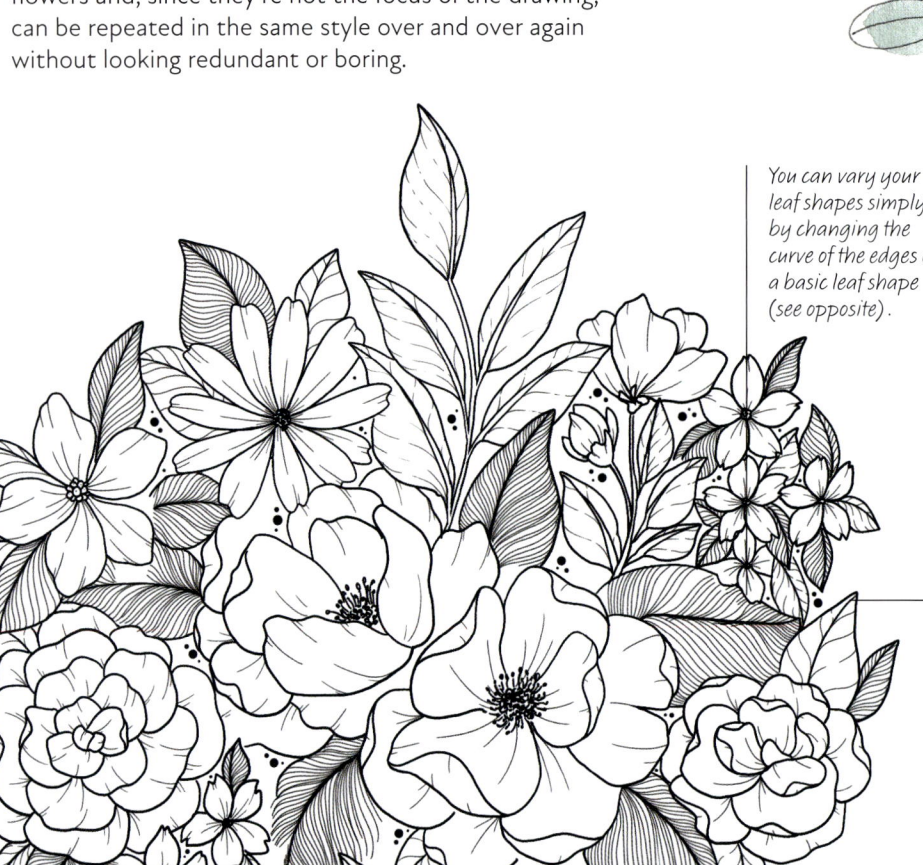

*You can vary your leaf shapes simply by changing the curve of the edges of a basic leaf shape (see opposite).*

*Suggest different types of leaves in an arrangement by using varying densities of shading (see page 103).*

# A simple leaf, with options

A simple leaf shape consists of two symmetrical curves with an elongated long line crossing it in the centre. The main shape usually has two rather pointy ends. You can lengthen the shape to make a thinner leaf, or widen it for a tropical leaf motif.

Master this simple shape and use it is a base from which you can develop more interesting types of leaf.

Add lots of small spikes around the edges to turn it into a leaf from a rose bush.

Experiment with the curves on each side of the leaf.

This immediately elevates the leaf to make it look more natural, while also creating visual interest.

Spikes can be rounded for a softer effect.

Give your leaf fluid, loose wavy edges and it will look thinner and longer.

Instead of smooth lines, add small spikes along the edge to create a completely new leaf from the same basic shape.

# Developing muscle memory

The more effortless your hand movement is, the better and more organic your leaf drawing will be. The best way to draw leaves is to not overthink the shape, and to let your muscle memory take the lead. There is only one way to improve your muscle memory: practice. The more you practise, the easier the drawing technique will become.

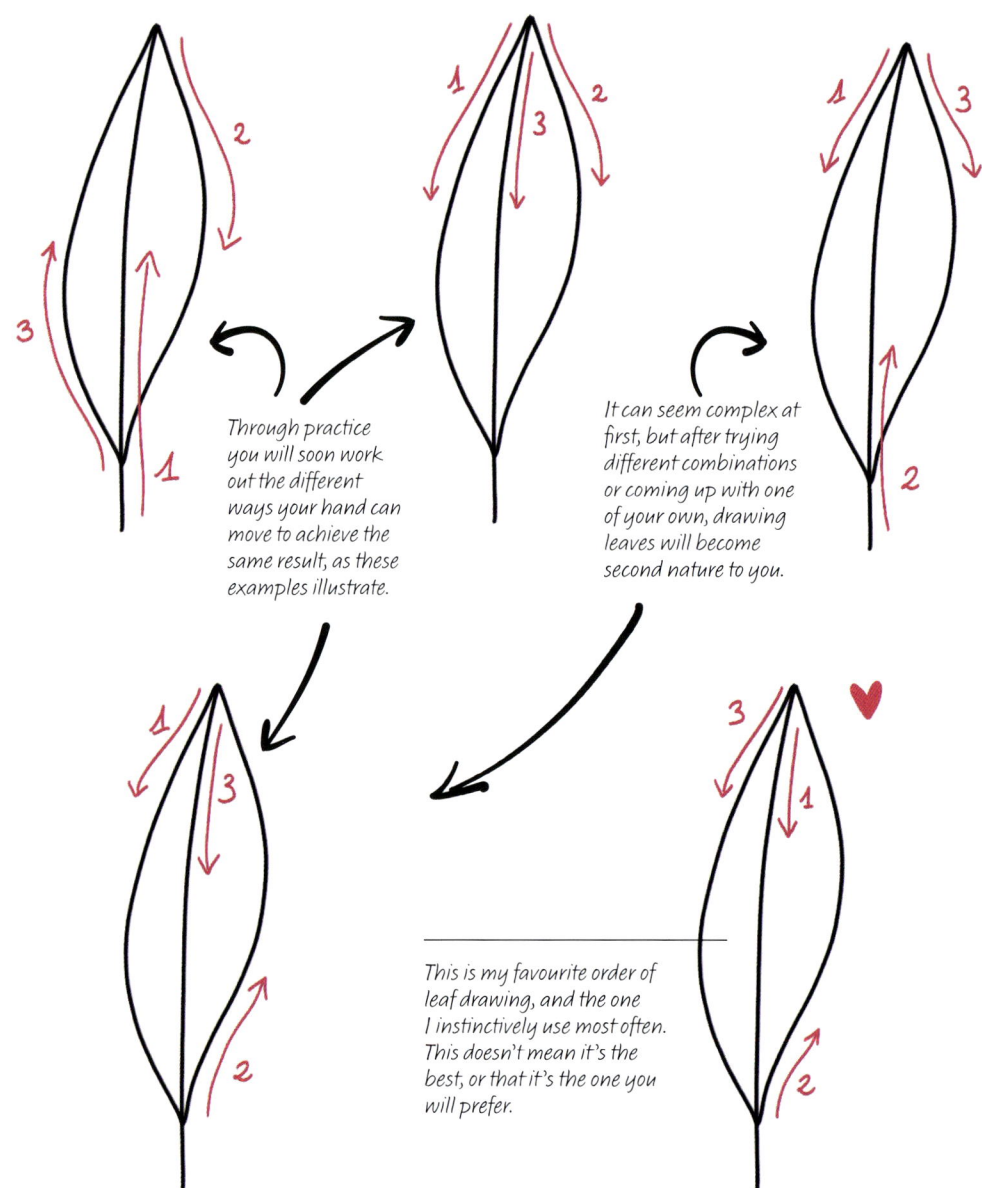

Through practice you will soon work out the different ways your hand can move to achieve the same result, as these examples illustrate.

It can seem complex at first, but after trying different combinations or coming up with one of your own, drawing leaves will become second nature to you.

This is my favourite order of leaf drawing, and the one I instinctively use most often. This doesn't mean it's the best, or that it's the one you will prefer.

# Shading leaves

Having decided on the shape of your leaf, you can add shading to bring it to life. As always, you can choose to keep your shading simple, or go all out and pick a highly detailed approach, depending on the style you want to achieve.

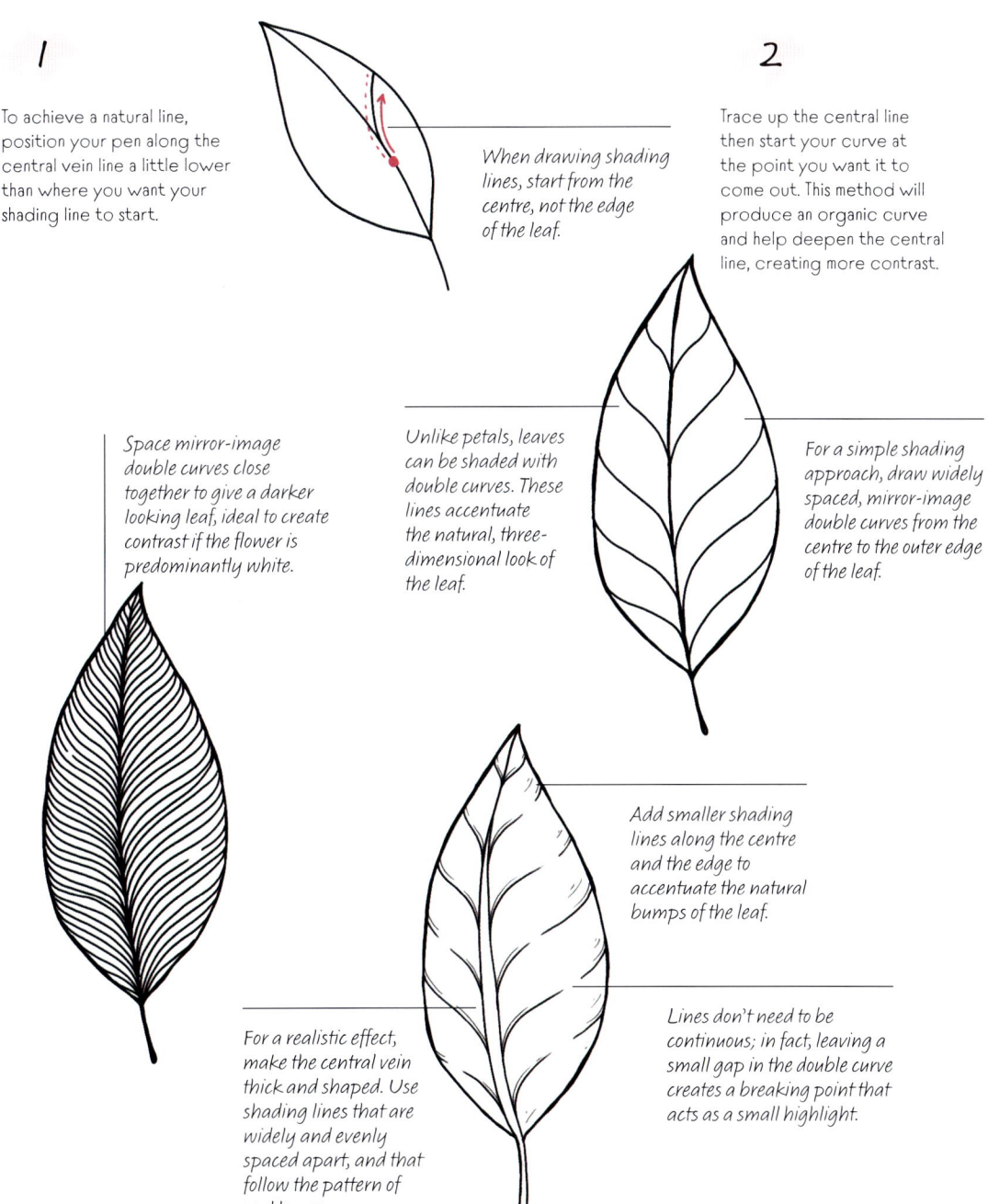

## 1

To achieve a natural line, position your pen along the central vein line a little lower than where you want your shading line to start.

*When drawing shading lines, start from the centre, not the edge of the leaf.*

## 2

Trace up the central line then start your curve at the point you want it to come out. This method will produce an organic curve and help deepen the central line, creating more contrast.

*Space mirror-image double curves close together to give a darker looking leaf, ideal to create contrast if the flower is predominantly white.*

*Unlike petals, leaves can be shaded with double curves. These lines accentuate the natural, three-dimensional look of the leaf.*

*For a simple shading approach, draw widely spaced, mirror-image double curves from the centre to the outer edge of the leaf.*

*Add smaller shading lines along the centre and the edge to accentuate the natural bumps of the leaf.*

*For a realistic effect, make the central vein thick and shaped. Use shading lines that are widely and evenly spaced apart, and that follow the pattern of real leaves.*

*Lines don't need to be continuous; in fact, leaving a small gap in the double curve creates a breaking point that acts as a small highlight.*

# Small-scale flowers

Whether you're working on a journal spread, a small card, or any project that doesn't call for large, fully fledged flowers, being able to scale down and draw beautiful small flowers will come in handy.

## Keep it simple

The secret to successfully drawing flowers on a small scale is to simplify and go back to the very essence of the flower, drawing only what's absolutely necessary to make it recognizable. This goes for ink and shading lines alike, because flowers drawn on a small scale don't have a lot of white space to fill, and too much inking or shading could result in a muddy mess of lines, taking away from the beauty of the flower.

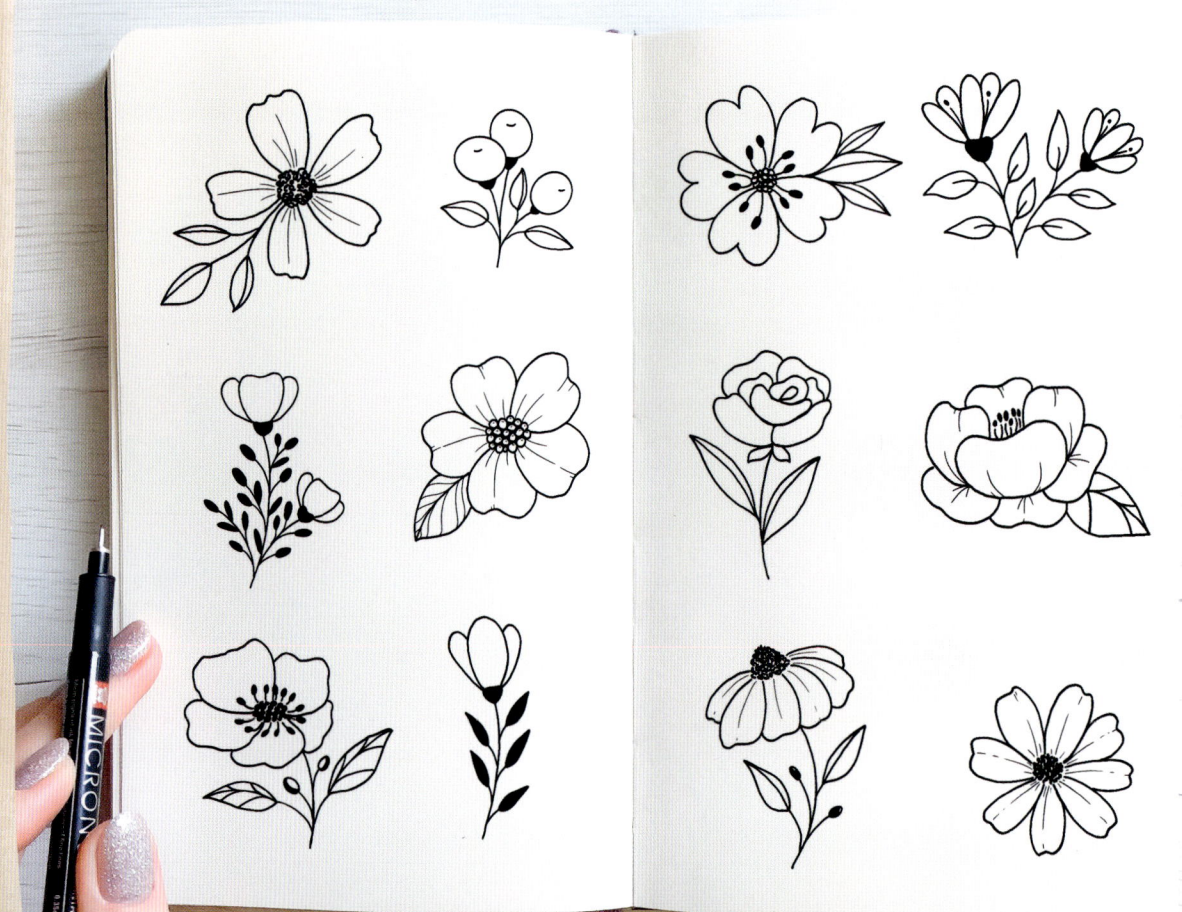

# Less is more

Using all of the techniques you learned in this chapter, and taking a less-is-more approach, you can draw small-scale flowers like the ones on the following pages. Pencil sketching can be useful at first, especially to get accustomed to the dynamics of the small-scale flower but, once you're confident enough, you can ditch the pencil and go in directly in pen to make the process even faster.

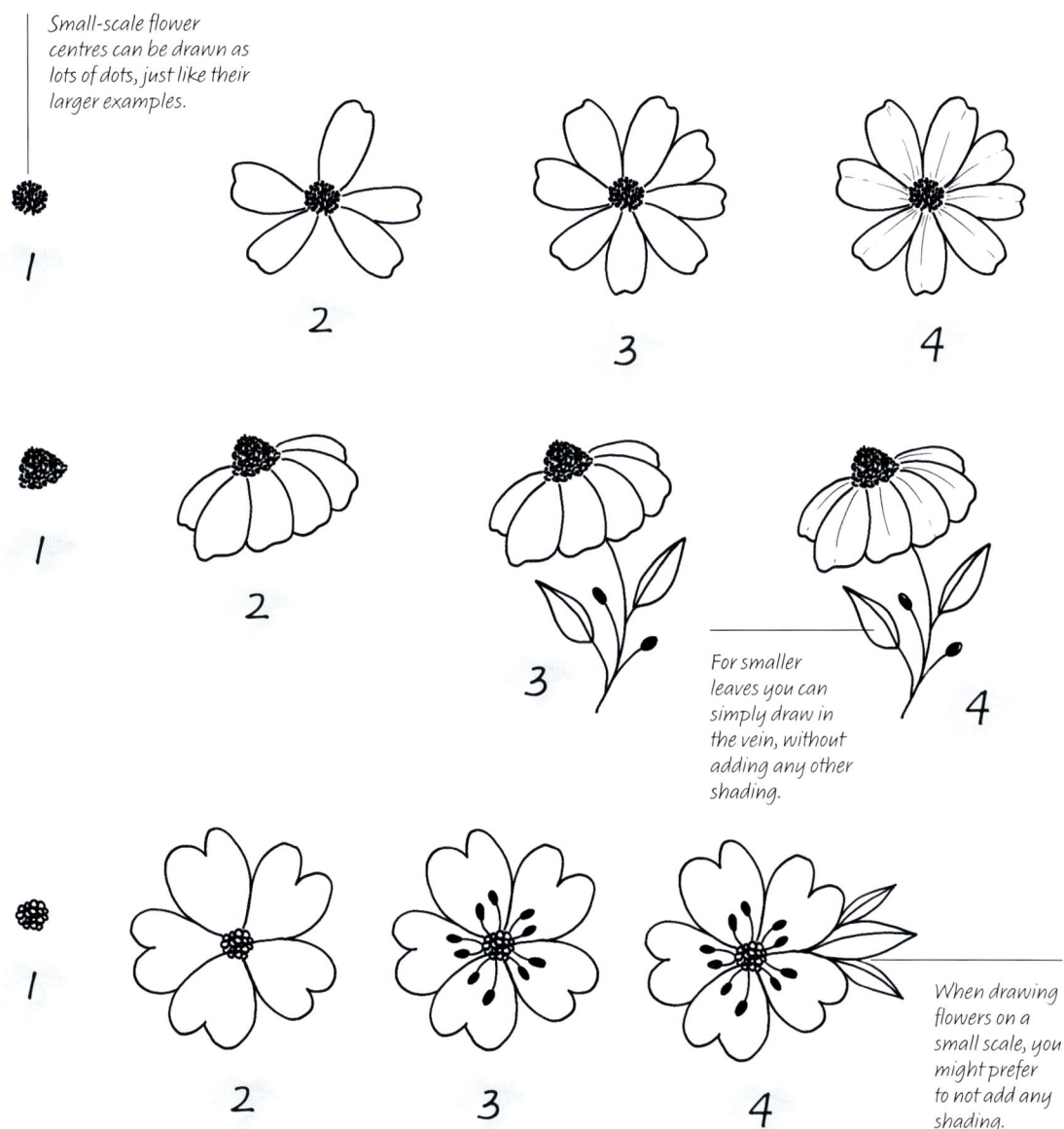

*Small-scale flower centres can be drawn as lots of dots, just like their larger examples.*

*For smaller leaves you can simply draw in the vein, without adding any other shading.*

*When drawing flowers on a small scale, you might prefer to not add any shading.*

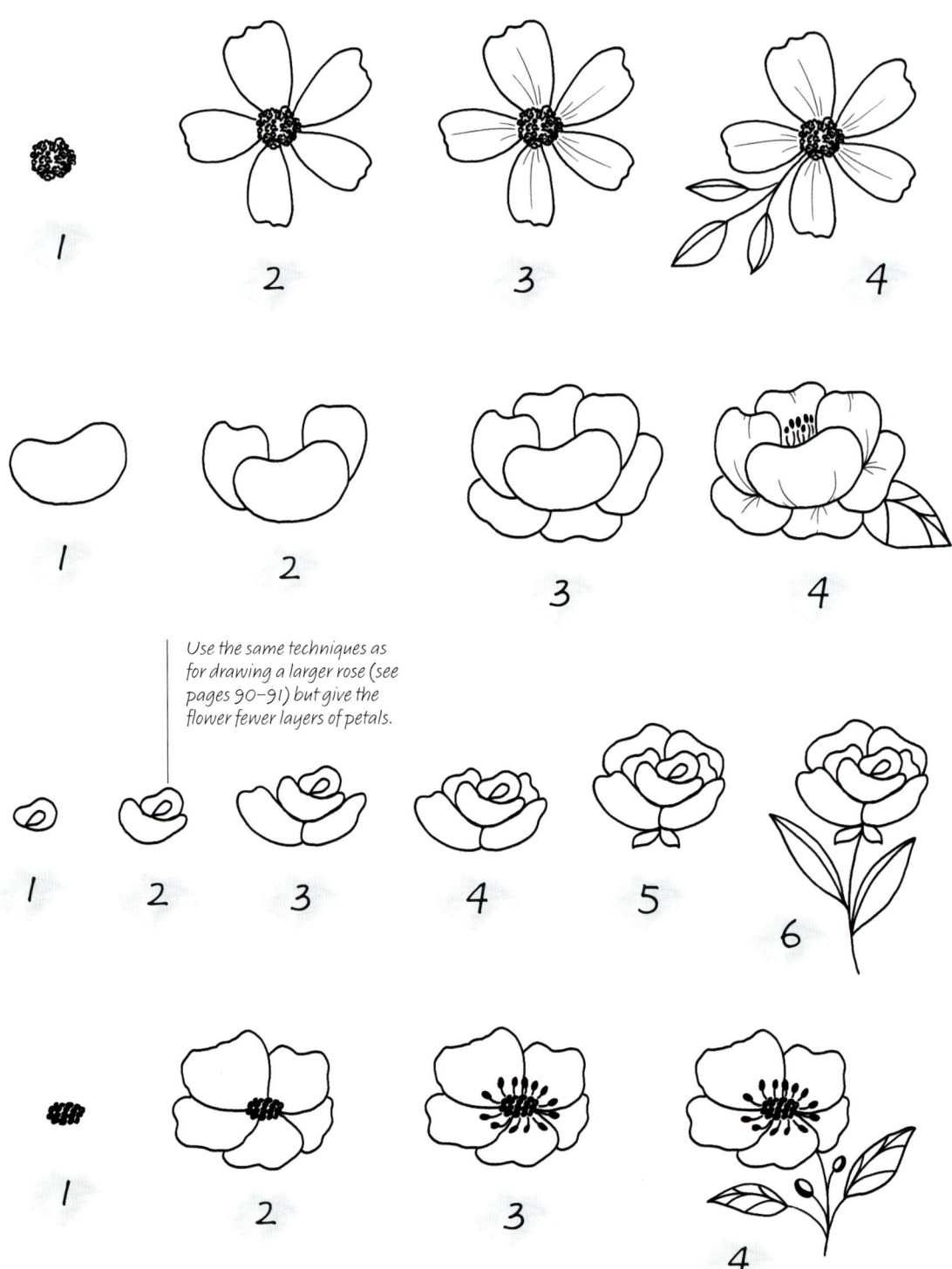

Use the same techniques as for drawing a larger rose (see pages 90–91) but give the flower fewer layers of petals.

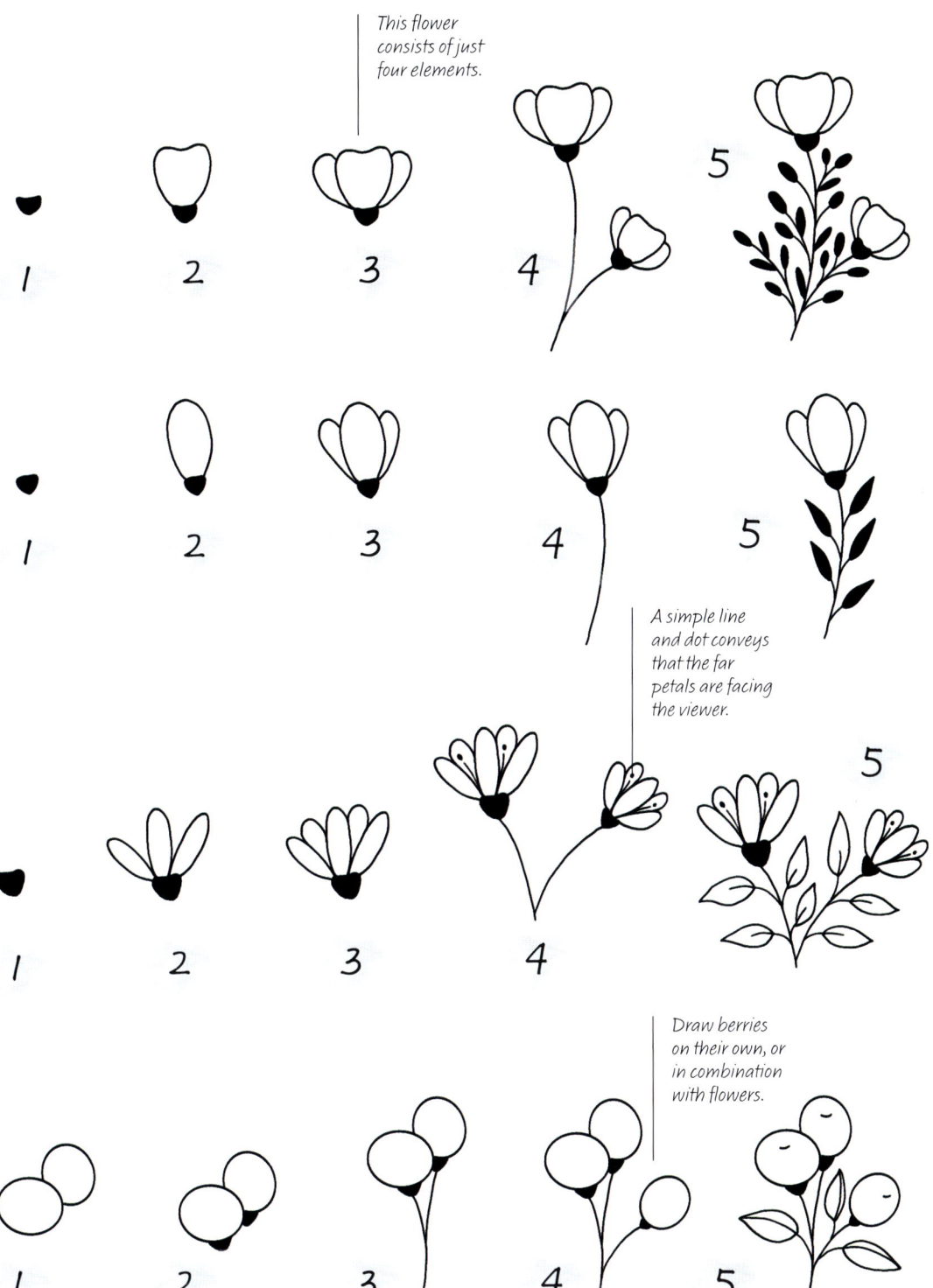

This flower consists of just four elements.

1   2   3   4   5

1   2   3   4   5

A simple line and dot conveys that the far petals are facing the viewer.

1   2   3   4   5

Draw berries on their own, or in combination with flowers.

1   2   3   4   5

# About composition

Before we move on to using everything we have learned about drawing flowers for decorating journals, personalizing stationery and creating wall art, we should take some time to think about how we will put it all together.

The word composition describes the way elements are arranged and interact with each other in a drawing. It comes into play every time you decide to draw something that's not a single flower, and it's the necessary backbone of any good piece of art. Composition is to drawing what plotting is to fiction writing: it's the framework upon which everything is built, a compass that drives every single stroke in the right direction.

A beautiful and complex drawing doesn't just happen by itself. The more effortless a drawing looks, the more effective the composition stage has been, and good composition is apparent when everything looks natural and spontaneous and the various elements fit together perfectly.

Despite it being such a pivotal stage in the drawing process, composition is often viewed as a burden instead of an essential skill to develop, and may therefore be skipped by beginners because it postpones the actual drawing stage and requires an extensive level of planning, especially for bigger projects. Generally speaking, the bigger and more complex the drawing, the longer the composition and planning stage should be. But the good news is that, as soon as you're done with it, you can immerse yourself in the fun of drawing without having to think too much about anything else.

Good composition is also a time saver: spending time in the beginning mapping out the drawing prevents you from being unsatisfied with your work and having to discard it and start again later on.

# Things to consider when planning a composition

In depicting botanical subjects we strive to emulate the organic and asymmetrical look of nature, avoiding overly stiff and artificial compositions. To begin the planning stage that will make this happen, there are a few things for you to consider.

## IDEA

Have a clear idea of what it is that you are drawing and take some time to visualize it in your mind. Is it a specific shape? Which flowers will be included? How many? Which colours are there, if any? Are the strokes bold and minimal or delicate and detailed? Does it include non-botanical elements? How are the various elements arranged? Answering these questions will help you clarify your vision and, with the final artwork in mind, the planning stage will be much easier.

## SURFACE

Where are you drawing? Is it on paper? In a journal? On canvas? Or the back of a denim jacket? Is it a coloured surface? Is it smooth or rough? The surface is just as important as your vision, if not more so, since every medium has its strengths and its limitations, so much so that sometimes it becomes the driving factor of the design itself. The drawing and the support live together in an inseparable bond and it's impossible to work on the composition without always keeping the surface in mind.

## IDENTIFY

What elements will make up your drawing? It's a good idea to write a list you can refer back to, and remember to include flowers of different sizes along with some greenery. Bigger is not always better, so start with the bare minimum of elements and think about repeating those you already have rather than introducing new ones.

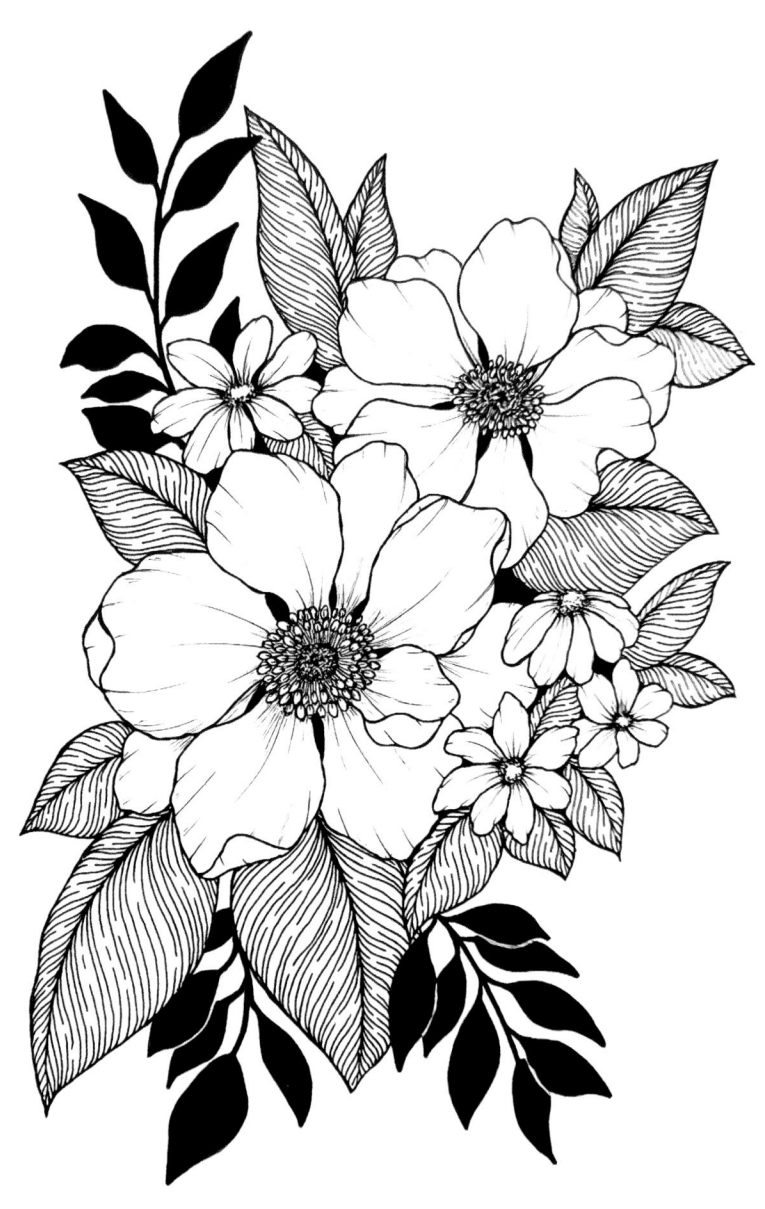

## FOCAL POINT

Choose the star of your drawing, which is usually the main flower. Without a focal point the result could be pattern-like, and the viewer might lose interest. Depending on the kind of composition you're going for (full page, wreaths, geometrical shapes, and so on) there are times when it's natural to position the focal point in the centre, and others when the best choice is to position it slightly off to the side.

## BALANCE VERSUS SYMMETRY

A composition is balanced when the weight of all its elements is evenly distributed and therefore visually appealing. It's balanced when looking at it nothing seems out of place. A composition doesn't need to be symmetrical to be balanced, it can be heavier on one side with other elements to counterbalance it. This is why you always need elements of various dimensions, or the same subject drawn from different angles or in different sizes.

## DEPTH

Colour contrasts, shading, and overlapping of elements all add depth to an art piece that would otherwise feel flat. Depth allows the focal point to really stand out and guides the viewer to the various levels of the drawing.

## UNITY

In a good composition all the elements are connected to each other, giving the viewer a strong sense of unity. No flower should float alone on the page away from the others, and everything should be interconnected by overlapping petals, stems, leaves or foliage. Choosing the perfect filler elements to the focal flowers is key to creating a cohesive composition.

## NEGATIVE SPACE

You don't achieve unity by overcrowding a piece. In fact, empty space is key to good composition. Negative space in a drawing is where the page is left blank, and it can either be around the composition or within it. Negative space declutters the drawing, allowing the drawn elements to stand out better.

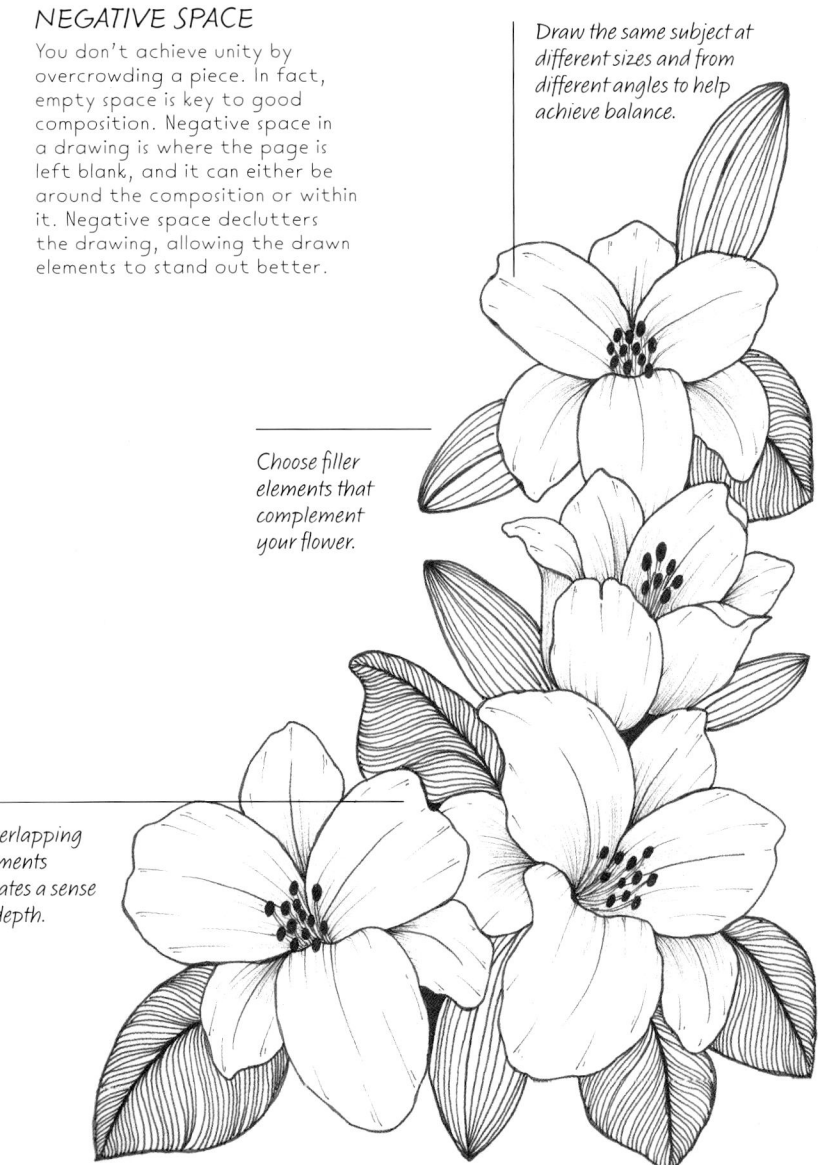

Draw the same subject at different sizes and from different angles to help achieve balance.

Choose filler elements that complement your flower.

Overlapping elements creates a sense of depth.

# Three rules for good composition

When drawing flowers the goal of composition is to achieve visual harmony, so that the drawing is pleasing to the eye and there's nothing to disrupt the viewer's gaze. You can achieve this by following these practical artistic rules.

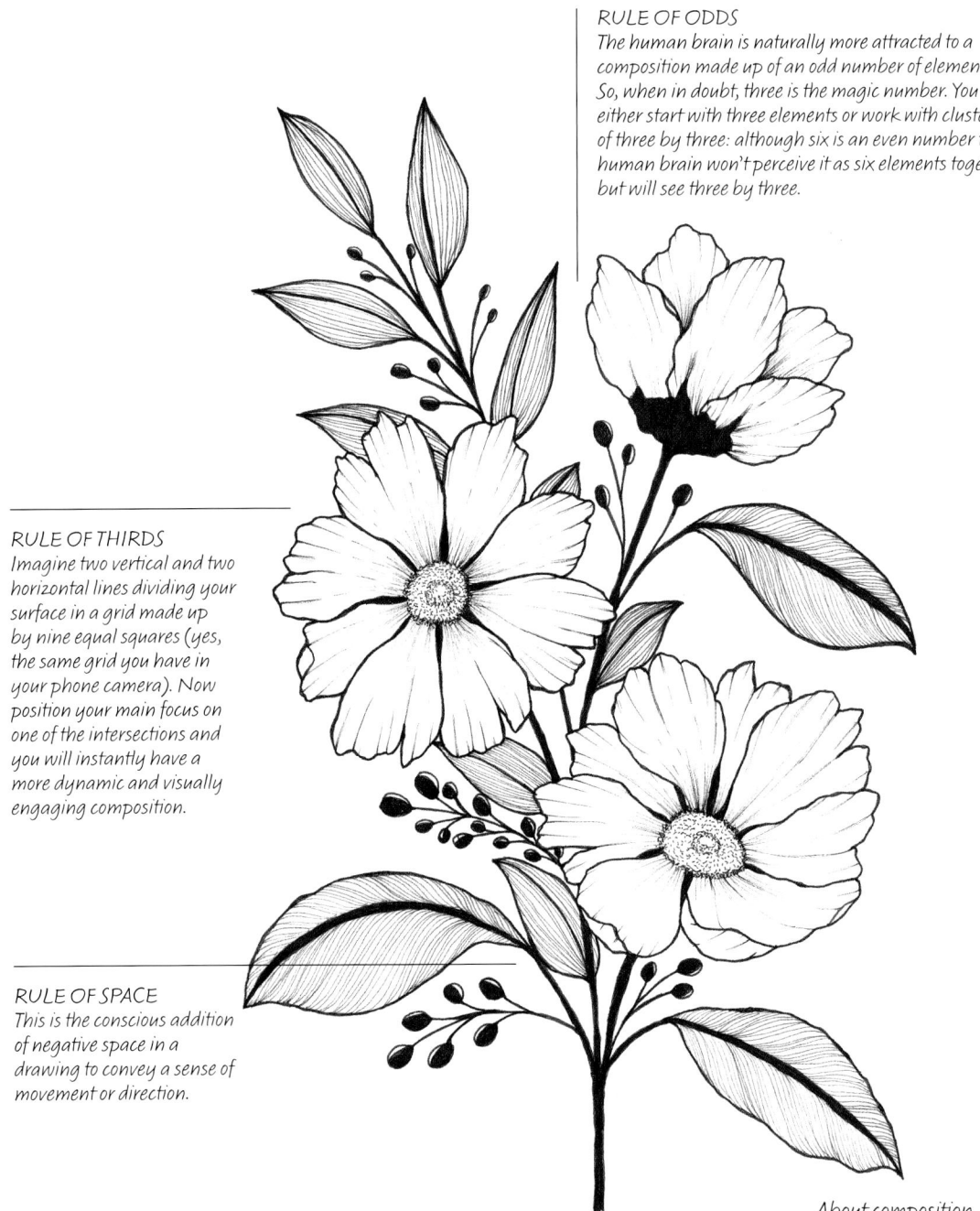

### RULE OF ODDS
The human brain is naturally more attracted to a composition made up of an odd number of elements. So, when in doubt, three is the magic number. You can either start with three elements or work with clusters of three by three: although six is an even number the human brain won't perceive it as six elements together, but will see three by three.

### RULE OF THIRDS
Imagine two vertical and two horizontal lines dividing your surface in a grid made up by nine equal squares (yes, the same grid you have in your phone camera). Now position your main focus on one of the intersections and you will instantly have a more dynamic and visually engaging composition.

### RULE OF SPACE
This is the conscious addition of negative space in a drawing to convey a sense of movement or direction.

# Flowers for journalling, stationery and wall art

# Flowers everywhere

Now it's time to have fun using your new skills and everything you've practised to bring life, elegance and a sense of wonder to your journals, stationery and home decor. In a world that increasingly leans towards the digital, the beauty of hand-written notes and personalized stationery remains unmatched, and by adding a touch of floral illustration you can turn an invitation, a thank-you card or a gift for a friend into a truly original and personal keepsake.

## About journalling

Journalling is a powerful mental health tool that is growing in popularity. It offers a means of self-reflection, stress reduction and personal growth. Incorporating floral illustrations into your journal can infuse your practice with artistic expression and transform your journal into a beautiful garden, making every page a reflection of your unique style and personality.

One particular type of journalling – bullet journalling – has taken the world by storm, offering a creative and organized way to not only navigate your inner world, but also to plan and track daily activities and feelings.

Created by designer Ryder Carroll, bullet journalling is the art of turning a blank (usually dotted) notebook into a fully customized planner with calendars, monthly, weekly and daily logs, to-do lists, trackers, goals and space for thoughts and feelings. You can find out more about the methodology at bulletjournal.com.

You can utilize everything you've learned about botanical illustration to elevate your bullet journal spreads and add a touch of natural beauty that will make them visually captivating.

### BIANCA'S TIPS

- Always start by planning and sketching out the layout of the spread, and think about how the flowers can complement it or fill any blank space, such as borders, headers or as decorative elements around your monthly or weekly layouts.

- Consider the type of paper in your bullet journal and test your artistic medium of choice beforehand, to ensure it doesn't bleed or smudge. Markers and fine line pens are always a safe choice.

- Celebrate the changing seasons by incorporating seasonal blooms and birth-month flowers into your bullet journal spreads.

- Don't be afraid to try new things, embrace variety and remember each spread is an opportunity to explore new designs and push your creative boundaries.

## No limits

Floral illustration can add life and elegance to any stationery design and using botanical elements in this way you can showcase your artistic talent and maybe even start your own art business.

You can add botanical drawings to greetings cards and complementary envelopes; wedding stationery and place settings; notebook or journal covers; calendars, planners and to-do lists; as well as bookmarks, tote bags and framed wall art.

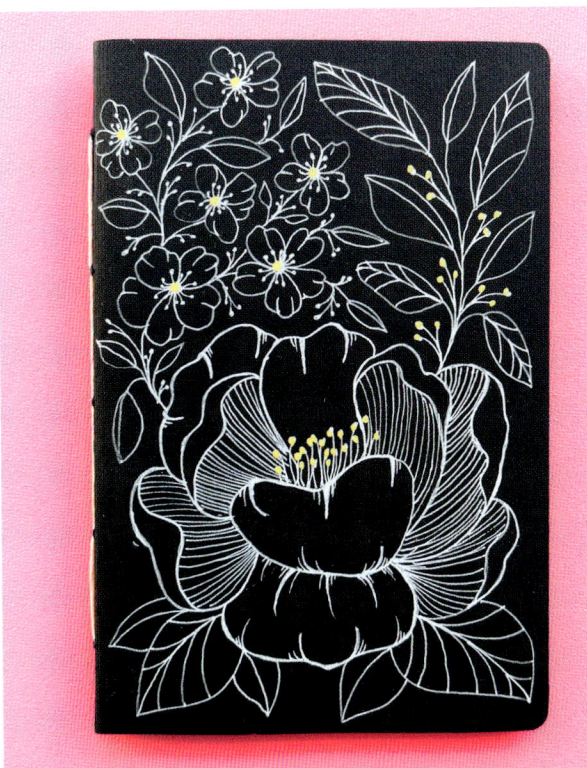

# Wreaths

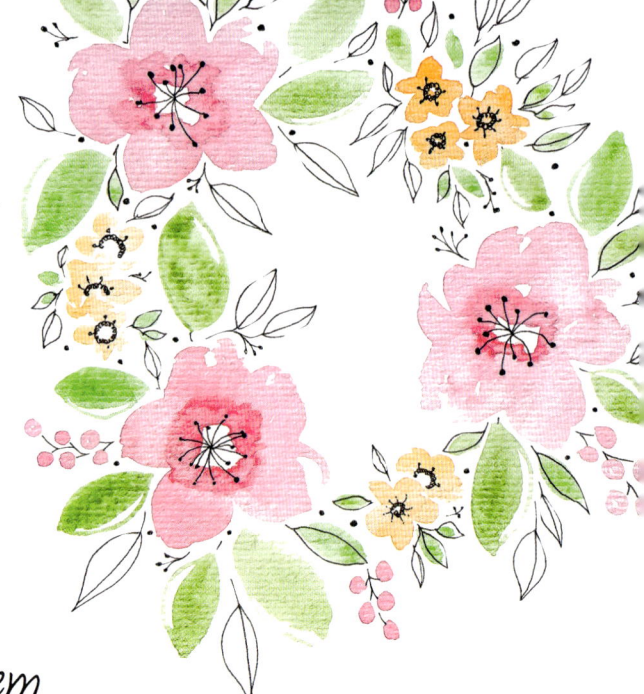

Drawing wreath designs is a versatile way to incorporate flowers into journals or on stationery. In journalling you can include wreaths on your cover page, as frames for quotes or affirmations and as design elements for calendars or weekly spreads. Stationery ideas include drawing a floral wreath on the front of an envelope with space for the address, or to decorate the front of a greetings card with a written message inside.

## A simple wreath system

Once you've settled on the shape of wreath you want to draw (circular, oval, square, and so on), use the sketching phase to decide which elements will be incorporated into the design and where they'll be positioned.

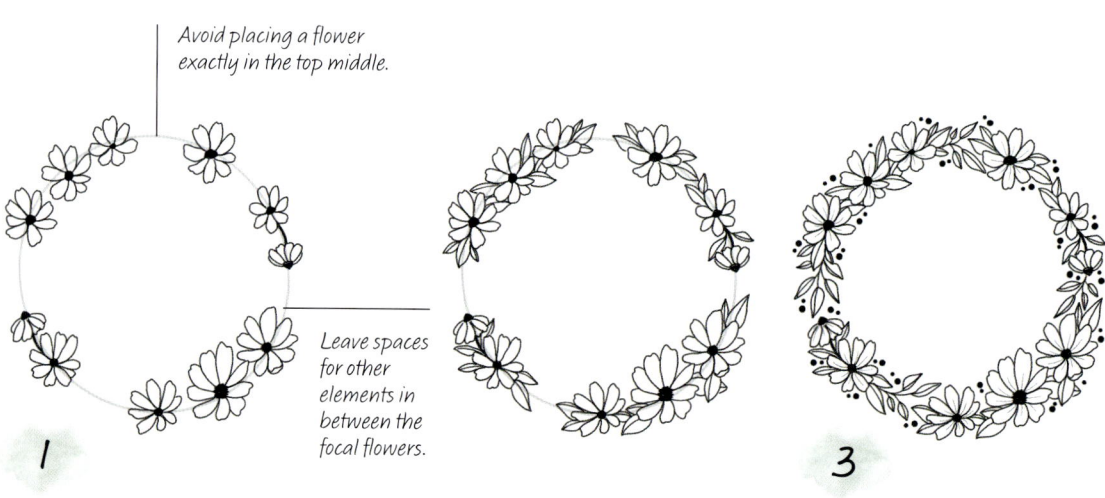

*Avoid placing a flower exactly in the top middle.*

*Leave spaces for other elements in between the focal flowers.*

**1** Place the focal flowers first. Positioning the largest flower in the bottom middle is a common and pleasing placement practice. Place the other flowers around the wreath or next to the focal flower.

**2** Add leaves to the flowers you've just drawn, making sure they are in proportion with the size of each flower.

**3** Fill in all the other elements, such as branches, buds or berries. Draw on both sides of the wreath, inside and out, to create movement.

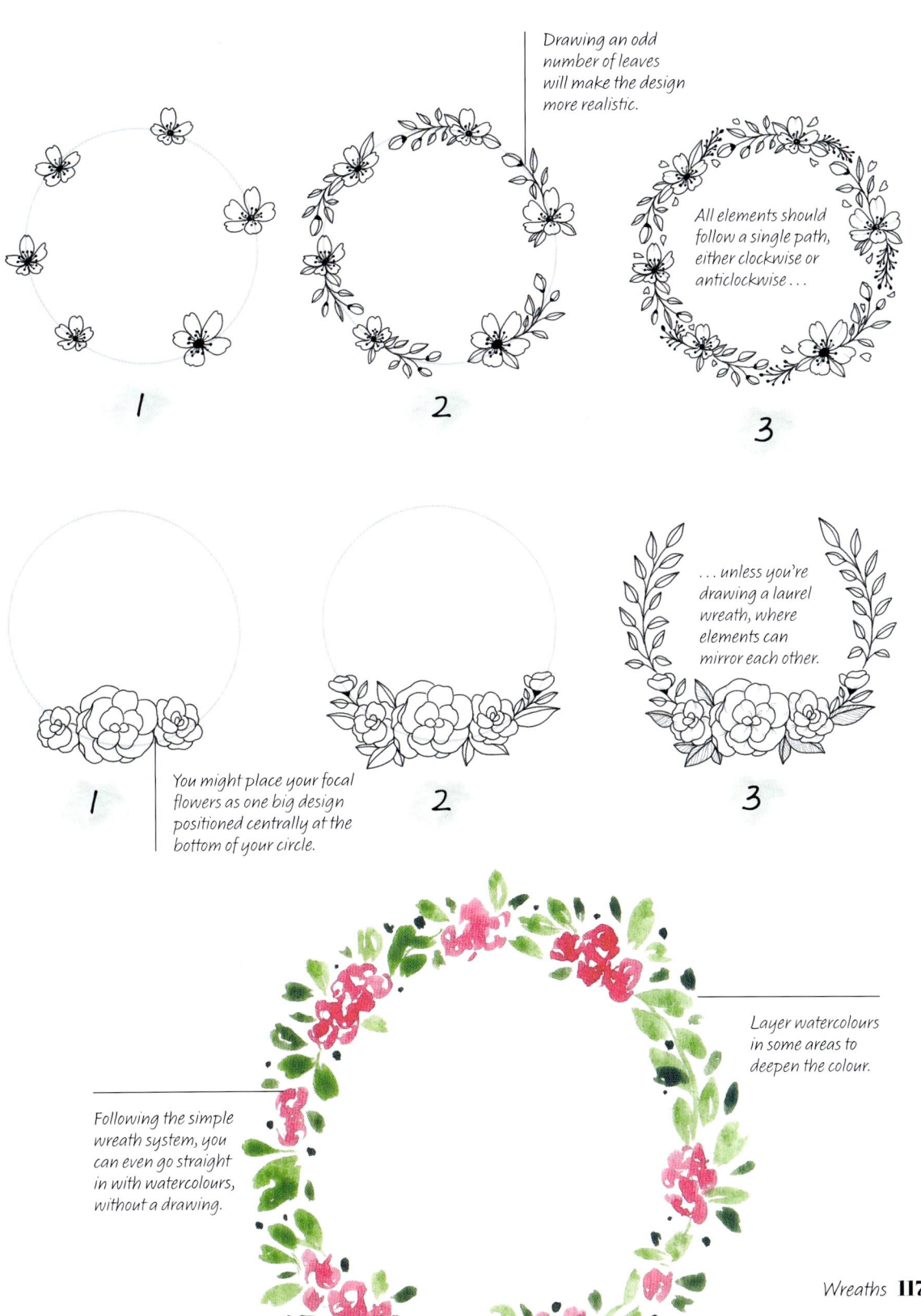

Drawing an odd number of leaves will make the design more realistic.

*1*

*2*

*3*

All elements should follow a single path, either clockwise or anticlockwise . . .

You might place your focal flowers as one big design positioned centrally at the bottom of your circle.

*1*

*2*

*3*

. . . unless you're drawing a laurel wreath, where elements can mirror each other.

Layer watercolours in some areas to deepen the colour.

Following the simple wreath system, you can even go straight in with watercolours, without a drawing.

# Working with many different elements in a wreath

If you want to include a wide variety of flowers and greenery in your wreath, it is a good idea to work on a far greater scale to prevent it from looking too crowded. The more elements you plan to include, the bigger your wreath should be, which is why this kind of project is perfect for book covers or full-page designs for cards or invitations, since the large space in the centre leaves room for text.

This kind of project requires detailed planning and a clear vision of how the final drawing should look, because there is no chance to make changes once the flowers are set on paper.

*If you have a tablet with digital drawing software you can use it as your sketchbook to plan intricate designs. Work in layers to move objects around freely until you're happy with the design, then use the digital sketch as your reference image while transferring onto paper.*

1  Mark your base shape (in this case a circle) with the position and space each flower will take, including where they will overlap. If you're working with many different flowers, write the name of the flower in the corresponding placeholder so you don't get confused.

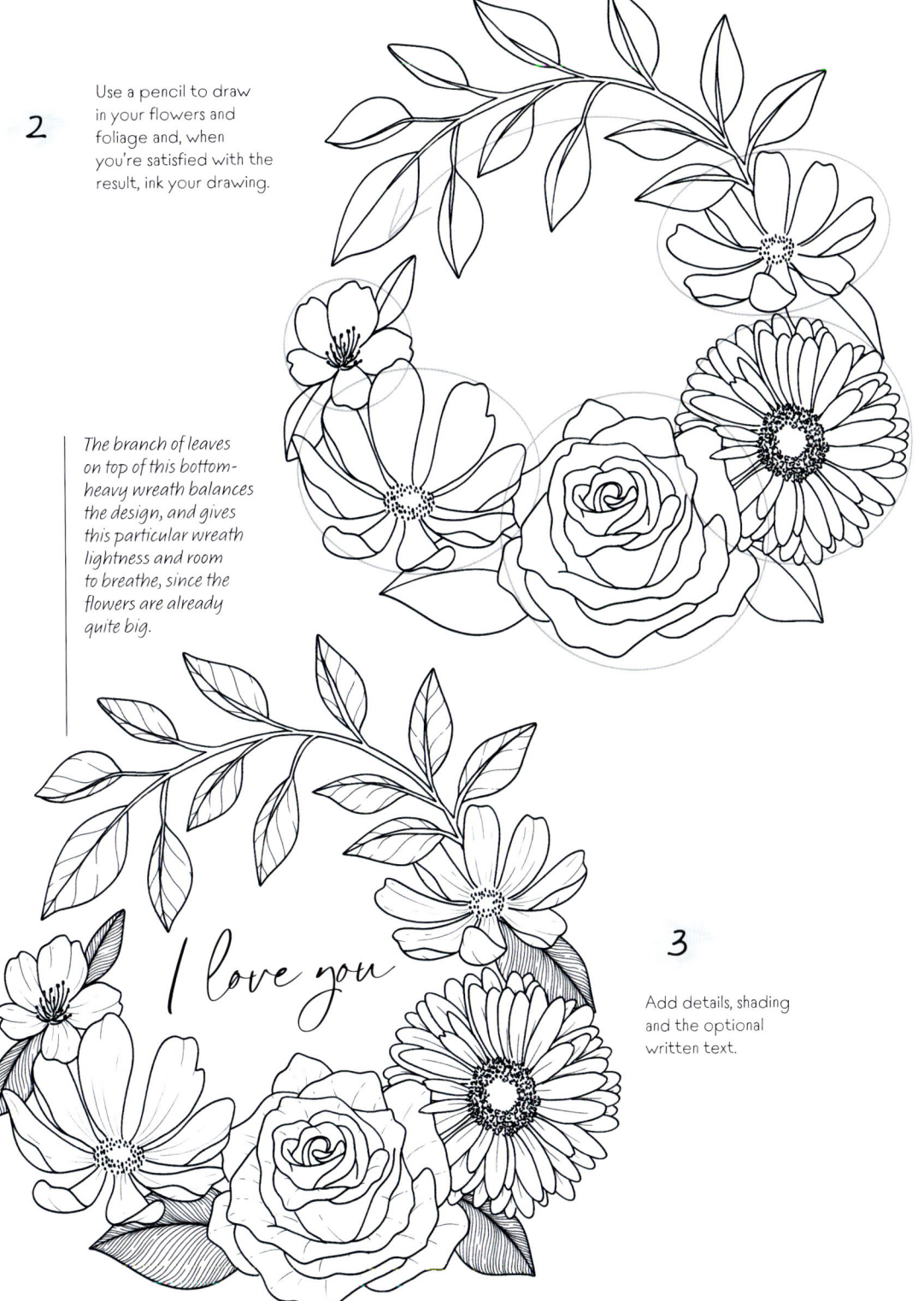

**2**

Use a pencil to draw in your flowers and foliage and, when you're satisfied with the result, ink your drawing.

*The branch of leaves on top of this bottom-heavy wreath balances the design, and gives this particular wreath lightness and room to breathe, since the flowers are already quite big.*

*I love you*

**3**

Add details, shading and the optional written text.

# Borders

Using floral illustrations to decorate borders is a beautiful way to add charm to any artistic project. Whether you're designing invitations, stationery or a journal spread, botanical borders can elevate the visual appeal and bring a touch of organic elegance.

There are infinite ways to approach a border design: it can be full and lush with vines, leaves and big blossoms; soft and delicate with small floral motifs or intertwining stems; or minimal and modern with simple outline drawings. Choose the style that best suits the vibe of the whole project.

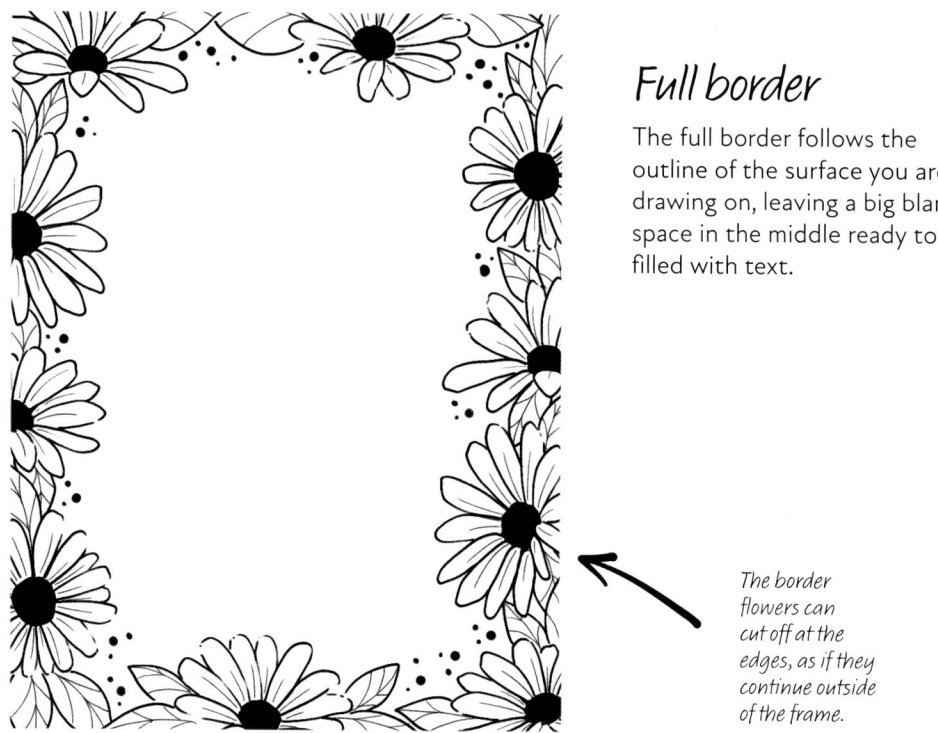

## Full border

The full border follows the outline of the surface you are drawing on, leaving a big blank space in the middle ready to be filled with text.

*The border flowers can cut off at the edges, as if they continue outside of the frame.*

# Upper and lower

Upper and lower borders are perfect for vertical spaces, and a solution that encompasses the text written in the middle of the pages.

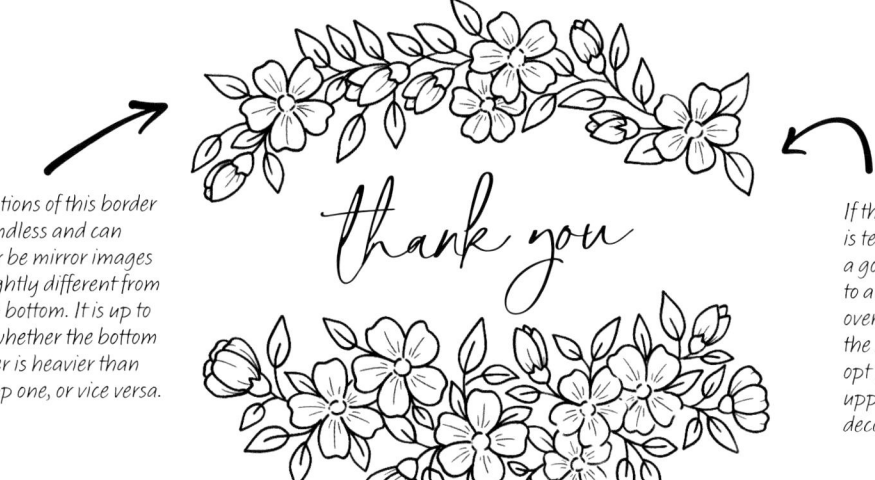

*Variations of this border are endless and can either be mirror images or slightly different from top to bottom. It is up to you whether the bottom border is heavier than the top one, or vice versa.*

*If the design is text heavy, a good way to avoid overcrowding the space is to opt for a single upper or lower decoration.*

# Corner decoration

Decorating just the corner of a frame is a good option for notepads, letter paper or journal pages where the main focus is the large amount of text that will be written within.

*Flowers as a corner decoration make the page look prettier without taking up too much space.*

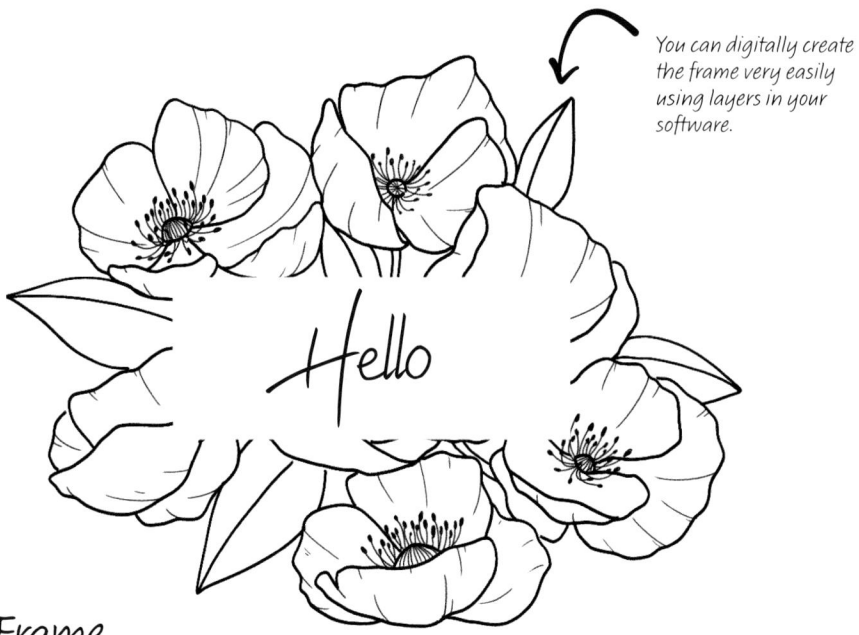

*You can digitally create the frame very easily using layers in your software.*

## Frame

Frames are perfect for headers, titles or anywhere where a small amount of text makes up the focal point of the design.

*To create this effect by hand, use washi tape to mark out the frame shape, then draw and ink your flowers, working over the tape. When you remove the tape, erase any visible pencil marks from the drawing.*

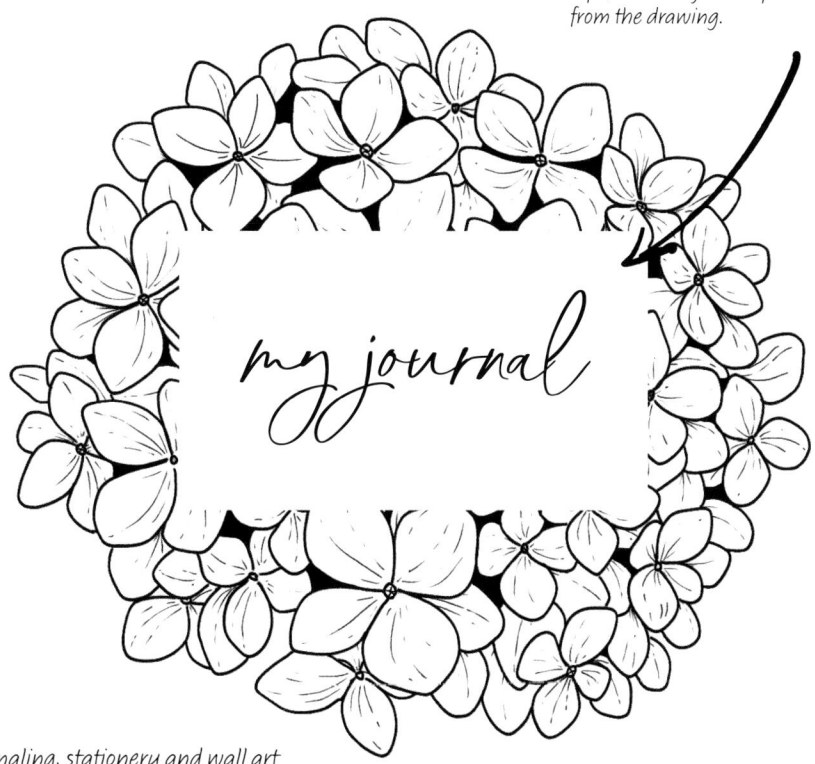

# Dividers

Dividers are thin and elongated designs whose main purpose is to divide batches of text or sections of a page. They're often simple and delicate, so they don't take up too much space.

*A divider could have a central focal flower with a symmetrical motif on either side.*

*A single sprig of leaves in a pleasing curve makes a simple and effective divider.*

*A divider does not have to feature symmetrical elements.*

*You might choose a symmetrical design.*

# Patterns

Drawing a floral pattern can be another creative way to fill any empty spaces or gaps in journals. Not only that, patterns can be used in any stationery item, for example, as covers for notebooks, as washi tapes or fabric designs, as borders for matching paper and envelope sets, as bookmarks, and much more.

Drawing patterns can be challenging, since they take up a lot of surface area, so to get more comfortable with this process try drawing patterns in small boxes, since working in a confined space should give you a better sense of control and be less overwhelming. This is also a good way to sample your design and check how the elements work with each other before committing to replicating it on a larger scale.

*Patterns feature repeating elements.*

## WHAT'S THE DIFFERENCE?

- What tells a pattern apart from a full-page design is the fact that a pattern calls for some sense of repetition, with the same elements being used over and over again to create a seamless effect. No one part of the design stands out on its own and all elements complement each other.

- A pattern can be cut into smaller pieces without losing meaning, while a full-page design could be difficult if not impossible to cut into sections without losing most of its beauty and visual interest.

*Patterned pages can be split up into smaller parts and still make sense.*

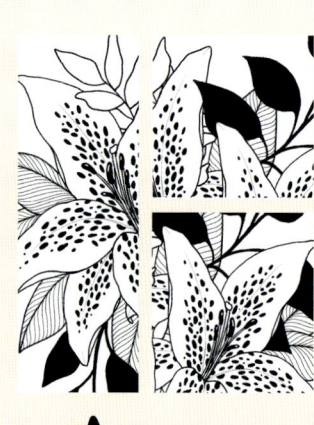

*A full-page design makes no sense when it is split into smaller parts.*

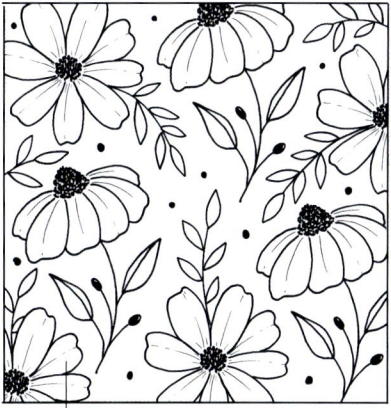

You may want to start with small-scale flowers, since they are easier and quicker to draw than larger blooms, especially if you're working on a smaller surface.

You can inslude shading lines, but keep it simple so the overall pattern does not become too busy.

It's fine to overlap elements in your pattern.

# How to draw a pattern

Big or small, the process of drawing a pattern is always the same. Start by choosing the blooms and greenery you want to draw. Remember that patterns feature at least a couple of elements that repeat, and think about the size of flower in relation to the size of surface you want to embellish.

*1*

Lightly sketch the basic shapes in pencil and the space each element will occupy. Position the main flowers first, then the leaves attached to the flower, then the supporting elements such as smaller flowers and foliage.

*Try to avoid a 'copy-and-paste' effect with the same flower in the same position over and over again.*

*2* Draw the focal flowers first, remembering to experiment with different orientations.

*3* Add smaller flowers.

**4**

Continue with the leaves and details.

This is where you can fill in the gaps to create a balanced pattern.

*Background details, like the dots in this example, fill the empty spaces and tie the design together.*

**5**

When you are happy with the placement of all the elements in your pattern, you can add details and shading.

**6**

You can also add a splash of colour to your design if you like.

# Full-page designs

Full-page designs allow you to work with bigger botanical elements, indulging in details and exploring complex compositions and different combinations.

The finished drawing spans the whole page, filling it with a work of art that fully expresses the intricate beauty of nature. They're perfect for cover pages for journals and notebooks or to decorate the side of a tote bag. The bigger the surface to fill, the better the result will be, especially if you've opted for a more photorealistic style of drawing.

*Make sure you know what the focal point of the composition is.*

*1*

Before starting, you need to have a rough idea of what you want to draw. Decide on your key elements, then make a simple sketch in pencil to guide your drawing and give a sense of the composition.

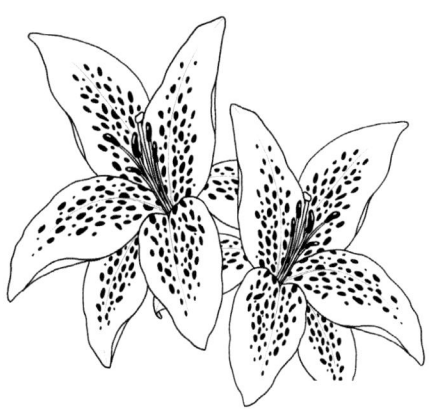

*2* Draw the focal point first, such as the flowers or a cluster of blooms.

*3*

Build up the drawing by adding other elements, such as more petals, leaves, branches and other supporting pieces.

**4**

Always consider
the placement and
proportions of the
elements so that the
focus is clear and the
various parts don't fight
with each other for the
viewer's attention.

*Try to overlap some of
the elements, which will
elevate the design and
enrich the complexity of
the composition.*

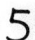

**5**

Refine the details and add
shading, remembering to use a
thinner pen for the fine lines.

*Step back and
observe your full-page
botanical design from
a distance, to ensure
it looks balanced and
visually pleasing.*

*Take your time and be
patient; this step is where
your artwork will really
start to come alive.*

# Flower arrangement

To successfully draw floral arrangements you must have a clear reference, or at least a very detailed structure in mind, because you will be assembling many elements in a composition that calls for a greater degree of realism than some other projects.

Arrangements are often intricate and present a multitude of elements to consider, such as the structure of the individual flowers, the textures of petals and the various shapes and sizes of leaves, all of this while ensuring correct proportions and perspective within the composition to achieve a pleasing result. This is why careful observation of the reference is key.

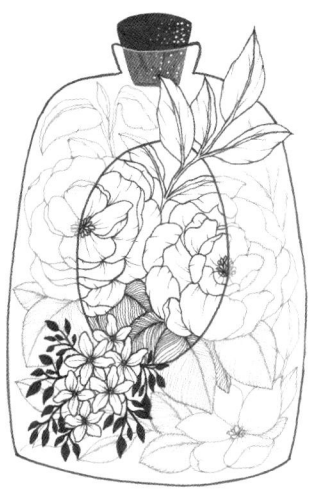

## Realism

Even if the composition is already provided by the source image, understanding the placement and distribution of flowers and foliage is important because you don't want to mindlessly copy what you see, but do need to have a deeper understanding of what is going on and how the elements interact with each other in order to recreate that on paper. This also comes into play when adding shadows and highlights to the final drawing.

## Stylization

If realism is not your preferred style, fear not, because when drawing floral arrangements, as with any designs, there is room for unique expression of personal style. If realism requires meticulous observation and precision, stylized representations are all about finding balance between simplifying the elements and retaining the main recognizable characteristics.

# Drawing a floral arrangement

No matter the style you choose, flower arrangements require patience and practice, but are always a rewarding drawing experience, filled with new lessons learned every time.

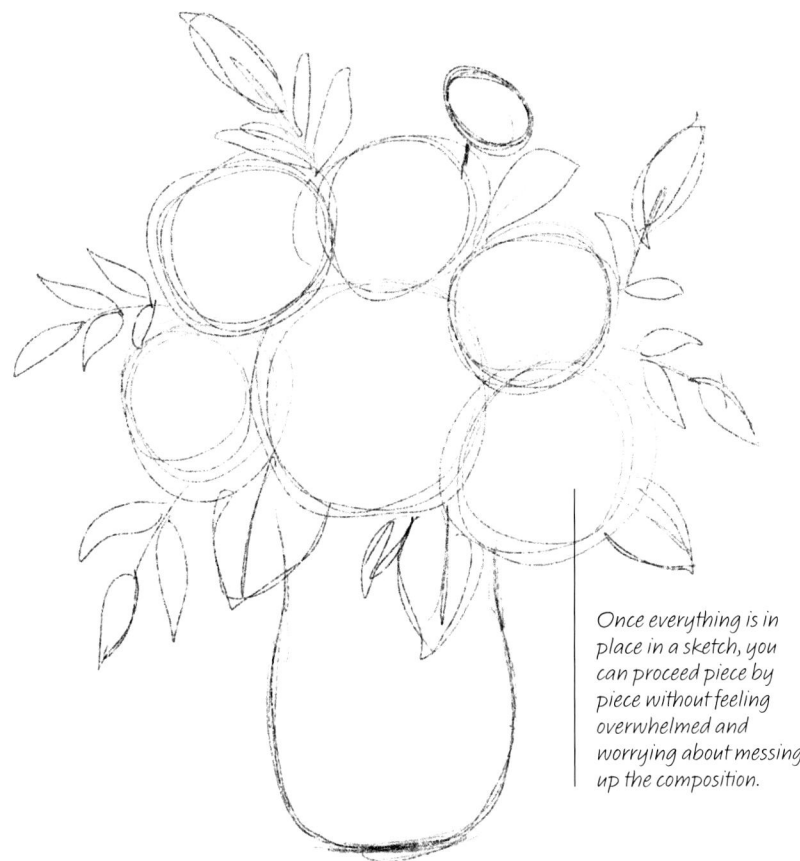

*Once everything is in place in a sketch, you can proceed piece by piece without feeling overwhelmed and worrying about messing up the composition.*

*1* Choose a reference and study it carefully. Find where the focal flowers are and how all the smaller elements complement and interact with them. Transfer the basic shapes of the flowers to paper to give a general guide to where everything goes.

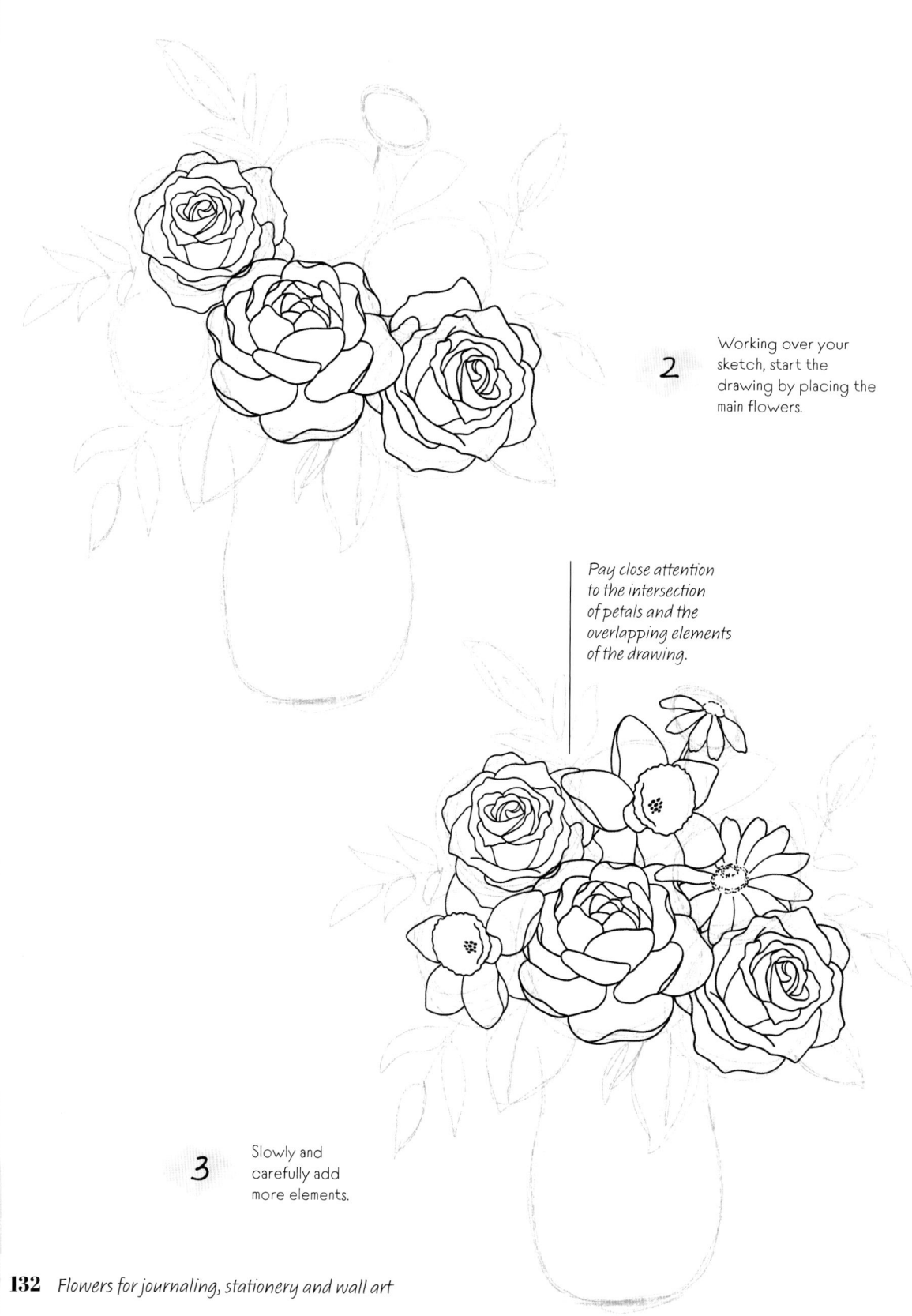

2 Working over your sketch, start the drawing by placing the main flowers.

Pay close attention to the intersection of petals and the overlapping elements of the drawing.

3 Slowly and carefully add more elements.

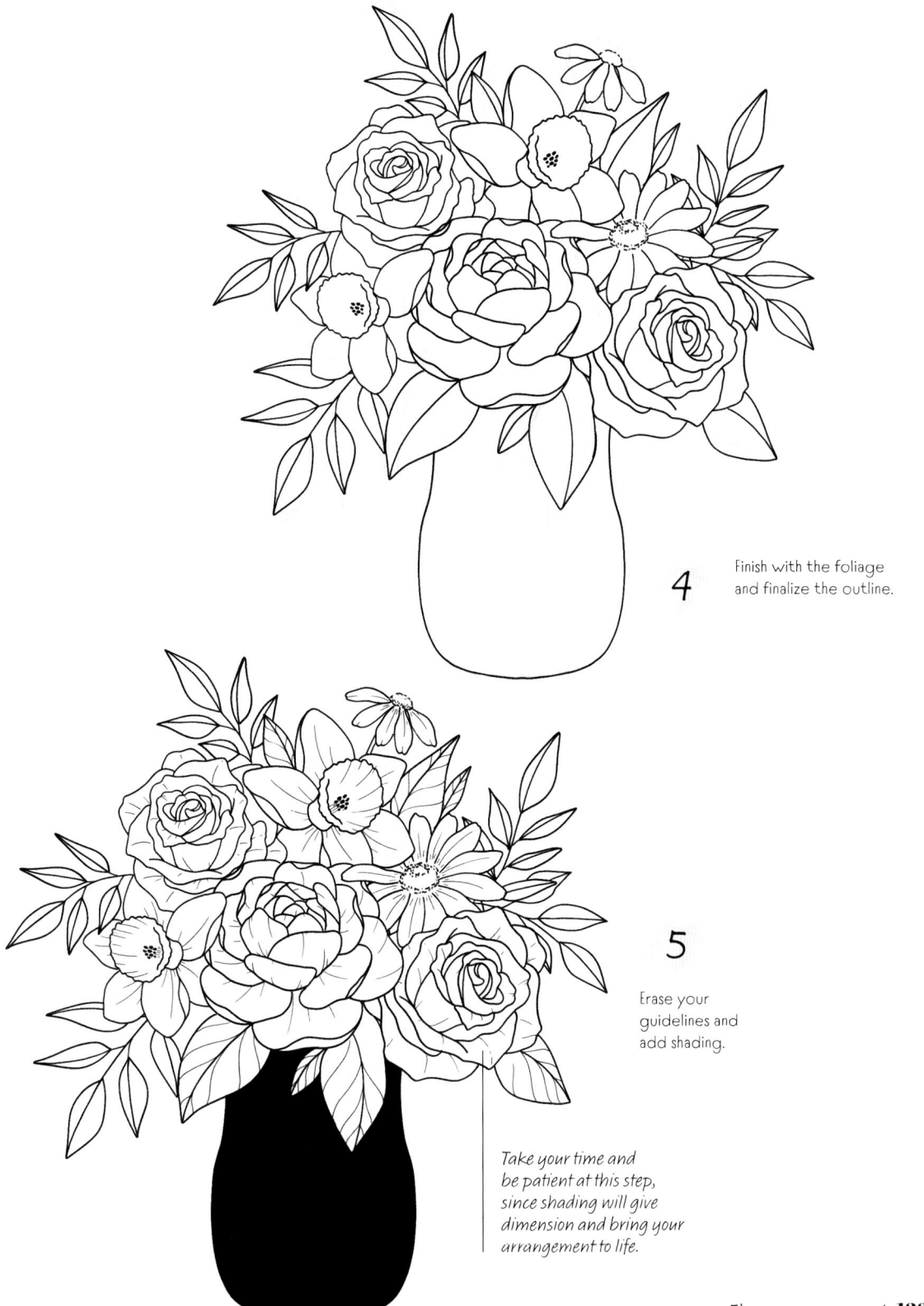

4 Finish with the foliage and finalize the outline.

5 Erase your guidelines and add shading.

*Take your time and be patient at this step, since shading will give dimension and bring your arrangement to life.*

# Letters

Perfect for wall art and stationery alike, combining letters and flowers is one of the best – and easiest – ways to create a bespoke artwork.

## Personalized gifts

Personalization as a trend has had enormous impact on the business of creating art products, transforming the way people engage with and purchase items. People love seeing themselves in a product as much as having a piece of custom-made art that reflects their personality.

A timeless source of customization opportunities is the first letter of a person's name, which people often associate with their identity and sense of self, becoming a symbol of their individuality. Personalizing something with the initial allows people to express their identity and make a statement about who they are. Personalization also gives them a sense of ownership and uniqueness.

The beauty of incorporating an initial into your botanical art is that it instantly becomes more tailored and thoughtful, expressing a deeper level of care and consideration, especially when the piece of art is a gift.

For newborns, a personalized botanical initial print makes a touching gift that can decorate the nursery and become a keepsake item for the baby to treasure as they grow older. I love the idea of the baby having their first experience of art with something tailor-made for them. Botanical initials also make a perfect birthday gift and are much appreciated by adults.

# Letters with flowers

The easiest way to incorporate letters and flowers is to take the letter and decorate it with blooms. This kind of project is perfect for beginners and experienced artists alike because you can modulate the complexity according to your skills.

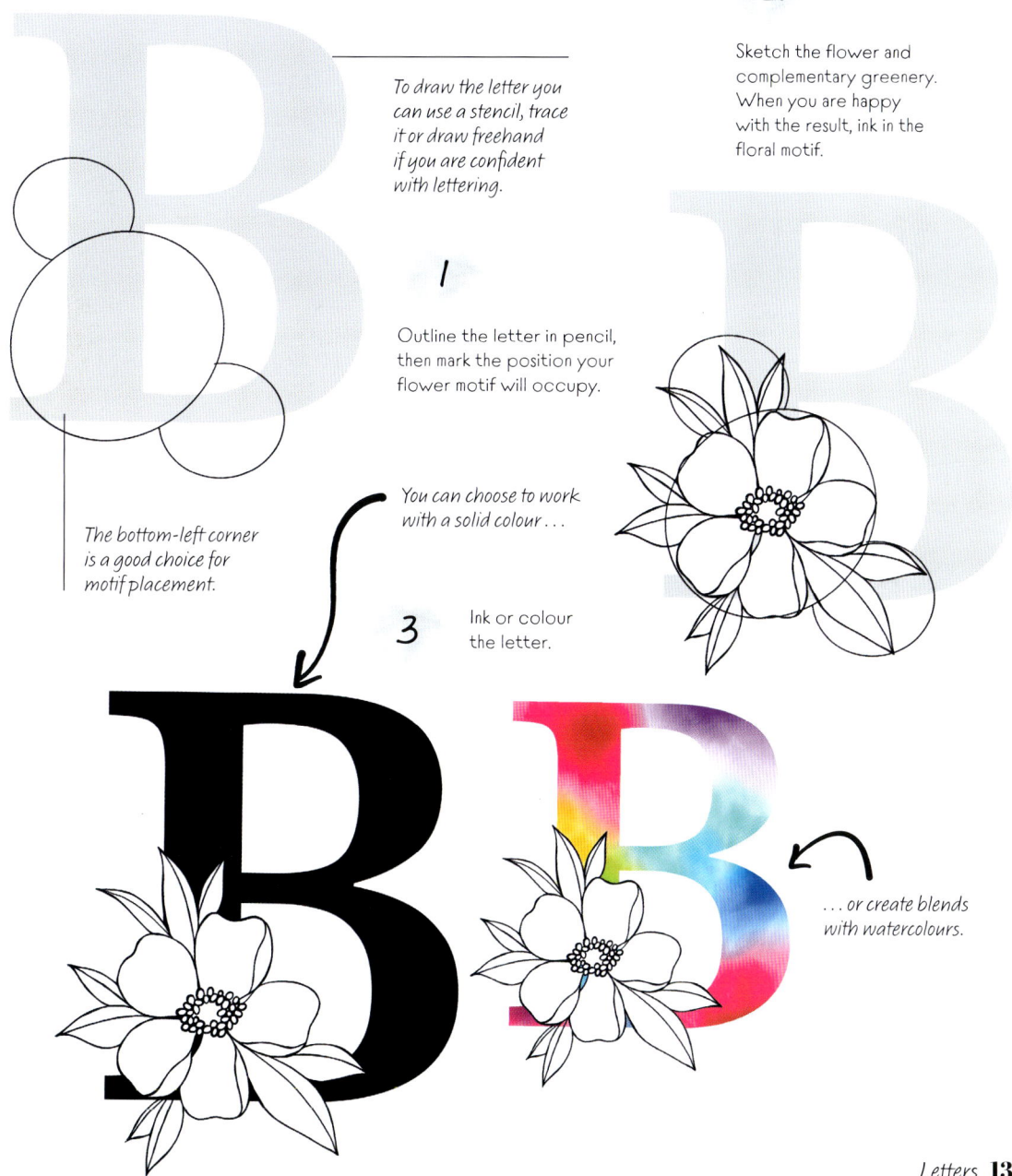

**2**

Sketch the flower and complementary greenery. When you are happy with the result, ink in the floral motif.

To draw the letter you can use a stencil, trace it or draw freehand if you are confident with lettering.

**1**

Outline the letter in pencil, then mark the position your flower motif will occupy.

The bottom-left corner is a good choice for motif placement.

You can choose to work with a solid colour . . .

**3** Ink or colour the letter.

. . . or create blends with watercolours.

# Letters in flowers

You can also embellish the whole letter with blooms by drawing small-scale flowers and leaves. You can use lots of different elements or a single element repeated over and over again – this stylistic choice is entirely up to you.

*1*

Draw the letter outline by hand, with a stencil or by printing and tracing. Start to draw your flowers one at a time, spacing them around the letter. Judging the positioning by eye may seem troublesome at first, but after some practice you will get better at placing and spacing. You can also mark the spaces then fill them with flowers, if you don't trust yourself to go with the flow.

*2*

When the main flowers are set, you should be left with space to add leaves and other detailed elements.

*3*

Add more leaves and stems to fill out the letter.

*If the space seems too big to be filled with just one leaf, add small branches.*

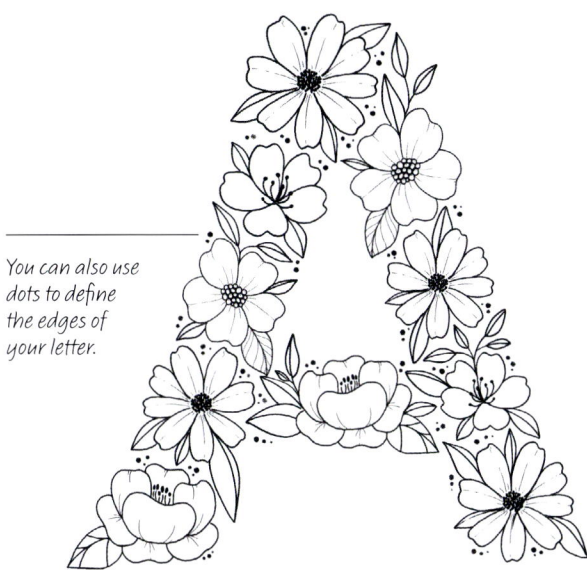

You can also use dots to define the edges of your letter.

*4*

Delete your pencil guide and, wherever you feel there's still too much space, add small dots that will bring the composition together.

## Gestalt principles

Gestalt principles explain how human perception of images works. They explore how people recognize patterns and shapes, and how they naturally group objects together, follow patterns and movement or how they instinctively simplify complex images.

In the examples here we use the proximity law, which teaches that visual elements that are very close together are often perceived as one group, forming their own object. In simple terms, flowers arranged to form a letter will make the viewer see the letter as a whole before seeing the flowers.

# Modern minimalist art

Minimalism is a form of artistic expression in which the work of art loses all unnecessary elements and is presented in its bone-bare structure. Even if at first glance a minimalistic drawing might look basic, this doesn't mean it's any easier and faster to produce than other styles of botanical drawing. In fact, minimalist art calls for an even longer study phase since you're not 'copying' from nature directly, but observing it and capturing its most essential form while still retaining recognizable features.

## Minimalist principles

You might like to incorporate some of the core principles that define minimalist art in your flower drawings, whether in journals, on stationery or as wall art.

### 'WHAT YOU SEE IS WHAT YOU SEE'
*This quote from Frank Stella, one of the earliest minimalists, expresses how the works strive for objectivity and lack of personal expression, emotional content and any deeper or hidden meaning. The focus is on the artwork itself, leaving room for free personal interpretation by the viewer.*

### THE BEAUTY IN SIMPLICITY
*Minimalism often employs basic geometric shapes, smooth and clean lines and limited colour palettes. Excessive detail and any form of shading or decoration are considered superfluous.*

### SKILLFUL SPATIAL BALANCE
*Minimalism pays careful attention to how the elements are placed and arranged within the artwork and skilfully uses negative space (empty areas) to create a balanced composition. White space is as important as the visual elements.*

# Applying the principles

You can apply these principles to your botanic drawing in a number of ways.

*Choose a limited colour palette or work monochromatically. Choose a background that allows the minimal design to stand out and be the main focus.*

*Simplify the shapes, lines and contours of flowers, leaves, buds and stems. Focus on capturing the basic geometric structures and key characteristics of the plant.*

*Use negative space strategically to intensify the visual impact of the drawing, giving it a greater sense of balance and harmony. Negative space can either be used around the composition or within it.*

# Minimal peony

Let's exercise these concepts with the most complex flower we've learned to draw: the peony. With its many elements, it's the perfect challenge to really apply the concepts of minimalism without losing the natural beauty and elegance of flowers.

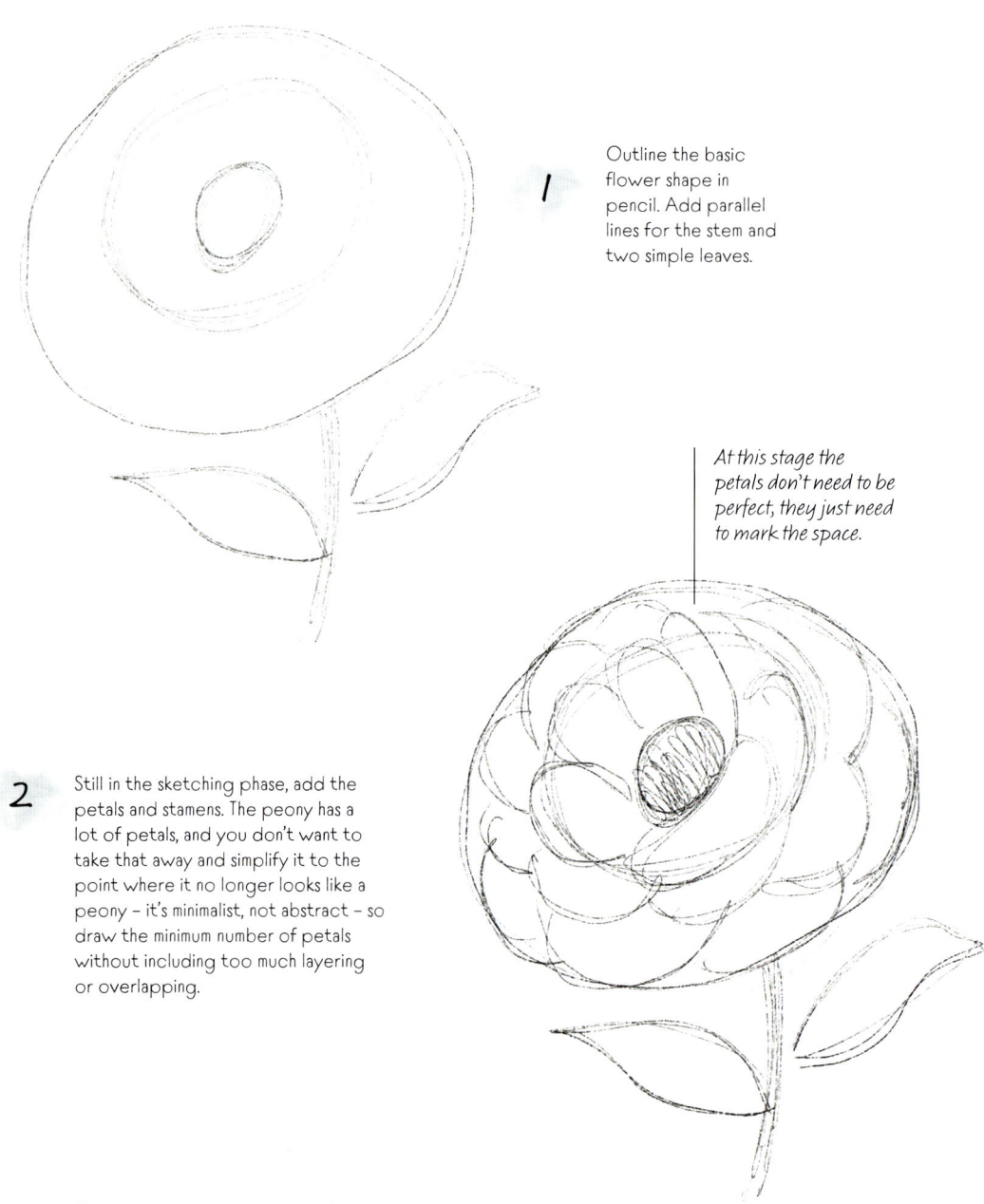

*1* Outline the basic flower shape in pencil. Add parallel lines for the stem and two simple leaves.

*At this stage the petals don't need to be perfect, they just need to mark the space.*

*2* Still in the sketching phase, add the petals and stamens. The peony has a lot of petals, and you don't want to take that away and simplify it to the point where it no longer looks like a peony – it's minimalist, not abstract – so draw the minimum number of petals without including too much layering or overlapping.

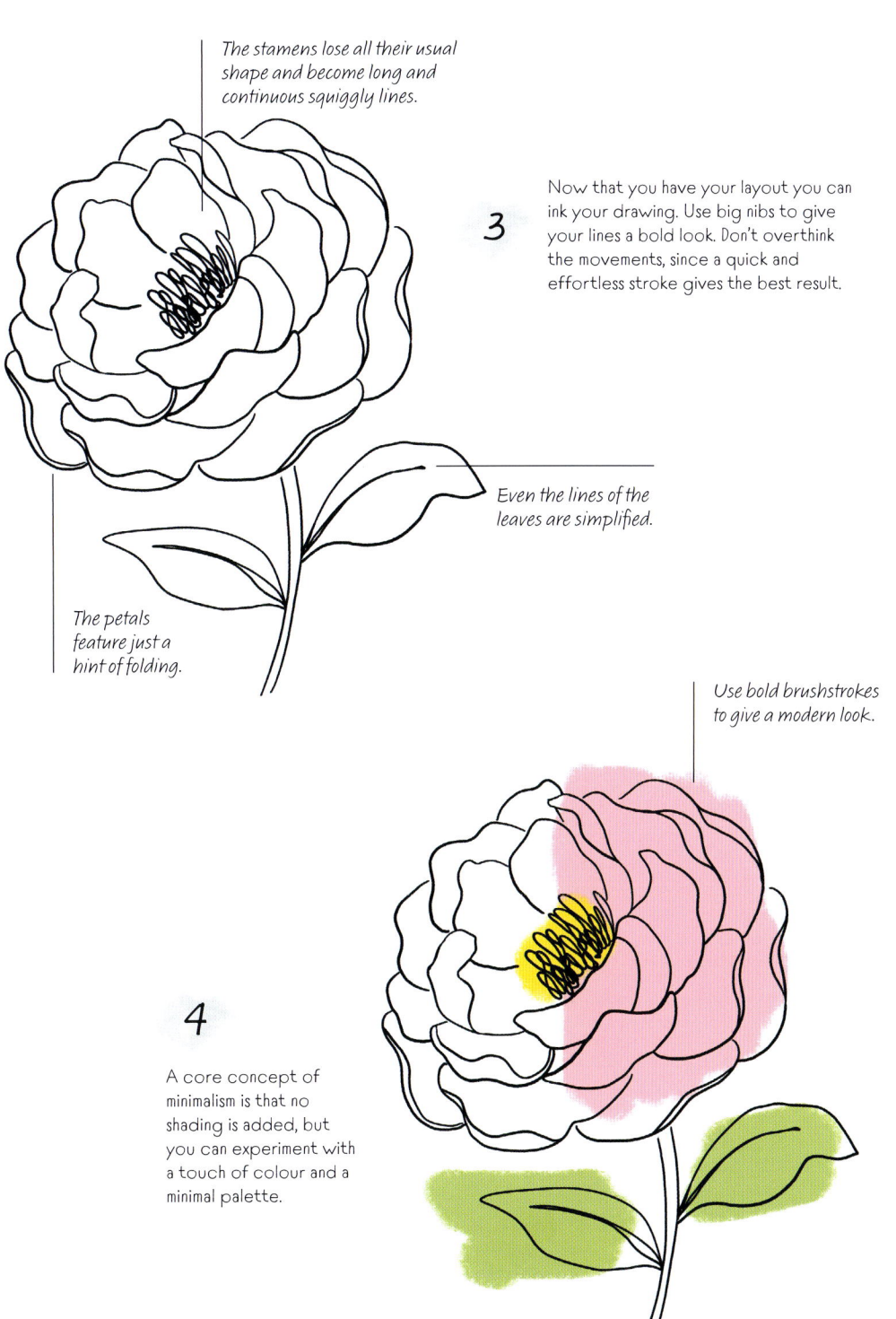

The stamens lose all their usual shape and become long and continuous squiggly lines.

**3** Now that you have your layout you can ink your drawing. Use big nibs to give your lines a bold look. Don't overthink the movements, since a quick and effortless stroke gives the best result.

Even the lines of the leaves are simplified.

The petals feature just a hint of folding.

Use bold brushstrokes to give a modern look.

**4**

A core concept of minimalism is that no shading is added, but you can experiment with a touch of colour and a minimal palette.

# Index

# Acknowledgements

Coming to write this book I had no idea how much it would have tested not only my creativity and perseverance, but also the strength of my support system. I had the privilege of having much more encouragement, understanding and love throughout this endeavour than I could have ever imagined, and for that I will be forever grateful.

First and foremost, I want to say the most heartfelt of thank you to my husband, Enrico. From the very beginning you stood by my side with unwavering faith and endless patience. Your support was my cornerstone, you always believed in me even when I doubted myself, and that gave me the strength to keep going. Thank you for understanding the times when I needed to immerse myself in drawing and writing, and for making me realize that I am, in fact, an artist even if I still struggle to call myself that.

Another big fuel to my determination was the support of my friends and family, their constant encouragement helped me through all the highs and the lows. Also, to my editors and the entire publishing team, thank you for allowing me to make my dream come true, believing in this project and helping me bring my vision to life, shaping it into what it is today.

A big thank you also goes to Royal Talens and Tombow for providing me with the art supplies needed to complete the artworks for this book. I've always been the greatest fan of the brands and I'm more than honoured to have them on board and support me throughout.

Lastly, to the readers who are holding this book in their hands, thank you for giving me the opportunity to take you with me in the wonderful world of botanical illustration. I hope the projects in this book will help you nurture the artist within you.

With deepest gratitude,